color

For Flora

Published in the UK by Ilex, an imprint of
Octopus Publishing Group Limited
Publisher: Alison Starling
Editorial Director: Helen Rochester
Managing Editor: Rachel Silverlight
Art Director: Ben Gardiner
Designer: Luke Bird
Senior Production Manager: Katherine Hockley

Published in North America by Smithsonian Books
Director: Carolyn Gleason
Senior Editor: Christina Wiginton
Editor: Duke Johns
Editorial Assistant: Jaime Schwender
Creative Director: Jody Billert

Library of Congress Cataloging-in-Publication Data
Names: Loske, Alexandra, 1969- author.
Title: Color : a visual history from Newton to modern color
matching guides / Alexandra Loske.
Description: Washington, DC : Smithsonian Books, 2019.
 | Includes bibliographical references and index.
Identifiers: LCCN 2018044586 | ISBN 9781588346575
 (hardback)
Subjects: LCSH: Color—History. | Colors—History. | Color in art. |
 BISAC: ART / Color Theory. | ART / Techniques / Color.
Classification: LCC QC494.7 .L67 2019 | DDC 701/.85—dc23
 LC record available at https://lccn.loc.gov/2018044586

Manufactured in China, not at government expense

23 22 21 20 19 5 4 3 2 1

For permission to reproduce illustrations appearing in this book,
please correspond directly with the owners of the works, as seen
on p. 238. Smithsonian Books does not retain reproduction rights
for these images individually, or maintain a file of addresses for
sources.

Color

A Visual History from Newton to Modern Color Matching Guides

Alexandra Loske

Smithsonian Books
Washington, DC

Contents

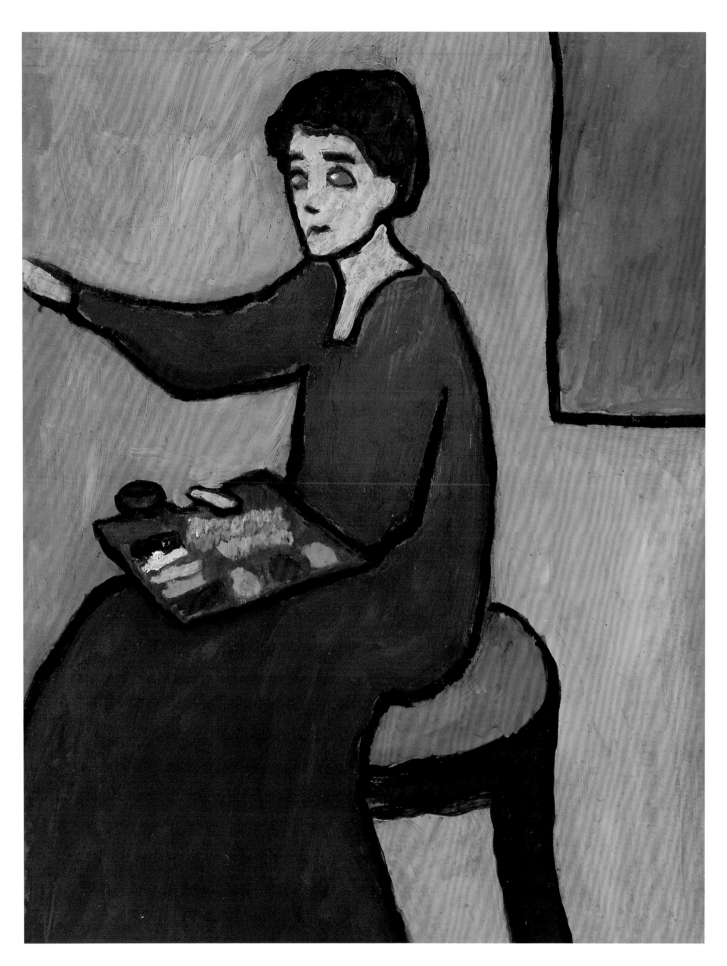

Introduction

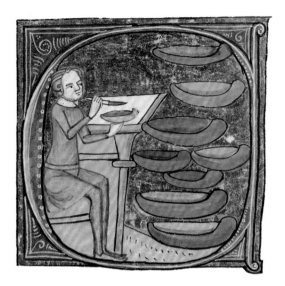

*The order of color, both
practically and conceptually,
is a mirror of its time*

This book charts the journey of color exploration, expression and discovery through painters' tools, art, printed ephemera and literature. Throughout history, artists, scientists and philosophers have attempted to explain and picture the order of the visible color spectrum. The order of color, both practically and conceptually, is a mirror of its time as well as the person who created it, and is of universal aesthetic appeal.

For artists working with material color, the order of color has had a particularly practical context: Where to place which color, on the palette as well as on the painting? How do colors influence each other, when physically mixed or optically juxtaposed? How to ensure you use an attractive or harmonious balance of colors on the canvas? An artist's palette is largely influenced by the medium the artist works in, where he or she works and by the kind of artists' materials that are available at the time, but it is also an expression of personal taste, style and the greater cultural context. Palettes and paint boxes can be the key that unlocks lost knowledge about color and how it was prepared and used. One of the earliest surviving paint boxes, used by the Vizier Amenemope of Egypt in c. 1427–1401 BCE, is a simple box with five pigments pressed into carved indentations: two types of carbon black, a mixed green pigment, blue frit and a red ocher. Despite, or even because of, its small size and simplicity, the box paints a vivid picture of the pigments available nearly three and a half thousand years ago.

Palettes also help us understand how and when artists mixed their colors, and how much they knew about pigments. The illustration of the initial "C" for Color in a fourteenth-century English manuscript (above left) tells us much about color mixing and tools in the Middle Ages: each color is kept in a separate dish and appears to be bright and premixed. More recent surviving painters' palettes can reveal how artists prepared the color composition of a specific painting: whether they worked outdoors on first sketches can be gathered from the size of a paint box and the medium; the selection of paints in the box and any traces of mixed paints left on the inside of a tin or the surface of a palette can tell us what pigments were available or popular, as well as how they were mixed and applied.

When painters include palettes in self-portraits or portraits of other artists, the physical object is then given a symbolical meaning, reflecting the person's character and artistic style, as can clearly be seen in a portrait by Gabriele Münter from 1911 (opposite). It likely depicts another Expressionist painter, Marianne von Werefkin, with whom Münter shared a passion for primary colors freed from representational constraints, arranged here almost like a collage for maximum brilliancy. This attitude to color is reflected perfectly in the sitter's palette included in the portrait, which she is holding at a slight angle, allowing the viewer to see how it is arranged. The painting is a

> *The predominantly abstract nature of color gives these images a timeless and universal quality*

carefully balanced composition in which the physical palette serves almost as a business card and signifier of artistic preferences.

From the early eighteenth century onwards, many color systems and diagrams were designed and applied in both the arts and sciences. They are frequently depicted as a circular shape, such as this relatively simple hand-colored color wheel (opposite) by British artist Robert Arthur Wilson. Wilson published it privately in the 1920s to illustrate his ideas about color order in relation to musical harmonies. Other diagrams are more fanciful and experimental, in the shape of triangles, diamonds or stars, or attempting three dimensions with "color globes," pyramids and cubes. Some of the earliest diagrams are simply lists of colors, usually intended to provide a resource for the reproduction or identification of colors, or an attempt toward standardization.

Changing ideas about color and the way we see it illustrated also reflect developments in print culture and technology, developing from uncolored to hand-colored plates, moving on to aquatinting and lithography, and further to photographic reproduction, large-scale silk screen-printing and eventually digital color systems in the more recent past. The kinds of publications we find these images in also tells us much about the use and understanding of color in certain times: when we see more art and theory books aimed at children and the general public, we know then that the populace was educated, and had access to painting materials and leisure time for hobbies.

Although this book is arranged in roughly chronological order, it is by no means a definitive history of color systems or color theory. It aims rather to celebrate the visual quality and beauty of color systems and concepts, and to showcase the creativity with which these have been devised. Many of the diagrams shown here are well known in the canon of historic color literature, but I have made a point of including several less familiar examples that complete the picture and may provide a few surprises. The same applies to art, especially from the late nineteenth century onwards, that directly addresses color order and color theory. Some very famous and popular works are represented here alongside lesser-known and recent examples, all of them underlining the continued interest and development of ideas about color.

Wherever possible, I have tried to show the visuals in the context in which they were published, whether as illustrations in a bound book or in other formats. Some of these publications show signs of heavy use in libraries and artists' studios, which makes them even more evocative. The predominantly abstract nature of color gives these images a timeless and universal quality that connects scientific, artistic and philosophical ideas expressed centuries apart. A color wheel by Moses Harris from the 1770s resonates easily with color ideas applied by the Bauhaus group to interior decoration, furniture and toys in the 1920s, as well as with a 360-degree walkway of rainbow colors created on top of a Danish art museum by Olafur Eliasson in 2011.

Opposite: Robert Arthur Wilson's hand-colored educational color circle in a 1920s pamphlet had an movable overlay to help artists create harmonious color combinations.

THE COLOUR CIRCLE

SCHEME *of* COLOURS

Unraveling the Rainbow: The Eighteenth-Century Color Revolution

The eighteenth century was a period of great intellectual, scientific and artistic ambition. The study of color was one among many subjects of interest, but in just the first decade of the century two things happened that changed the field forever.

Sometime around 1706, the German chemist Heinrich Diesbach, working with the alchemist Johann Konrad Dippel, invented a new pigment called Prussian blue. This deep, rich blue based on an iron compound is often considered to be the first modern color: that is, an inorganic and chemically produced pigment. It was a good alternative to the expensive mineral pigment ultramarine, and its invention heralded

> *By splitting white light, Newton identified the visible range of colors, or the rainbow spectrum*

the beginning of the commercial and large-scale production of a range of new pigments. This advancement would ultimately lead to good-quality color becoming more affordable and available—not only for artists but also for any industry that worked with pigments.

The other, slightly earlier, event was the publication of a book. In 1704 the English scientist Isaac Newton published his *Opticks*, the comprehensive result of many years of researching light and color.

By splitting white light, Newton identified the visible range of colors, or the rainbow spectrum. In *Opticks*, he built a color system around his findings, and he visualised this system in a circular shape, making it one of the first printed color wheels, albeit an uncolored one. Attempts toward an objective color system had been made before, but this was a substantial and hugely influential model based on decades of scientific experiments. Newton demonstrated the relationship between light and color, and convincingly argued for a certain number of "pure" hues that might provide the basis for a standardized color system.

Newton's ideas were quickly disseminated, discussed and promoted in European intellectual circles. Soon other researchers began to create color diagrams that would prove useful to the sciences and the arts. Many authors of color treatises were indeed scientists as well as artists, or poets as well as scientists. A surprising number of writers on color were botanists, geologists or entomologists, which might partly explain a heightened interest in accurate color representation. This was certainly the case with the British entomologist Moses Harris, who included color wheels, such as the one shown opposite, in his illustrated books on insects in the 1770s and even wrote a short, illustrated treatise just about color. Almost all images in printed publications on color were copperplate engravings or wood cuts. In the later eighteenth century, more and more of these images were colored, but hand-coloring was still the only way to ensure accuracy in depicting color systems or color charts.

What unites most color literature from the eighteenth century is an approach to color theory based on science, investigation and the search for

OPTICKS:

OR, A
TREATISE

OF THE

REFLEXIONS, REFRACTIONS,
INFLEXIONS and COLOURS

OF

LIGHT.

ALSO

Two TREATISES

OF THE

SPECIES and MAGNITUDE

OF

Curvilinear Figures.

LONDON,

Printed for SAM. SMITH, and BENJ. WALFORD,
Printers to the Royal Society, at the *Prince's Arms* in
St. *Paul's* Church-yard. MDCCIV.

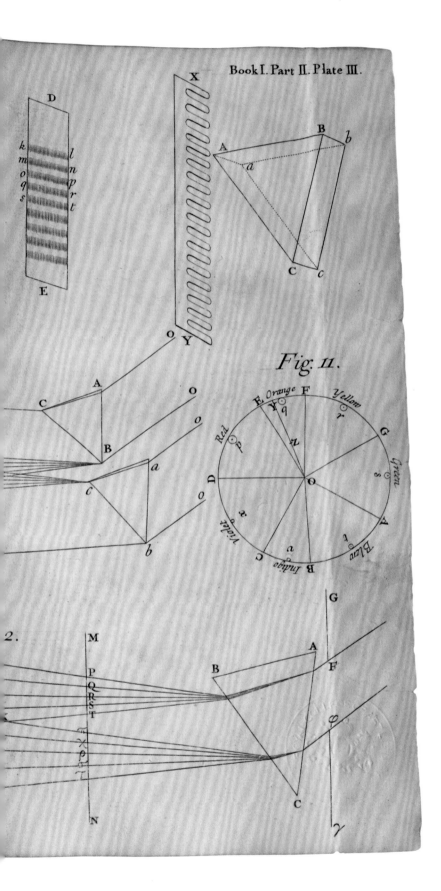

Book I. Part II. Plate III.

Fig. 11.

color systems and schematic representations, reflecting Enlightenment values. These diagrams were designed with the aims of clarity and instructive usefulness. Their format ranged from color charts and lists to various geometric shapes, with the circle or wheel dominating.

For centuries, the rainbow had been used in art, mainly as a symbolically charged trope in both landscape painting and portraiture, often with little regard for optical accuracy. The post-Newtonian era saw a shift in the style of the rainbows and other figurative representations of color, with a much greater emphasis on scientific accuracy.

Perhaps the most surprising thing was that the subject of color was becoming popular and accepted in academic discussion. For centuries it had been considered inferior in the hierarchy of the elements of art. By the end of the eighteenth century, however, color had become a standard element in aesthetic discourse, teaching and academic publications, although *colore* had not quite achieved the same status as *disegno* (line drawing).

Between 1769 and 1790, the President of the Royal Academy in London, Sir Joshua Reynolds, delivered lectures at the recently founded institution, in which he still discussed color cautiously and predominantly in the context of the Italian masters, and even then only as a subordinate element in the art of painting. However, a change was coming. The influence of Newton and his followers, combined with the invention of many new pigments as well as watercolors in moist cake form, had made painting with color an exciting occupation not just for serious artists but also for a much wider audience. The color revolution had begun.

Left: Newton's color circle, the diminutive and deceptively simple diagram marked "Fig. 11," which is shown on a fold-out sheet in *Opticks*.

Isaac Newton Presents the Rainbow

The most influential book on color published in the eighteenth century was Isaac Newton's *Opticks: A Treatise of the Reflexions, Refractions, Inflections and Colours of Light*. First published in 1704 in English, when Newton was at the height of his fame, it was translated into a Latin edition in 1706 and went into many further editions in several other languages, and remained the focus of intellectual discussion and criticism in the field of color studies until well into the nineteenth century.

Newton had bought his first prism in the early 1660s and begun experimenting on a serious level in 1666 while he was Professor of Mathematics at the University of Cambridge. He presented the results of his *experimentum crucis* (crucial experiment) of splitting white light into colors in the *Philosophical Transactions of the Royal Society* as early as January 1671. A sketch by Newton (opposite) illustrates the setup of his experiment, and provides the first image of white light being refracted into the visible spectrum. Although he eventually identified seven colors—red, orange, yellow, green, blue, indigo and violet—he noted only five in this sketch (initially, orange and violet were omitted). Newton also proved that these colors could be considered "pure" (or what we might call primary), as they could not be split any further.

Newton envisaged color in a deceptively simple-looking color wheel, included in *Opticks* in the form of a copperplate illustration (see previous page). Handily, this plate folded out of the book so that readers could consult the illustration while reading the accompanying text. The seven colors he identified form the wheel like unequally carved slices of a cake, with the poles of the visible spectrum—red and violet—meeting at the axis marked with a D. Though the uncolored circle does not immediately strike one as sophisticated, Newton was already making attempts at

introducing a three-dimensional and mathematically quantifiable system, with the letters that mark the circle offering a means to describe the precise qualities of a specific color. Notes in the text explain how the saturation of each color increases from white at the center, marked O, to its fullest saturation at the circumference. Additionally, Newton describes the mixing of the colors with their neighbors, so while the arch DE (for example) describes the color red, we can imagine that red to be graded toward violet at point D and orange at point E, while the lower-case letters at the center of each arch describe the color's purest form.

The diagram includes an example of how it could be used. The circles above the lower-case letters of each segment represent different quantities of colored

The seven colors Newton identified form the wheel like unequally carved slices of a cake

rays, for example, one ray for indigo and violet, through to ten rays for red, yellow and orange. From here, Newton calculated a common center of all these colors, marked by the letter Z. Drawing the line OY, from center to circumference, shows that the resulting compound will be a reddish orange, and since the Z is a little more than halfway down this line, the color will be low intensity, with a lot of white light.

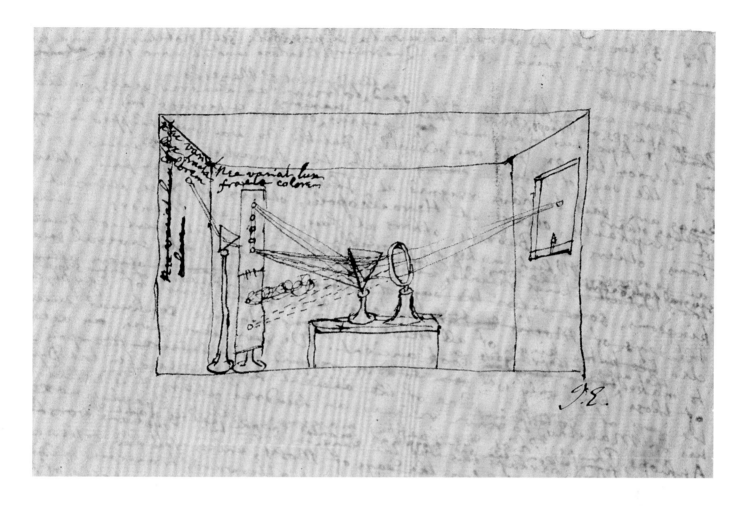

The usefulness of this wheel for artists or anyone working with material color is not quite clear, since Newton was working with light—that is, with immaterial color, also known as additive color. While the spectrum of colored light combines to create brighter, whiter light, mixing together the same range of colors in the form of paint would make for a darker, duller mixture. The wheel also places complementary colors opposite each other, as far as possible in an asymmetric design, but Newton did not elaborate on how this might affect the use of color in art or design, something much discussed by later color theorists.

The unequal division of the circle, with indigo and orange allotted much smaller segments, is another curiosity. An equally proportioned circle divided by an even number would make for a more aesthetically pleasing (and possibly more useful) diagram. Newton's aim, however was "not to explain the Properties of Light by Hypotheses, but to propose and prove them by reason and experiment," making *Opticks* exemplary of the values of the Enlightenment.

Newton's colors do in fact represent the range of electromagnetic radiation, known as wavelength, that the human eye can see, despite the fact that the concept of wavelengths was not yet understood.

As for the seven colors identified on his wheel, like Pythagoras two millennia before him, Newton was making symbolic associations between music and color. Each segment of his wheel relates to one of the seven diatonic intervals of the Doric mode, beginning and ending at D to form an octave. As we shall see, the notion that color and music should be linked was explored later by many other color writers and artists, well into the twentieth century, with abstract artists like Wassily Kandinsky and Robert and Sonia Delaunay exploring synaesthetic aspects of color and music experience (see pages 156–157).

Although Newton's wheel drew criticism from contemporary and later thinkers, it was—and remains today—one of the most influential systems for ordering color. If few people today can confidently differentiate indigo from blue, most any child will be familiar with the Newtonian acronym "ROY G BIV."

I. Ordnung
der
Farben claſſe.

XII. g. Feuerblau. I. gatt. Blau.

XI. g. Veilenblau. II. g. Meergrün.

X. g. Veilen
roth. III. g. Grün.

IX. g. Kar=
maſinroth. IV. g. Oliven
Grün.

VIII. g. Roth. V. g. Gelb.

VII. g. Feuerroth. VI. g. Oranien gelb.

Die
Blühenden
Farben.

Taking Up the Challenge: Color after Newton

If Newton had set the challenge of how best to order color, he would certainly not be the last to attempt a definitive, graphic system of color. In 1708, the first known colored images of color circles (see overleaf) were published in Claude Boutet's *Traité de la peinture en mignature* on facing pages. The circles are decorated with pictorial scenes featuring putti and aristocratic ladies in genteel settings.

The first of the circles follows Newton's system: it is asymmetric and comprises seven colors—albeit now evenly proportioned. The second circle shows twelve colors and is symmetrical, perhaps to better illustrate the relationship between the colors—complementary colors in particular. In contrast to Newton's illustrations, they are colored, by hand in watercolor, and the figurative scenes at the bottom of the page make it clear that the subject of work is material color.

Newton's theory of color was influential long after the publication of *Opticks*, and beyond his native tongue. The Austrian Jesuit priest and entomologist Ignaz Schiffermüller discussed why he supported Newton's theory in *Versuch eines Farbensystems (An attempt toward a system of colors)*, published in 1772. Where Newton proposed seven pure colors, however, Schiffermüller's color wheel (left) comprised twelve: three primary, three secondary and six tertiary colors, each in equal 30-degree segments—like Boutet, changing Newton's asymmetric and unequally divided spectrum into a symmetrical system.

Schiffermüller applied his system strictly to material color and the art of scientific illustration, yet he nevertheless paid tribute to Newton's experiments with the pictorial vignettes surrounding the circle, presenting painting, or the material application of color, in the context of his scientific methods.

In the eighteenth century, some attempts were made at depicting color systems in three dimensions. The aim of such schemas was to include other dimensions of color, such as saturation or the light value of tints. Some of these early three-dimensional systems have triangular and pyramidal shapes, such as one proposed by the German astronomer and map-maker Tobias Mayer in 1758. He in turn influenced the German astronomer and mathematician Johann Heinrich Lambert, who interpreted and extended Mayer's numbered triangular system and presented a seven-tiered *Farbenpyramide* (color pyramid) in 1772, containing 107 tints (below).

The topmost triangle represents "whiteness or light," while the colors in the lowest triangle "are mostly quite dark except where they border on yellow." The pyramid sits on a base of twelve pigments, named in the text as Naples yellow, lamp black, king's yellow, juice green, auripigment, chrysocolla, azurite, verdigris, smalt, cinnabar, indigo and Florentine lake. These are twelve pigments (as opposed to color names) that were commonly available in Germany in 1772, so apart from creating a conceptual diagram of color, he was also

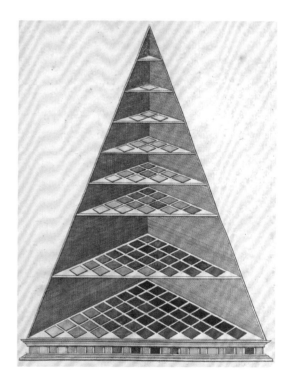

providing practical advice on which pigments could be considered to resemble the colors outlined above. Lambert also provided a key for the 107 tints displayed in the tiers of the pyramid, thus stressing the applicability of his system to merchants and the dyeing industry, as well as artists, and placing his system firmly in the world of material color.

Left: Ignaz Schiffermüller's color wheel from 1772 pays homage to Newton's findings but proposes a more equally divided order, with twelve colors rather than seven.

Right: Johann Heinrich Lambert's *Farbenpyramide* was created the same year as Schiffermüller's circle. This color pyramid places the primaries red, blue and yellow in the corners, with various combinations in between.

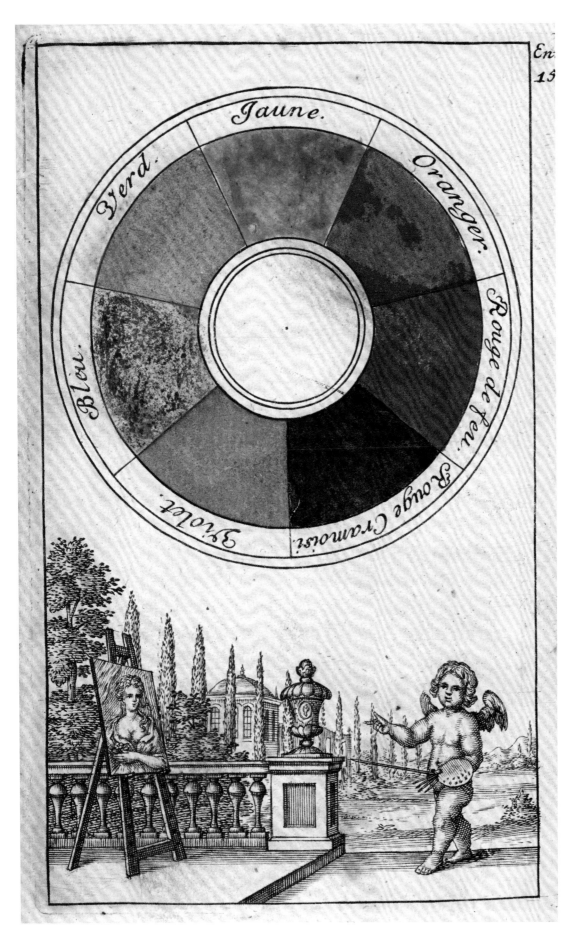

Left & right: In 1708, Claude Boutet produced what are believed to be the first colored color wheels. The one on this page appears to follow Newton's ordering, giving seven colors rather than the even-numbered, symmetric kind offered on the facing page. You will notice, however, that rather than the two kinds of blue proposed by Newton (indigo and blue), Boutet depicts two kinds of red: "Rouge de Feu" (fire red) and "Rouge Cramoisi" (crimson red).

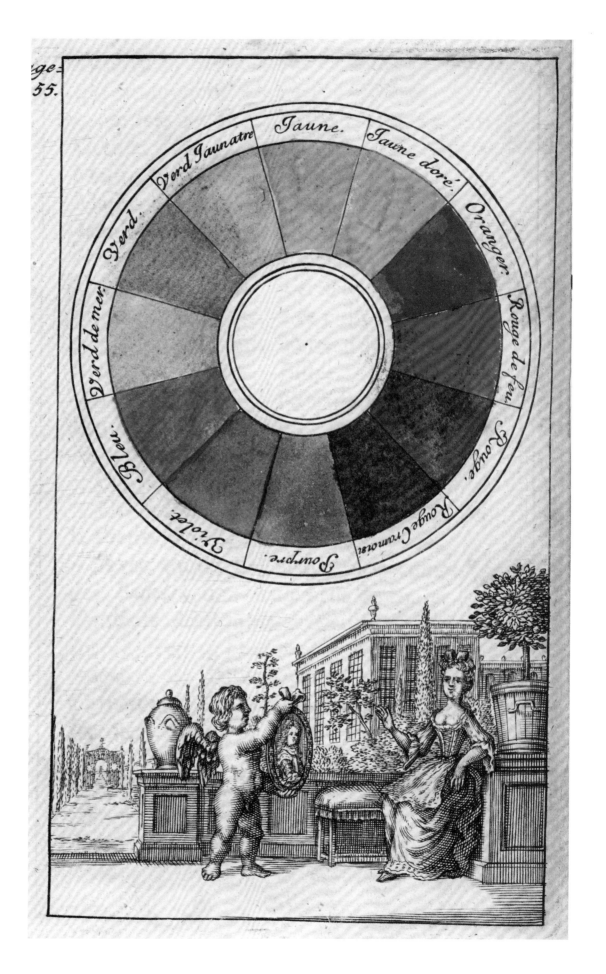

Allegorical and Figurative Images of Color

Even before Newton's color theory had become part of the scientific vernacular, representations of color and color order often featured in paintings in the form of rainbows or palettes. They are seen most prominently in allegorical self-portraits depicting the art of painting or coloring, as in Giovanni Domenico Cerrini's *Allegory of Painting* (1639), opposite. Usually—as with Cerrini's example—Painting is represented by a woman holding palettes and brushes, or by putti or cupids playing with artists' tools, or combinations of these. In personifications of the art of painting or color, artists often made visual and compositional references to color order. The colors of the fabrics in this painting, for example, are all pure primaries: blue, yellow and red, plus green, which was often considered a primary. Associations of color and the art of painting with women are likely to have their origins in Greek mythology, where the goddess Iris was the personification of the rainbow and a messenger of the gods. This also explains the clouds and skies in conjunction with colors and rainbows that make frequent appearances, especially in baroque and rococo painting.

Figurative and allegorical representations of color continued to be published throughout the eighteenth century alongside abstract diagrams and charts. They appear to have had a popular appeal as affordable prints, as the case of Angelica Kauffman's *Colouring* suggests. Kauffman, a founding member of the Royal Academy in London and, incidentally, later a friend of Johann Wolfgang von Goethe, was commissioned in 1778 to produce ceiling roundels for the new Council Chamber in the Royal Academy when it was still located at Somerset House on the Strand, in London. The four roundels, painted in oil, depict the "four elements of art:" Design, Invention, Composition and Color. Female allegorical figures are usually set in a neoclassical context; Kauffman's *Colouring* (see overleaf) depicts a female painter dipping her paintbrush into a Newtonian rainbow. A chameleon in the foreground offers a further allusion to color. The images were stipple-engraved by Francesco Bartolozzi in 1787 and appear to have been some of the most popular prints after Kauffman, even though the engraving renders them black and white. The rainbow might here symbolize the painter's understanding of color as relying on Newton's findings. Significantly, the color scheme of the original painting is formed of dominant shades of the three primaries: red (in the woman's shawl or cape), yellow (her dress) and blue (the sky), all set against neutral naturalistic browns, greens and grays.

Intriguingly, the earliest description of the painting by Joseph Baretti in *A Guide Through the Royal Academy* from 1781 mentions a prism in place of the paint palette: "*Colouring* appears in the form of a blooming young Virgin, brilliantly, but not gaudily, dressed. The varied Colours of her garments unite and harmonise together. In one hand she holds a prism, in the other a brush, which she dips into the Tints of the Rainbow." It is possible that the prism was painted

Associations of color and the art of painting with women are likely to have their origins in Greek mythology

over at some point. Kauffman's fascination with the rainbow and, it can be assumed, the study of color literature, was later echoed by the second president of the Royal Academy, Benjamin West, who as early as 1787 would advise his students to use the rainbow as a guiding principle in painting: "in that point Nature has placed the most glowing colours of the Rainbow, so that any deviation from this order of colours becomes offensive, and sikens every Eye."

The conflation of the symbols of contemporary color theory and the material aspects of painting, combined with overt references to Newton, can also be seen in an anonymous print from the same period

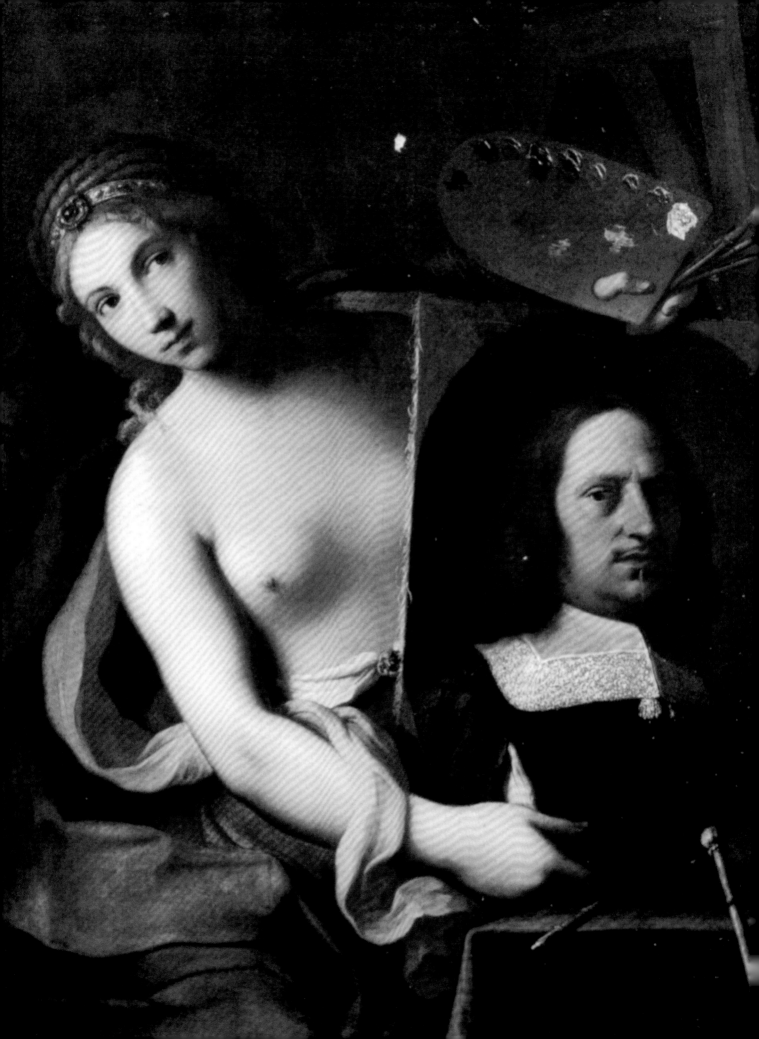

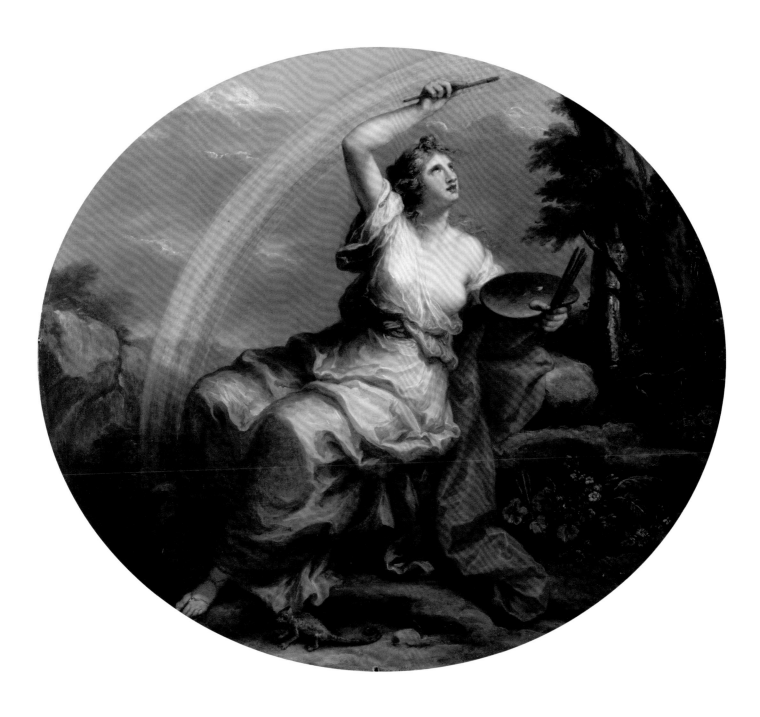

Above: Kauffman's image
of *Colour* (1778–80) was
hugely popular, even as
an uncolored print after
the original, showing how
important color and color
theory was becoming in the
artworld. Previously, it had
been treated as inferior to
design and line drawing.

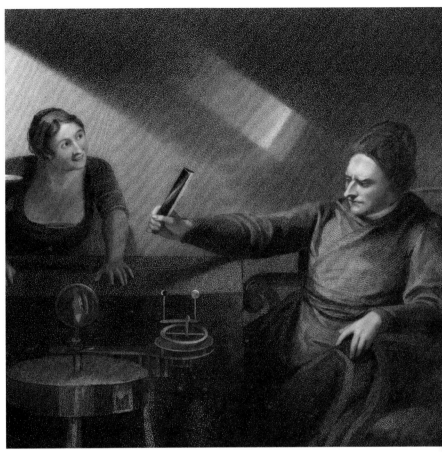

entitled *Theory of Colours* (1785), above left. Here, the reference to Newton is made explicit by a female figure holding a prism against the sunlight, with the spectral colors appearing on what could be a large sketchbook or portfolio. Multiple pictorial references are made to painting and even the production of pigments: gathered on the table next to the figure are a painter's palette with paint brushes, a vial (most likely for the preparation of pure pigments), a book (an allusion to the theory underpinning painting) and flowers, which might represent the genre of flower painting or the imitation of nature in painting in general. A large vat in the background might be for pigment production or pigment storage. This small but significant engraving reflects the appreciation and status of color studies and color theory in the later eighteenth century and refers to their application in the fine arts and even pigment production.

Into the nineteenth century, figurative pictorial images of color theory, optical concepts or the art of painting in general made way for much more literal and narrative illustrations. A number of decorative prints depicting Newton carrying out his experiments with prisms and light were produced throughout the nineteenth century, as for example a posthumously published print after George Romney entitled *Newton with the Prism* (1809), above. The scene is romanticised, showing Newton surrounded by scientific instruments and apparently performing his experiments with a prism in order to educate two young women, possibly his niece and a maid, present; this perhaps being indicative of the association of the art of watercolor as a pastime for young ladies.

J. C. Le Blon and the Trichromatic System

The exchange of ideas occurring within Europe during the eighteenth century is evident in the plethora of early translations of published works, the number of authors with a multicultural background or education, much cross-referencing in the works, and the occasional bilingual edition. J. C. Le Blon's *Coloritto*, or, *The Harmony of Colouring in Painting/L'Harmonie du coloris dans la peinture*, first published in London between 1723 and 1726 as a bilingual English/French edition, is an excellent example of this cosmopolitan attitude, as well as being an important early work on multicolored printing technique.

Born in Frankfurt, Le Blon had studied in Rome and Switzerland and gained experience in his profession as an engraver and printer in Paris, London, Germany and Amsterdam. He was credited by the influential color theorist Faber Birren as being responsible for initiating the prevalence of the trichromatic color system. Older color systems were frequently tetrachromatic—comprising four colors, usually red, yellow and blue, and black or green—although the concept of three primaries, as the basis for mixing all other hues, had been long known to artists.

Le Blon applied his system to printing, and invented a three-color (and four-color, with the addition of black) printing technique described in *Coloritto*, which could reproduce works of art with fair accuracy—far better than the black-and-white reproductions available at the time. He stated: "Painting can represent all visible Objects, with three Colours, Yellow, Red, and Blue; for all other Colours can be compos'd of these Three, which I call Primitive." The cost and resources required for such prints was, however, prohibitive, and Le Blon's model was unsuccessful, commercially at least.

But his method was well founded. Perhaps it helped that, unlike many of his contemporaries, Le Blon clearly understood the difference between subtractive and additive color. In his short and now extremely rare publication, the author differentiates between the two, referencing Isaac Newton: "I am only speaking of Material Colours, or those used by Painters; for a Mixture of all the primitive impalpable Colours, that cannot be felt, will not produce Black, but the very Contrary, White; as the Great Sir Isaac Newton has demonstrated in his *Opticks*."

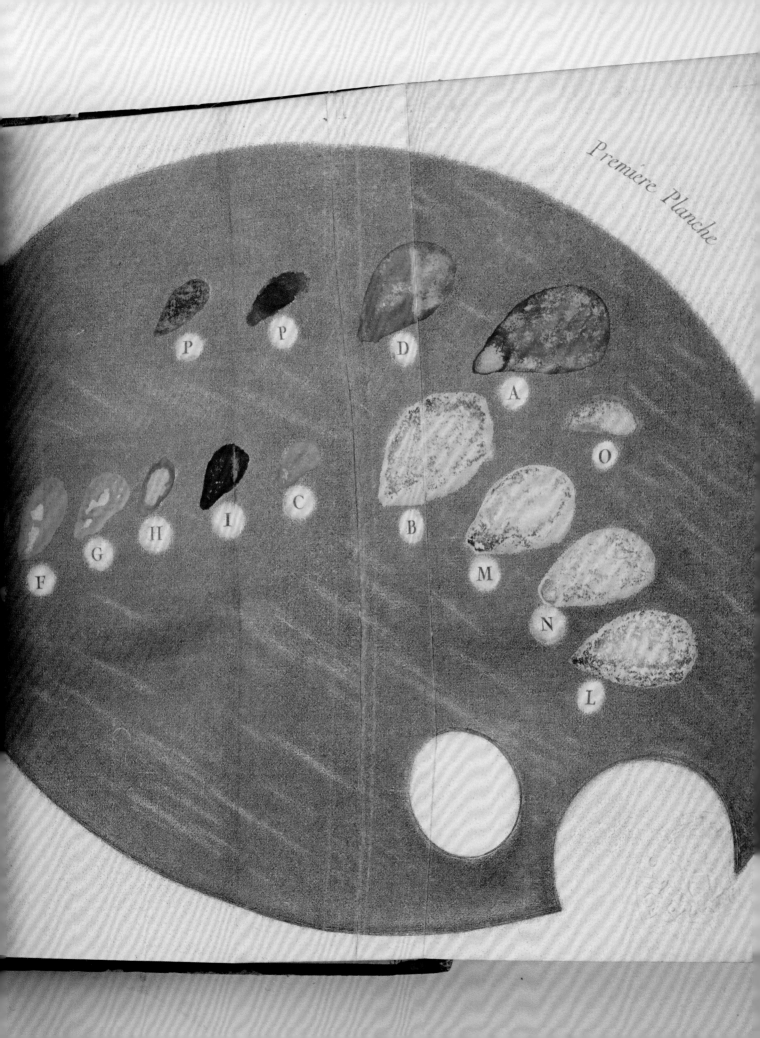

PRISMATIC

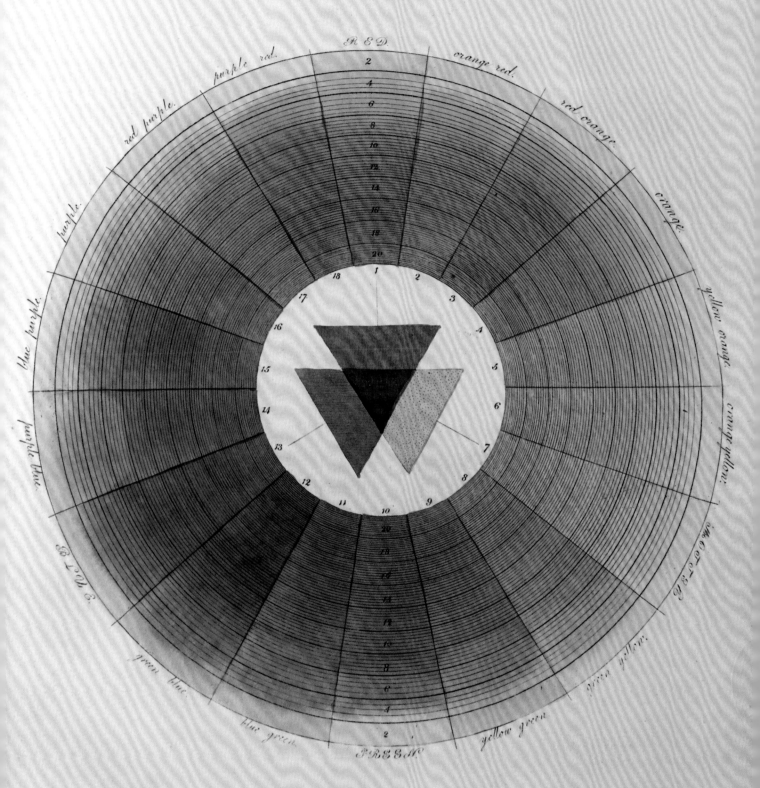

Moses Harris: Colors for the Natural World

In England it was the entomologist Moses Harris who produced the first comprehensive system of colors in his short publication *The Natural System of Colours* (*c.* 1769–1776). Harris's theory provides a good example of the muddling of additive and subtractive color that was common throughout the eighteenth century. He explained: "By the term colour, or colours, we would be understood to mean one or all of those appearances which are seen in the rainbow refracted by the prism, or that so beautifully decorate the leaves of flowers, or any other substance except such as are white, which is but a term for a total privation or absence of colour . . . " combining Newton's light-based color theory with concepts of beauty in nature, as expressed by Edmund Burke and William Hogarth in the mid-eighteenth century. Despite the reference to Newton's experiment, his description of white as an absence of color makes it clear that its application is subtractive, or material, color.

Harris's system provided guidance for painters and pigment-makers, based on a principle of three primary colors or "primitives" (red, yellow and blue), three "mediates" (orange, green and purple), and their various combinations. He illustrated his work with copper plates showing two concentric circles, each comprising eighteen sectors of "prismatic" and "compound" colors at varying degrees of intensity, resulting in a total of 660 different tints. The overlapping triangles of primaries and secondaries sit prominently in the center of each circle. As this system could not be adequately represented by the mechanical coloring techniques available at the time, Harris himself engraved the copper plates and hand-colored them, using pigments such as red lead, which was one of the earliest pigments to be created artificially—it can be found in medieval manuscripts, and is still in use today. Some of the colors in surviving copies of the first edition have deteriorated badly, showing black splotches on the color wheels, most likely caused by delayed chemical reaction of mixed pigments and painting materials.

We don't know exactly what inspired Harris to produce his concise book on color, but it is most likely that he saw the need for a practical and precise guide to the use of color in scientific illustrations. Before color photography, such illustrations would have been essential for the reliable description and identification of natural forms. His much larger publications on the insects of Britain are lavishly illustrated with meticulously colored plates, showing the exact coloring of flies, moths, beetles and butterflies. In one of these books, *Exposition of English Insects*, he applied his color wheel to the specific purpose of representing the many shades of brown, gray and black found in insects (see page 10). Like Newton's wheel in *Opticks*, it can be seen as a color guide for the figurative illustrations in the books. In the accompanying text he addresses the responsibility of the artist to use his or her professional judgment when producing tints. He also includes an explanatory key to the tints in the circle, which names and describes the colors shown in it.

In true Enlightenment spirit, accuracy in depicting the natural world was of utmost importance to Harris, and his color wheels were nothing less than complex tools with which to achieve this. The fact that the color wheel plate is often missing in copies of *Exposition* might indicate that many of his readers removed it from the book block to consult alongside the other plates.

Left & overleaf: Moses Harris's color wheels show a "prismatic" range (left) of eighteen hues, based on the primaries red, blue and yellow, and their immediate combinations, and "compound" colors (overleaf), based on orange, green and purple, and their combinations.

6

PRISMATIC.

Red, orange-red, red-orange ; orange, yellow-orange, orange-yellow ; yellow, green-yellow, yellow-green ; green, blue-green, green-blue ; blue, purple-blue, blue-purple ; purple, red-purple, purple-red.

COMPOUND.

Orange, olave-orange, orange-olave ; olave, green-olave, olave-green ; green, slate-green, green-slate ; slate, purple-slate, slate-purple ; purple, brown-purple, purple-brown ; brown, orange-brown, brown-orange.

If the colours were divided into a still greater number of teints or divisions, which it is conceived is all that can be done in attempting to improve the system, it would not render it more useful, but rather tend to create confusion between the teints which are now just sufficiently conspicuous, and would be one step toward reducing it to the chaos from which the author has taken so much pains to extricate it.

In contrasting colours, so frequently necessary in various branches of painting, this work will be found of great use ; for if a contrast is wanting to any colour or teint, look for the colour or teint in the system, and directly opposite you will find the contrast wanted ; viz. suppose it is required to know what colour is most opposite, or contrary in hue, to red ; look directly opposite to that colour in the system, and it will be found to be green, which is the compound of the two other primitives : the most contrary to blue is orange, and opposite to yellow is purple ;

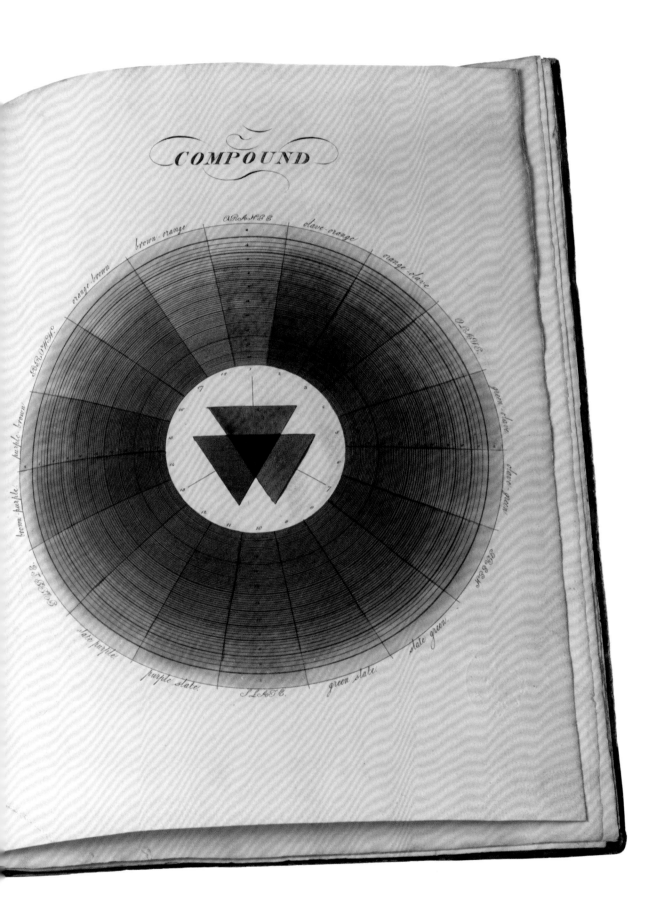

The Beautiful and the Sublime

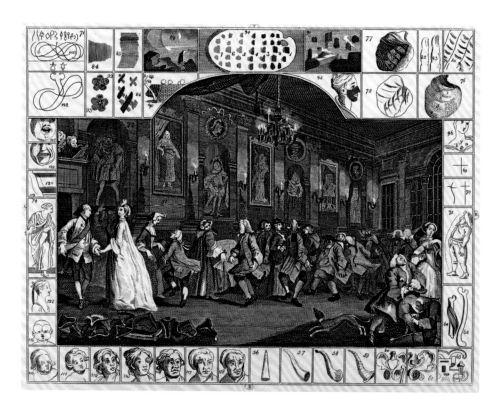

Most of the color manuals published in the eighteenth century were concerned with painting techniques and how to prepare paints and apply surface finishes. Robert Dossie's *The Handmaid to the Arts* was one of the most popular books of this kind. First published in London in 1758, it went into numerous revised and enlarged editions up until 1829. The enduring demand for Dossie's *Handmaid* and similar publications might have been influenced by the increased promotion of the arts in Britain from the mid-eighteenth century onwards. These technical handbooks rarely mentioned color theory beyond basic principles of color mixing.

A number of artists and philosophers were, however, expressing views on color in relation to aesthetic ideas of beauty and "the sublime." While beauty was considered a standard that could be identified, measured and even created, the concept of the sublime described a more elusive reaction; an impression of grandeur, awe and fear. It encompassed things that were both fascinating and threatening, impressive and untameable, for example vast mountain ranges, storms and darkness. Especially later in the eighteenth century we see this reflected in large-scale paintings of alpine landscapes, disasters at sea, storms or biblical scenes such as Noah and the Flood.

Edmund Burke was one such thinker who included a chapter on "Colour considered as productive of the sublime" in his *A Philosophical Inquiry Into the Origin of Our Ideas of the Sublime and Beautiful* (1757). He advocated darkness and gloom in painting and architecture and advised against gaudiness induced by color: "The cloudy sky is more grand than the blue; and night is more sublime and solemn than day."

Not so, however, for Burke's contemporary, the painter William Hogarth. Hogarth was strongly influenced by Isaac Newton's *Opticks*, and possibly also by a painting manual by Dutch painter Gérard de Lairesse, published in English with the title *The Art of Painting* in 1735. Like Newton and Lairesse, Hogarth embraced the concept of pure prismatic colors. He disliked darkness and shadows in painting, despite sometimes considering them necessary. In his privately published treatise on taste *The Analysis of Beauty* (1753) he proclaimed that "[t]here are but three original colours in painting besides black and white, viz. red, yellow and blue. Green, and purple, are compounded . . . however these compounds being so distinctly different from the original colours, we will rank them as such." He applied this five-color system to an artist's palette, even including it in one of the

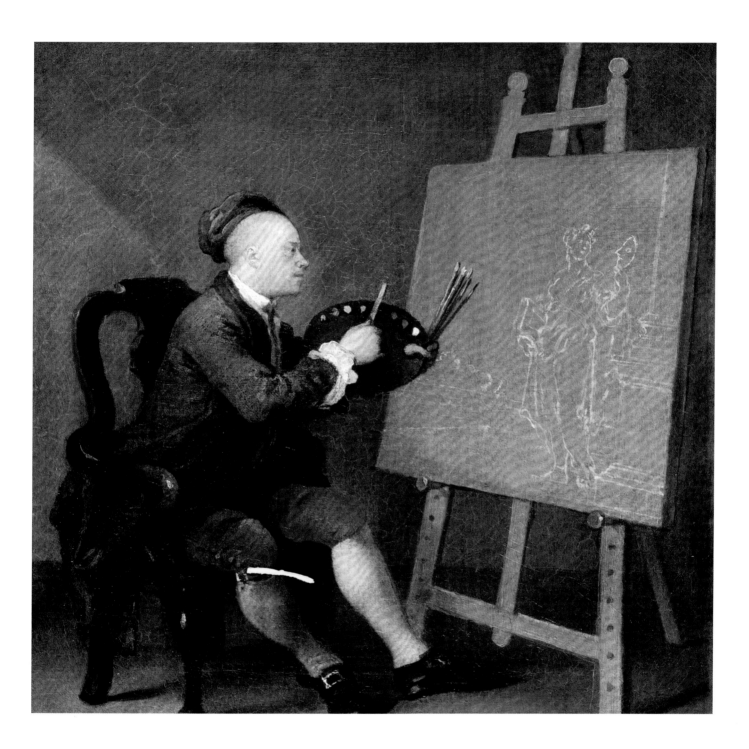

instructive fold-out plates that illustrate *Analysis of Beauty* (above). The palette image is only a small part of a much larger, uncolored etching, but there is some detail, with the blots being graded and numbered to indicate seven degrees of brightness and permanency.

For Hogarth, the palette had a symbolic significance. He included painters' tools in several of his self-portraits, often placing them prominently in the composition. In his self-portrait from 1757 (above), we see him sitting in a chair, looking at a large canvas,

about to start painting. The palette forms the focal point of the painting, linking the artist with the canvas spatially and symbolically. The tints on the palette are arranged along the outer edge and consist of six bright colors, more or less resembling his system of a few pure tints from which all others can be created. There is an additional blot of white nearest to the thumbhole, and no sign of blacks, browns or grays. Here is Hogarth putting his ideas about coloring into practice, holding his palette up like a trade card.

The Picturesque Palette

The later eighteenth century saw a dramatic rise in the popularity of the medium of watercolor, linked to the invention of solid, soluble watercolor cakes by William Reeves in *c.* 1780, making it easy for artists to carry a range of colors in compact form and paint *en plein air* or while traveling. While mid-eighteenth century aesthetic ideas were split between the contrasting concepts of the beautiful and the sublime, a third way later arose that sought to combine the ideals of both. This new vision of nature known as the "picturesque" may have been made possible simply because more artists were able to paint outdoors, farther afield and in remote places, and spend time actually observing their subject.

Around 1790 the English artist and author William Gilpin, one of the key proponents of the concept of the picturesque, included comments on a color system based on three primaries in a notebook entitled *Hints to Form the Taste & Regulate ye Judgment in Sketching Landscape*. This was perhaps an early draft for his influential *Three Essays: On Picturesque Beauty, on Picturesque Travel and on Sketching Landscape*. Referring to landscape painting, he states: "In order to colour chastely & Harmoniously, use only 3 Tints: Red, yellow, & Blue, of wh[ich] compose the other colours wh[ich] are requisite to make out the parts in the diff. distances." On the facing page he sketched

a color chart illustrating tints that he recommended to achieve the appearance of certain levels of distance, alongside a small landscape sketch composed with these tints (right).

Gilpin's concern for color "chastity" and harmony is connected to picturesque ideals of a natural, "rugged" beauty, but his dedication to a trichromatic system is exemplary of the heightened awareness and understanding of both basic principles of color order and issues of pigment purity and color mixing in the late eighteenth century. This is reiterated in print in *Three Essays* some years later (1792), to which Gilpin added a poem titled "On Landscape Painting":

One truth she gives, that Nature's simple loom
Weaves but with three distinct, or mingled, hues,
The veil that cloaths Creation: These are red,
Azure, and yellow. Pure and unstain'd white
(If colour deem'd) rejects her gen'ral law,
And is by her rejected.
[...]
Draw then from these, as from three plenteous springs,
Thy brown, thy purple, crimson, orange, green,
Nor load thy pallet with a useless tribe
Of pigments, when commix'd with needful white,
As suits thy end, these native three suffice.

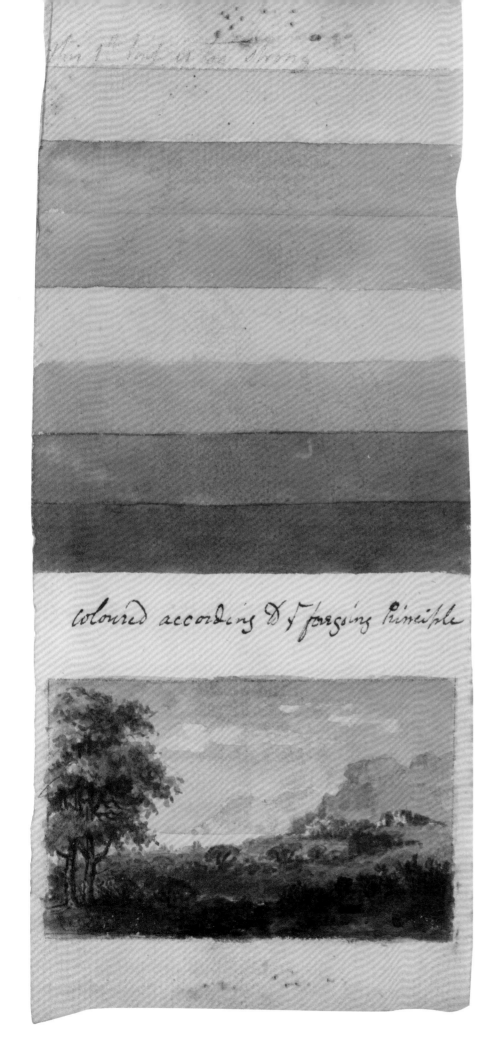

coloured according to y foregoing principle

Left: A sketch from Gilpin's notebook from *c*. 1790, intended to show the use of color in depicting distance. The greatest space is given to the hues that comprise the background as it recedes. On the facing page in his notebook, Gilpin added notes expounding on their use, including: "Shadow of the clouds comprised of all the tints," "Blue at the remotest distance" and "The foreground of the same but deeper. On this, browns and greens to be laid to make out the parts."

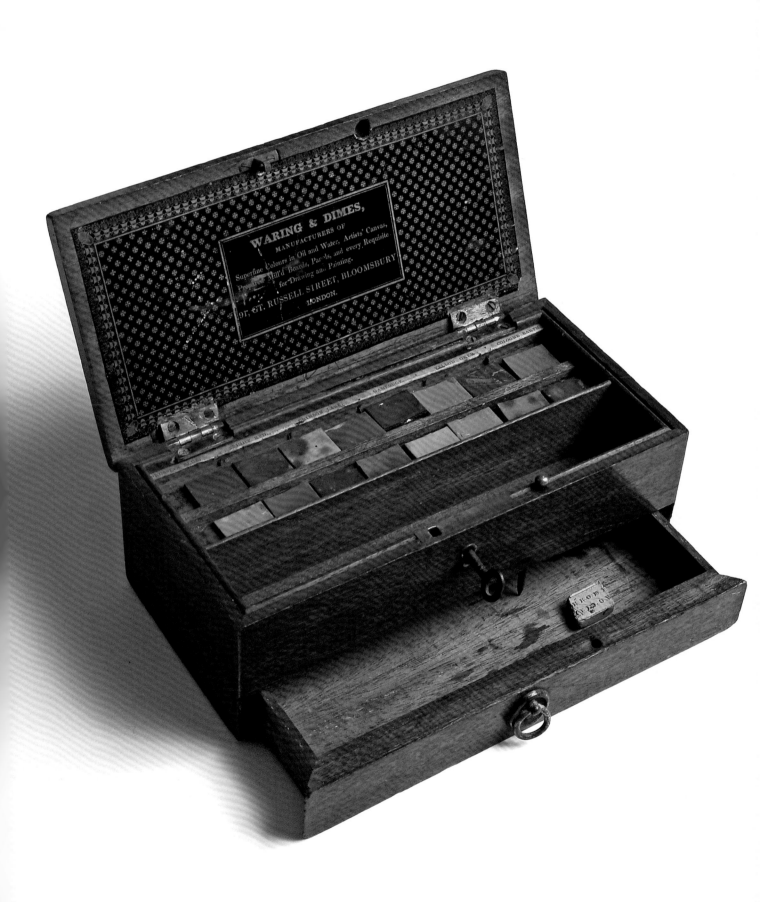

Colormen: Apothecaries for Painters

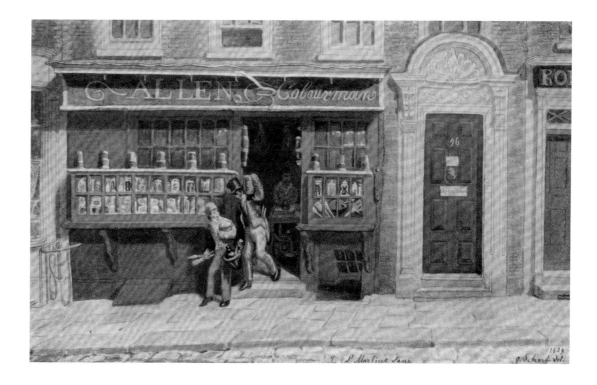

"Colorman" was a term for a person who either supplied pigments or assisted an artist in the messy and labor-intensive process of making pigments and preparing paints, varnishes and other materials. It is not known when exactly the term was first used, but professional colormen appear to have been operating in England since at least the 1720s. In an overview of trades in London from 1747, the author, Richard Campbell, comments that the colorman "is, in some shape, the Apothecary to the Painter," subtly comparing paint-making to alchemy. Extensive training and experience were necessary to become an established colorman, as Campbell explained: "No Man is fit to keep a Colour-Shop who has not served an apprenticeship: The articles they deal in are so many, and require such a nice eye, and so great practice to be a judge of them, that even seven years are too little to learn this trade."

Toward the end of the eighteenth century, the color trade expanded significantly and many large-scale firms and shops were founded, manufacturing and selling a wide range of artists' materials, including newly invented watercolor cakes and portable artists" boxes. Some of these firms are still trading today, such as Reeves (founded by the Reeves brothers in 1766) and Rowney's (founded in 1783 by Richard and Thomas Rowney—now Daler-Rowney). Winsor & Newton, founded by the painters William Winsor and Charles Newton, were operating in London from 1832 and became one of the leading British art suppliers in the Victorian period.

George Scharf's painting from 1829 (above) of Edward Prascey Allen's shop in St. Martin's Lane in London is one of very few detailed images of a color shop in the early nineteenth century. The exterior is brightly painted in green, and brushes, jars of paint and other painting materials are displayed prominently in the windows. Two men—probably a painter and his apprentice—are shown leaving the shop, laden with supplies, and inside the shop we can just about see the colorman grinding pigment. This real shop was conveniently located in the same building as "Mrs. Wats/Laydies School"—these ladies would almost certainly have received classes in painting in watercolor.

The "Lost Secret" of Venetian Coloring: A Woman Fools the Art Establishment

A biting satire on the art establishment's gullibility and their obsession with color in the 1790s

In this large (55 x 41 cm) and busy print (opposite) the satirist James Gillray mercilessly pokes fun at the British art establishment, such as it was at the end of the eighteenth century. The image is full of recognizable figures and details, and invites the viewer to look at it closely and discover ever more meanings. The full title of the print is *Titianus Redivivus;—or—The Seven-Wise-Men consulting the new Venetian Oracle*. The Latin part means "Titian born again"—a reference to the Venetian painter Titian, known for his revolutionary use of color in the sixteenth century. The central female figure balancing on a rainbow that is arching over the "academic grove," representing predominantly the Royal Academy in London, is a woman called Ann Jemima Provis. Provis had just caused a storm in the art world by claiming that she had discovered an old manuscript detailing the secret of Titian's use of color in painting. She offered this "lost secret" to the Academy, but it was later discovered that she was a fraud. She holds a palette and brushes, wears a gown with a long train of peacock feathers and seems to reign supreme, but before her is a simple clay pot in which she crudely mixes her colors, in the manner of common sign-painters rather than distinguished artists.

The image is filled with speech bubbles of additional text that satirize the affair. Each of the painters in the first row is poised with a palette, brush and paint board, and the texts in their speech bubbles show how each of them were fooled by Provis's lies. "Will this Secret make me Paint like Claude?—will it make a

Dunce, a Colourist at once?" asks the painter on the far right, identifiable as Joseph Farington.

One who has already had access to part of the fake manuscript and hoping to benefit from it financially is the reigning President of the Royal Academy, the American Benjamin West, who can be seen among a small shadowy group in the foreground on the right. Fleeing the scene, he says to the printer Josiah Boydell: "Charming Secret Friend, for thee to dash out another Gallery with!—but I'm off!!" In the bottom left corner we can see the late first President, Sir Joshua Reynolds, who had been cautious about elaborate use of color in his teaching, turning in his grave, exclaiming: "Black Spirits & White; Blue Spirits & Grey. Mingle, mingle, mingle!—you that Mingle may."

The image is a highly entertaining and biting satire on the art establishment's gullibility and their obsession with color in the 1790s. Its iconography uses familiar symbols and imagery of the theory and practice of color and coloring, including rainbows, palettes and other artists' materials, all in an ironic manner. Gillray was perhaps inspired by Angelica Kauffman's ceiling roundel commissioned by the Royal Academy in 1778, in which a female figure representing color is depicted dipping her brush into a rainbow (see page 22). Certainly, he would have had good inside knowledge of the institution he so fervently rejected: in the late 1770s he had studied there under the Italian engraver Francesco Bartolozzi—the same Bartolozzi responsible for the popular prints of Kauffman's roundels.

Opposite: This busy print by James Gillray from 1797 satirizes the art establishment of the nineteenth century, embodied in London's Royal Academy.

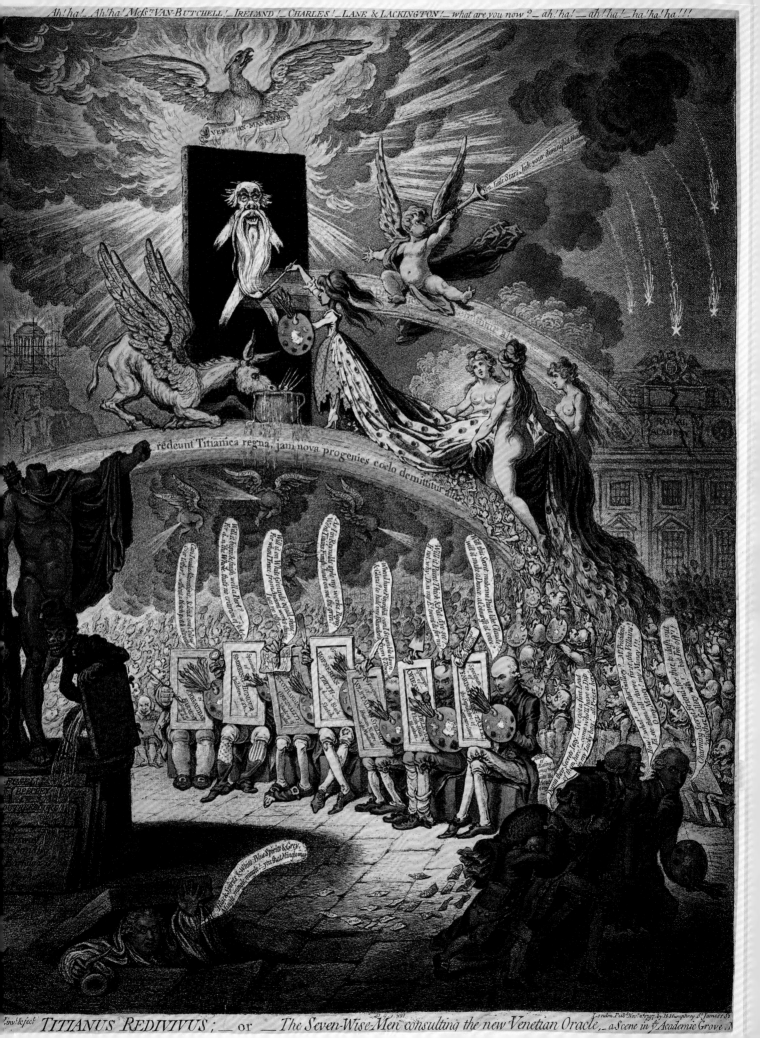

TITIANUS REDIVIVUS; — or — The Seven-Wise-Men consulting the new Venetian Oracle, — a Scene in ye Academic Grove. N

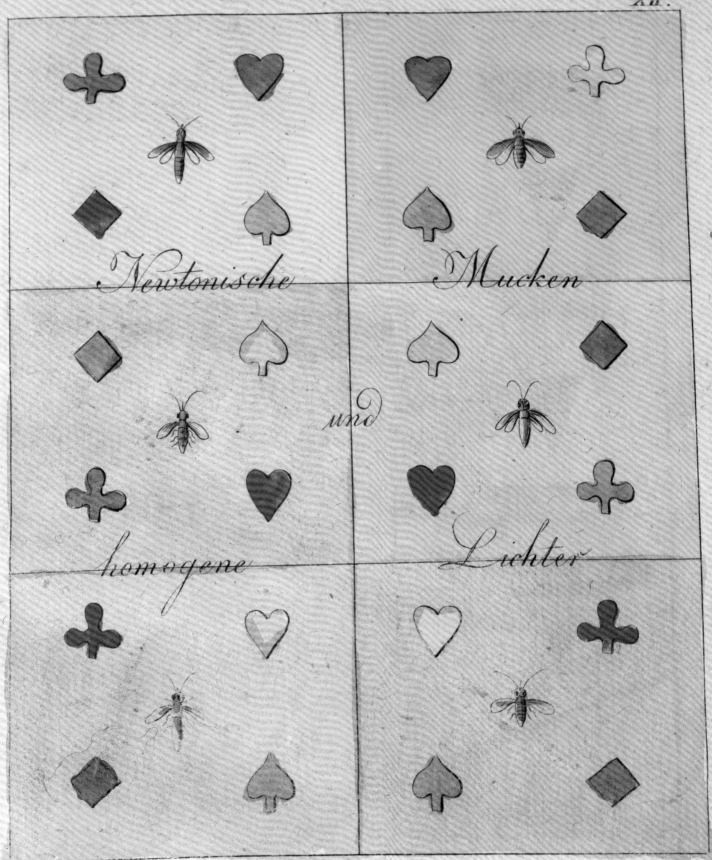

Newtonische Mucken und homogene Lichter

Romantic Ideas and New Technologies: The Early Nineteenth Century

The early nineteenth century saw a surge in painters' manuals and general publications on color, as well as theoretical treatises. The reasons for this spanned ideas rooted both in Enlightenment thinking and in notions of beauty and composition taken from the Romantic movement. Scientists and artists alike were lecturing on color, proposing color theories and publishing practical color manuals. In this period, the boundaries between these quite different fields were often blurred. Color theories, charts and diagrams were also often embedded in books on interior design or painting manuals. In the nineteenth century, ideas from the seemingly disparate worlds of science, philosophy and the arts met in new and fruitful combinations. There was also significant cultural exchange among color writers within Europe, manifested in the number of dual-language editions and early translations of books that were available.

Illustrating books on color in color remained costly and labor-intensive, as lithography—a new mechanical method of reproducing images—was still in its infancy. In the early years of the nineteenth century we find a curious and exciting variety of illustrations dealing with the difficult issue of conveying ideas and practical advice about color in images. Some authors or publishers decided not to include color illustrations, in order to make the books more affordable. Often plates were colored by hand, for the all-important sake of accuracy, and books were then marketed as highly desirable and collectible objects in an attempt to appeal to bibliophiles. Other authors and publishers used a combination of methods, for example enhancing prints with hand-coloring, or giving the readers the option of purchasing either a colored or uncolored edition, according to the price they were willing to pay.

Many early-nineteenth-century color writers focused on themes such as light and shade, composition, color harmony and contrast. Building on the concepts of the sublime and the picturesque developed throughout the eighteenth century, the prevalent aesthetic across the arts in the early nineteenth century was Romanticism. This new movement was partially a backlash against the ideals of rigid order, temperance, rationality and physical materialism imposed under the Classicist and Enlightenment modes of thinking that had previously dominated. In contrast, Romanticism emphasised darkness, chaos and mystery, the emotional and the subjective.

> *It is in the early years of the nineteenth century that we find a curious and exciting variety of illustrations*

One of the leading authors on color in this period was Johann Wolfgang von Goethe. Poet and playwright, novelist, scientist and statesman, Goethe exemplifies the pluralistic character of his time. His work meanwhile—the substantial and strongly anti-Newtonian treatise on color *Zur Farbenlehre*—is equally representative of Romantic ideals in the themes with which it is preoccupied and its focus on subjective or psychological perception. Goethe's ideas not only characterise the period he lived through,

Left: With this plate from *Farbenlehre* (1810), Goethe subtly ridicules Newton's method of experimenting with small objects or creatures on pieces of paper to prove his theory of homogenous lights and colors. In his comments to the plate, Goethe accuses Newton of being random in his methodology and claims that he recreated Newton's experiment with colored paper and could see a range of colors where darker and lighter shades meet.

The Industrial Revolution was making everyone richer. With greater wealth came more leisure time

but also remained important—and controversial— long after his death. His treatise may read more like a catalog of phenomena than a theory—descriptive rather than analytical and scientifically applicable— but it had great influence on artists and philosophers; in the latter case pre-empting phenomenology.

At the same time, many other artists, scientists and writers were experimenting with color and publishing on the subject, resulting in some of the most visually striking examples of illustrations in the history of print culture. Although the topic of color was popular, and the creative and publishing output unprecedented, illustrated books remained expensive both to make and buy, and were therefore available only to a relatively small readership. This began to change around the late 1830s, when books on color became significantly smaller in size and scale, utilizing new reproduction methods, and thus appealing to a much wider readership. The same applied to painting materials. Smaller, cheaper and more convenient paint boxes, watercolor satchels, paint in collapsible tubes, and other artists' tools made painting out in the open or in cramped spaces easier and led to a sharp rise in the popularity of painting as a pastime.

At the same time as manufacturers were adapting to make their products available to the general populace, the growing availability of these items also reflects the changing social and economic situation in Europe. The Industrial Revolution that had begun in the second half of the eighteenth century was making everyone richer. With greater wealth came more leisure time, and a new social strata—the middle class—arrived to make the most of it. Amateur painting, naturalism and outdoor pursuits flourished, as did general interest in academia. Color was a popular topic for the public in a similar way to the pop-science books of today.

In the nineteenth century we also see how the concept of interior design develops as a distinct art form. Apart from house-painters' and decorators' manuals and high-end publications depicting grand interiors, magazines that gave advice on colors and fabrics for soft furnishings became fashionable. The lists of available colors and the fabric samples provided in the London fashion magazine *The Repository of Arts, Literature, Commerce, Manufactures, Fashions and Politics* by Rudolph Ackermann are not so different from the color charts that can be picked up in DIY stores today. It was the beginning of the commercialization of color.

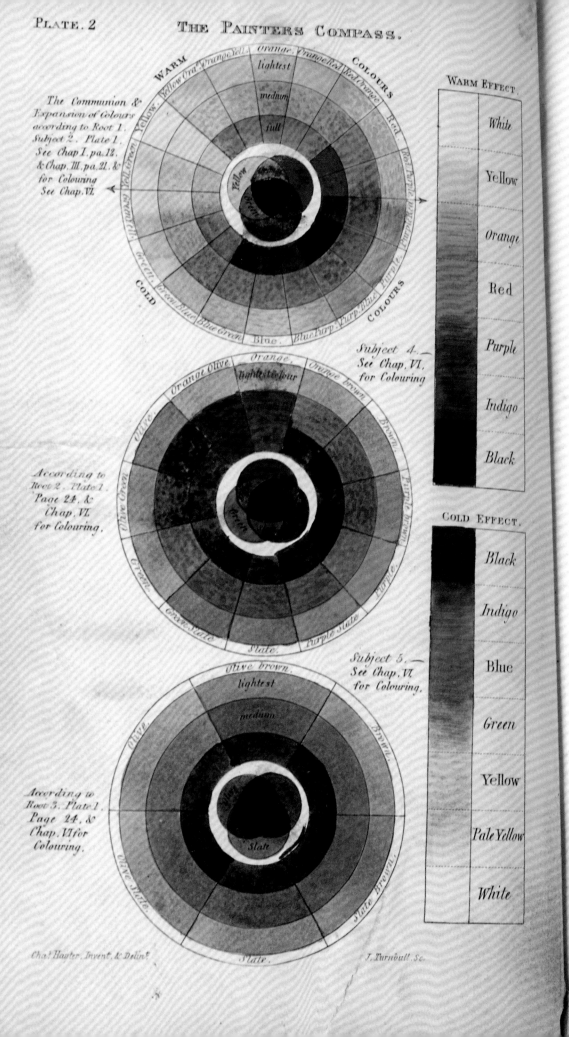

The Communion &
Expansion of Colours
according to Root 1.
Subject 2. Plate 1.
See Chap I. pa. 12.
& Chap. III. pa. 21. &
for Colouring
See Chap. VI.

WARM COLOURS

Yellow Oran. Orange Yell. Orange Orange Red Orange

lightest

medium

full

Yellow

Yellow Green

Green

Green

COLD COLOURS

Green Blue Blue Green Blue Blue Purp. Purp. Blue

Subject 4.
See Chap. VI.
for Colouring

According to
Root 2. Plate 1.
Page 24. &
Chap. VI.
for Colouring.

Orange Olive Olive Orange light Yellow Orange brown

Olive

Olive Green

Green

Green

Slate Purple Slate Grave Slate

Subject 5.
See Chap. VI.
for Colouring.

According to
Root 3. Plate 1.
Page 24. &
Chap. VI for
Colouring.

Olive brown.

lightest

medium

Olive

Slate

Brown.

Slate Brown.

WARM EFFECT.

White

Yellow

Orange

Red

Purple

Indigo

Black

COLD EFFECT.

Black

Indigo

Blue

Green

Yellow

Pale Yellow

White

Chas Hayter. Invent. & Delin. J. Turnbull. Sc.

The
datum of
which is
complet
of proce
"root,"
ment of
or "con
only pro

The
allusive
colour
is suffi
three *

* It
coloured
veniently
designed
to compr
ses, by g
the prac
many me
and on a
is clearl

Darkness and Light:
Goethe Challenges Newton

German polymath Johann Wolfgang von Goethe was interested in many aspects of the sciences, including botany and geology. He had begun experimenting with color in the 1780s, and published treatises on color as early as 1791–92, including *Beyträge zur Optik (Contributions to Optics)*, in which he proposed a dualistic color system based on the polarity of darkness and light, represented by the "pure" colors blue and yellow, from which all other colors derived, including red. Goethe argued that black and white were not colors as such, but instead representations of total darkness and the brightest light:

> ... *hence pure white represents light, while pure black represents darkness, and in the manner in which we call prismatic appearance colour, black and white cannot be considered colours; but there are black-and-white pigments, which allow the appearance to be seen on objects.*

In true empirical spirit, readers of *Beyträge zur Optik* were encouraged to recreate certain experiments with three-sided prisms, often involving looking through a prism at various objects and surfaces. For this purpose Goethe included an expensively produced set of 27 woodblock-printed and colored "playing cards" with the publication.

Goethe pursued his research into color for a further twenty years, culminating in what was probably the most substantial treatise on color composed in the nineteenth century. *Zur Farbenlehre* (literally: *On the Doctrine of Colors*) was published in three volumes between 1810 and 1812. Despite all his significant publications of literature and poetry, he considered this large work on many aspects of color perception, creation, meaning and application his most important intellectual achievement. His intention was to not just present another color system but to link color to many aspects of science, art, design and psychology, and put his study into the wider context of the history of color writings. The sheer volume of text in *Farbenlehre* is partly explained by Goethe's observational style. Where Newton was devoted to objective scientific theory, Goethe's approach reflected the times he lived in: subjective and physiological perceptions, rooted in human experience, were no less important than Newton's rationally proven "facts." The observations Goethe collected focus on the various phenomena of color, including impressions of after-images, contrast

effects of color on the appearance of other colors, and the effect of color on the appearance of size ("[b]lack dresses make people seem smaller than light ones"), for example. These observations at least have the benefit of being backed up by his experiments. Later he goes on to discuss purely subjective moral, psychological and cultural associations with color.

The third volume includes sixteen colored plates, several of them consisting of multiple images. Not many of the images show diagrams that order color in a logical and practically transferable system, but they do illustrate the number and complexity of Goethe's observations.

Goethe attempted to disprove Newton's color theories by recreating some of his prismatic experiments. In the "Polemic part" of his *Farbenlehre*, he questions and tests the validity of Newton's research methods and findings. Goethe's main argument against Newton concerned the creation of color. While Newton had proven that, in certain contained circumstances—namely a darkened room and one directed ray of pure sunlight—the visible color spectrum appears (at a certain distance) as a refraction of that ray of light, Goethe argued that these were unnatural circumstances. His own theory was that color was created at the point where darkness and light meet. He supported this theory with the playing cards in his first publication and similar illustrations to his *Farbenlehre*. Anyone, he claimed, could look at his illustrations of black-and-white geometrical shapes through a prism, in ordinary light conditions, and see color appear on the edges and fringes. He also included a number of colored copperplate engravings illustrating the failings of Newton's methods in the collection of plates accompanying his *Farbenlehre*, for example one entitled "Newtonische Mucken/Newton's Flies" (opposite), where he questions Newton's method of experimenting with small objects or creatures. The sum of these observations doesn't really add up to a concise "theory" of colors so much as a detailed catalog of their qualities.

Goethe's complete *Farbenlehre* must have been a daunting publication. Only the first, "didactic" volume was translated into English by Charles Lock Eastlake (see pages 84–85) and it was not published until 1840. There is no doubt that *Farbenlehre* made an impression on other color writers, academics and artists in the mid- and late nineteenth century, most notably J. W. M. Turner (see pages 82–83). Turner aside, however,

Opposite: The elaborate first plate of the third, "historical," volume of *Farbenlehre*. It is composed of eleven separate numbered images, ranging from a simple color wheel, to colored shadows, the appearance of a flame against a dark background, and even to a landscape scene as it would appear to a person suffering from a particular kind of color blindness.

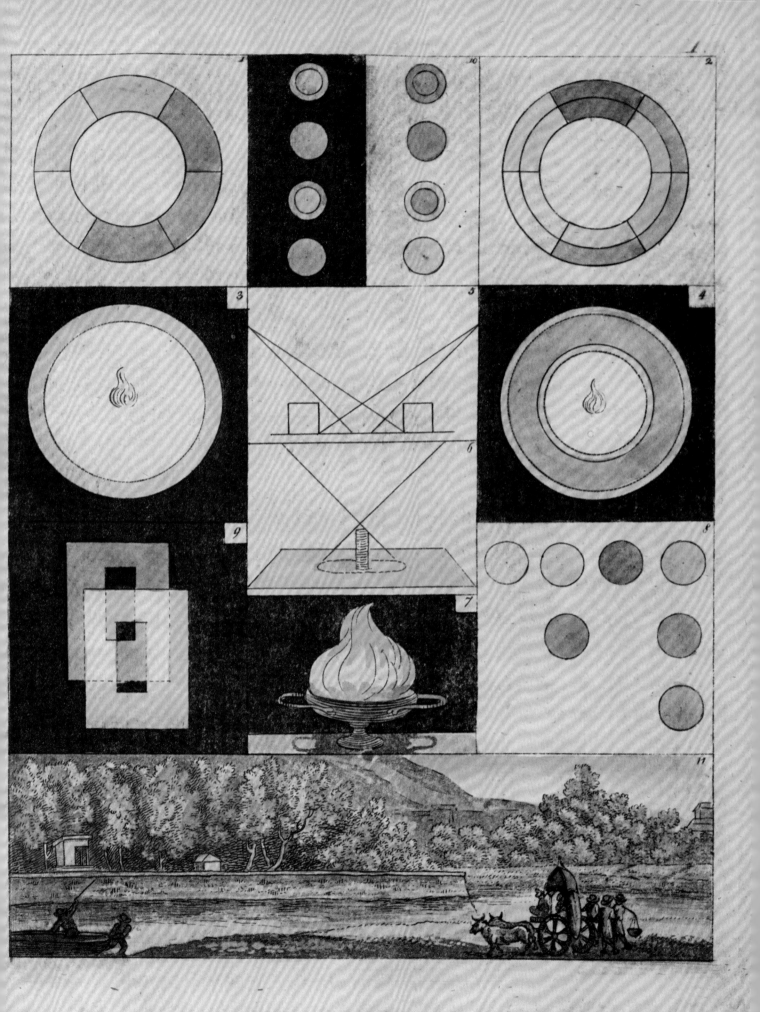

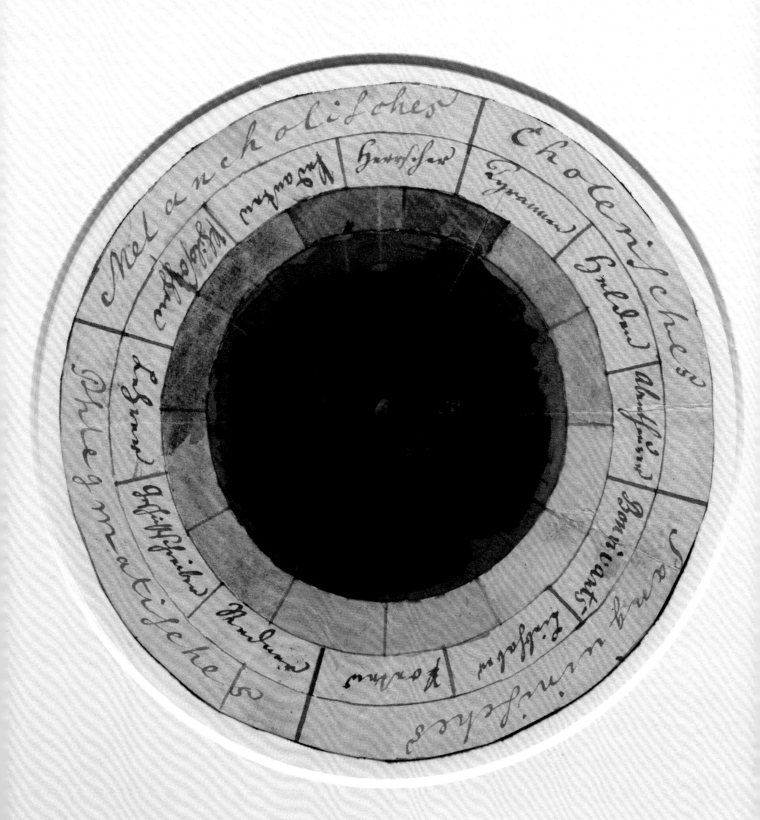

direct references to Goethe's color studies are notably rare in English literature before the 1840s. In the preface to his translation Eastlake notes the criticism Goethe's theory had received in the years immediately after its publication. He acknowledges that while some of it was justified, some was self-inflicted by Goethe, who had been unnecessarily harsh and uncompromising in his attacks on Newton's much-respected *Opticks*. However, he argues that with the passing of 30 years a calmer and less-vindictive assessment of Goethe was possible and that there was much in his observations that was very useful to a wide range of artists and thinkers, and that, likewise, Newton's theory had its shortcomings, omissions and fanciful elements. A particular merit of Goethe's work, according to Eastlake, was his applicability of color theory to the arts and his focus on "the phenomena of contrast and gradation, two principles which may be said to make up the artist's world, and to constitute the chief elements of beauty."

John Gage suggested that in Germany in the 1840s, Goethe's color theory had a low reputation among artists and was not often mentioned in related literature until much later. Nevertheless, seen in the greater context of Romantic and later art and philosophy, Goethe did have a substantial legacy in a new generation of artists and writers who began to consider subjective color perception, emotional responses and analogies between colors and character qualities and moral connotations. One of the earliest examples of Goethe's impact was Arthur Schopenhauer's important philosophical treatise *Über das Sehn und die Farbe* (*On Vision and Colors*), published privately in 1816 following conversations between the two writers. It did not reach a wide audience, but a revised and extended edition was published in 1854. Another author influenced directly by Goethe was the German physiologist Johannes Peter Müller, who had studied *Farbenlehre* in preparation for a scientific publication on the physiology of sight in 1826. Later in the nineteenth century we see a slow but steady increase in the appreciation of his color theory, frequently in the context of art and design and beyond the German speaking area. In 1867 an article by British decorator John Gregory Crace, of the famous Crace Firm, entitled "On Colour," discussed at great length the concept of color contrast and Crace noted that "several men of high attainments have written upon this subject, more particularly Goëthe [*sic*], who published his interesting work 'The Doctrine of Colours' in 1810, and it has since been translated by Sir Charles Eastlake, who added to it notes of great interest and usefulness." He also references Field and Chevreul, but it is Goethe's experiments and writings he appears to rate most highly. In one instance Crace compares an observation he made of colored shadows to Goethe's example of a dark after-image of a white girl's face. By contrast, he says about Chevreul: "Though I highly appreciate and admire his theories, I do not always agree with him when he regulates decorative effects of color."

The twentieth century saw a great reappraisal and appreciation for Goethe's color work and color theory in general, especially among abstract and Modernist artists. Philosophers, too, continued to be inspired by *Farbenlehre*, most notably by the Austrian-British Ludwig Wittgenstein in *Bemerkungen über die Farben* (*Remarks on Color*), written in 1950/1 but first published posthumously in 1977.

The Temperament Rose

The color wheel opposite was drawn in *c.* 1799 during an excited (and inebriated) exchange about color between Goethe and Friedrich Schiller. Entitled *Temperamenten-Rose* (*Temperament Rose* or *Vane*), the German poets were making a visual analogy between colors and the ancient concept of the four bodily humors, resembling four basic temperaments: choleric, sanguine, melancholy and phlegmatic, and assigned specific occupations and character traits to each group. For example, according to Goethe and Schiller, teachers can be found in the phlegmatic group, while lovers and bon vivants are of a sanguine nature. Rulers are among the melancholy, but in close proximity to choleric tyrants. In an earlier sketch Goethe assigned sensual and character qualities to colors, such as "good," "powerful" and "gentle." Goethe later explored these seemingly unscientific associations and analogies in the didactic part of the 1810 edition of his *Farbenlehre*. Color order systems based on the concept of the four temperaments have been mooted since at least classical times, but the addition of specific human character types was at first probably an experimental and playful take, resulting from the exchange with Schiller. However, the extent to which Goethe later applied moral values to colors can perhaps be attributed to his exchanges and friendship with many contemporary Romantic artists and writers, who explored the relationship between the individual and natural order in the widest sense.

Opposite: Goethe's *c.* 1799 *Temperamenten-Rose.* As Newton drew analogies between color and music, here Goethe and Schiller relate color to the four humours and associated character types, extrapolating further to various occupations.

Observing Newton in the Garden

Humphry Repton was an English draftsman and designer who embarked on a career in landscape gardening in 1788, not long after the death of the Lancelot "Capability" Brown in 1783. Repton quickly established himself as the leading landscape designer in Britain and published widely on architecture, design and landscape gardening, sometimes challenging aesthetic ideas of the Picturesque; at other times, embracing them. In particular, he was interested in how the four elements of the art of painting—composition, design or drawing, expression and coloring—could be applied to his work. In an 1803 publication entitled *Observations on the Theory and Practice of Landscape Gardening*, he noted the importance of the careful application of color to ornament: ". . . improper colouring may destroy the intended effect of the most correct design and render ridiculous what would otherwise be beautiful."

Repton was particularly interested in color both as a product of and in relation to light. In the same book, he informed the reader of his conversations with the politician William Wilberforce about a "new theory of colours and shadows" he'd read of in an article by the mathematician Dr. Isaac Milner. Milner's theory dealt with the principle of complementary colors and ideas of color harmony as expressed by many other theorists in the early nineteenth century. What may have impressed Repton, who was particularly concerned with the effects of light on color, was Milner's effortless explanation of Newton's experiments with immaterial color, which he applied to light conditions in nature, with notes on how the human eye reacts and adjusts to changing light conditions. Milner also offered practical advice concerning material color. Repton was so taken with Milner's article that he went to great lengths to obtain permission to reproduce it in full in *Observations*.

In his last publication before his death, *Fragments on the Theory and Practice of Landscape Gardening* (1816), Repton devoted an entire chapter each to the themes of contrast and color. He elaborated on contrasts observed in a landscape in respect of light conditions and how they affect the appearance of foliage, and further discussed the color schemes of gardens and the varieties of texture and size of plants and flowers. The chapter "Of Colours" gives recommendations not only for the use of color in gardens but also in landscape paintings and the coloring of prints, based on experiments with prisms that he carried out himself. Repton then provided instructions for the colorers of his own prints, based on his observations and experiments. These instructions give a rare insight into the production of books containing hand-colored plates in the early nineteenth century:

> *As the Plates in my former work employed a great number of women and children in colouring them, I expect to render the process much more easy in this present work, by the following instructions given to the printer and colourer. The Plates to be printed in a bluish-grey ink (this is the neutral tint for the light and shade of the Landscape); the colourer to wash in the sky with blue or violet, &c. according to each sketch; also going over the distances with the same colour; then wash the foregrounds and middle distances with red, orange, or yellow, copying the drawings; and when dry, wash over with blue, to produce the greens in the middle distances: this being done as a dead colouring, a few touches with the hand of the master, and a harmonizing tint to soften the whole, will produce all the effect expected from a coloured print.*

Repton included in this chapter a plate (opposite) that shows the colors he observed during his prism experiments, as well as a "Diagram to explain the Harmony of Colours" in a star-shaped design, and diagrams illustrating the duality of cold and warm tints and their uses in a painting—"for sky & distances" and "for the foregrounds," respectively. Two pictorial images show his theories applied to a landscape early in the morning, before and just after sunrise.

While Repton was discussing color theory predominantly still in the context of landscape gardening and landscape painting, the fact that he considered his own findings useful for producing and coloring prints is typical of the interdisciplinary nature of color studies in the nineteenth century and is indicative of architects and designers beginning to see a practical use for color theory in the early nineteenth century, anticipating David Ramsay Hay's *Laws of Harmonious Colouring, Adapted to House-Painting*, published just twelve years later.

Opposite: Among other details included on this plate of *Fragments* (1816), Repton gives the "Relative Proportions" of each color in Newton's color wheel, where violet dominates with 80 degrees assigned it, ahead of blue and green with 60 degrees each. Repton was particularly interested in immaterial color and how light affects the appearance of interiors and exteriors.

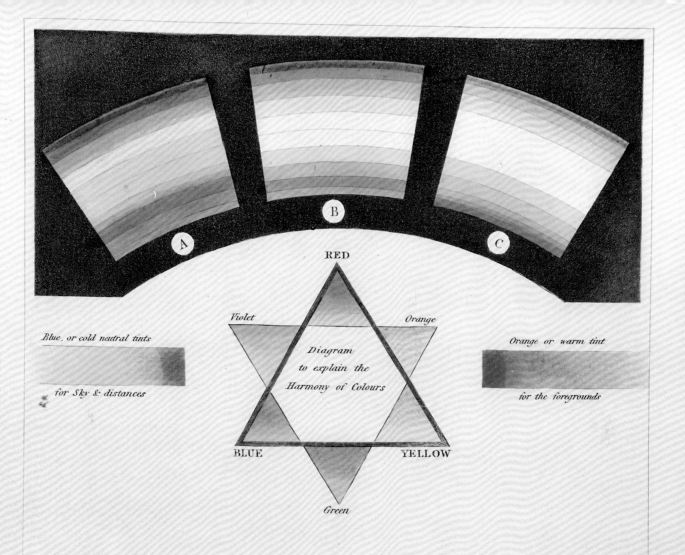

A B C

RED

Violet *Orange*

Blue, or cold neutral tints

Diagram
to explain the
Harmony of Colours

Orange or warm tint

for Sky & distances

for the foregrounds

BLUE YELLOW

Green

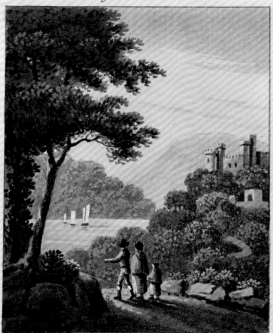

Morning. after the Sun is risen.

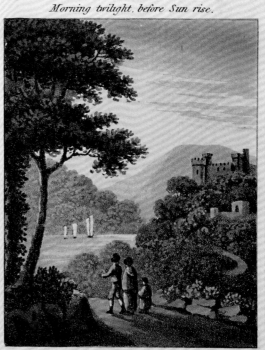

Morning twilight. before Sun rise.

Relative Proportions

45 Red
27 Orange
48 Yellow
60 Green
60 Blue
40 Indigo
80 Violet
───
360 parts
according to S.
J.ˢ Newton's scale
of Quantity

London, Published by J. Taylor, Feb. 1, 1816.

Reading Color:
William Oram's Memorandums

The architect and painter William Oram wrote about the use of color in landscape painting in the second half of the eighteenth century and planned to publish a treatise on the subject. For some unknown reason this never happened, but after his death in 1777 his widow gave his manuscripts to a certain Charles Clarke, who described himself as "a near relative" of Oram's. Clarke edited and published the manuscript in 1810, at the beginning of a great surge in new publications on many aspects of color and painting, perhaps seeing a financial opportunity. Oram's treatise is much concerned with composition and perspective, but he combines this with practical notes on which pigments to use and how to combine them. The final chapter is titled "A palette of colours for painting skies and buildings," and offers simple lists and tables of colors. Oram stressed the importance of observation, meticulously describing the colors of nature in changing weather and light conditions.

The book does not differ greatly from other writings on landscape painting from the period, but the illustrations are unusual and resourceful. Clarke decided not to include colored illustrations, possibly to keep the cost of the book down. Instead, the images have descriptions of color printed onto the relevant areas. The editor refers to this as a color or picture "memorandum." The plates are not too dissimilar to an artist's quick pencil sketches annotated with comments about color, light and shade, but here the notes are instructive and carefully chosen. Often the notes are a shortened version of Oram's much more detailed text. A sky in his "Memorandum of a Picture by Nicholas Poussin" (far right), for example, is described as "light warm" in one area and "darkish purple and soft broke with a little yellow" in an adjacent area. A hill in the foreground is "whitish but the whole dark soft and strong enamelled much in the general look or hue." The simpler "Memorandum of a Sky" (right) is still fascinating in the number of colors it details as all appearing in one sky—reds, blues, greens, yellows and purples—a variety that might seem natural to the eye

MEMORANDUM OF A SKY.

but which is made explicit and strange when written; and also that "light," as well as warmth, are considered renderable qualities, as in "Yellow greenish light all along" and "Darkest Warm Purple."

It is not known who created the plates, but they clearly illustrate Oram's observational, yet highly personal, accounts of color arrangement. These memorandums inadvertently create sometimes confusing and sometimes poetic images of the color scheme of a painting or an observed scene. You can literally read color here.

Right: Oram's memorandum paints a technicolor sky, with "Greenish blue light" in the top left, "All red light" in the foreground cloud, "Yellow greenish light all along" the middle, and "Darkest Warm Purple" in the lowest cloud.

Opposite: The "Memorandum of a Picture by Nicholas Poussin" gives more detail of particular features in comparison to each other, such as the "Dark blue hills . . . bluer than the sky next them."

Pl. 5. pa. 62.

Fine blue

Light Warm

Darkish Purple and soft broke with
a little Yellow

Strong brown
oker black &
white much
darker than
the Sky

Dark blue hills made with
blue white and light red,
bluer than the Sky next them

Strong and dark

very
Brown Whitish

Whitish but the whole

dark soft and strong

enamelled much in the general look or hue

I.S. sculp.

Memorandum of a Picture by

NICHOLAS POUSSIN,

Sold by Auction 16.th Dec.r 1756.

Publish'd Aug.t 1, 1810, by White & Cochrane, Fleet Street.

Mary Gartside's Abstract Color Blots

Between 1805 and 1808 the little-known painter Mary Gartside published three books on painting in watercolor that reflect an interest in the practical applicability of color theory. Little is known about Gartside's life except that she taught watercolor painting to ladies and exhibited some of her own botanical drawings at the Royal Academy in 1781 and at other London venues until 1808. While it was acceptable for women to teach watercolor painting, it was less common for them to publish so extensively in the field.

Gartside's first book, privately published and printed in London by T. Gardiner in 1805, was modestly titled *An Essay on Light and Shade, on Colours, and on Composition in General*. It was intended for Gartside's students and at first glance is nothing more than a painting manual for ladies, like its very short predecessor, a pamphlet entitled *An Essay on Light and Shadow* (c. 1804). However, a closer look at its content, style and illustrations makes it clear that this was more than an amateur's manual. An extended but otherwise quite similar second edition of the work in 1808, published by William Miller, was boldly renamed *An Essay on a New Theory of Colours*.

Like many of her contemporaries, Gartside referred directly to Isaac Newton and Moses Harris, while also showing some sympathy for Goethe's dualistic color system. What makes Gartside's *Essay* stand out among the wealth of illustrated books on color and painting published in her lifetime is the way she illustrated it. Apart from two standard tables of seven prismatic and compound colors (reminiscent of Harris, but in the shape of boxes) and a color wheel, she illustrated eight tints in a most unusual manner. The tints (white, yellow, orange, green, blue, scarlet, violet and crimson) roughly follow Newton's prismatic spectrum, with the addition of white. These plates are full page, freely painted watercolor "blots," showing the named

tint at various degrees of saturation, and blending abstractly with others, usually greens and browns.

Until much later in the nineteenth century there is no other example of a color system that is as inventive, but Gartside's work was overlooked in literature until fairly recently. In 1948 her blots were discussed in relation to Moses Harris by the scholar F. Schmid, who described them as "very fantastic and modern, suggesting paintings by the Swiss artist Giacometti, or even a Walt Disney film."

While the combination of beauty and usefulness of Gartside's illustrations is undeniable, the inclusion of such complex hand-colored and freely painted plates raises questions about how they were produced, who painted them, and to what degree the author was involved in the process. Even a cautiously estimated print run of between 150 and 200 for *Essay on Light and Shade* means that, in total, between 1,650 and 2,200 plates needed to be produced. It is highly improbable that Gartside, or indeed many other authors of similar books, painted all the plates for her publications herself; it is likely she engaged her young female students in the process. Her later publisher William Miller stressed her direct involvement with image production and used this as a selling point. In an advertisement placed in the *Morning Post* on February 9, 1809, announcing the publication of her third book, *Ornamental Groups, Descriptive of Flowers, Birds, Shells, Fruit, Insects, &c., and Illustrative of a New Theory of Colouring* he informed potential purchasers that "This beautiful work is printed on imperial drawing paper, and each number, containing six plates, mounted and coloured by and under Miss Gartside's immediate eye." The labor-intensive production of any color-illustrated book in the early nineteenth century is a reminder of how precious and expensive books still were in that period.

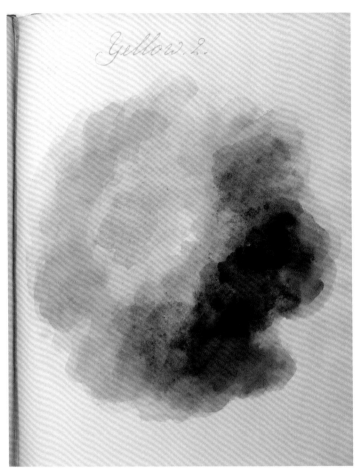

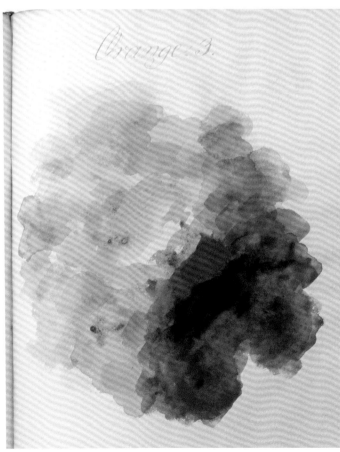

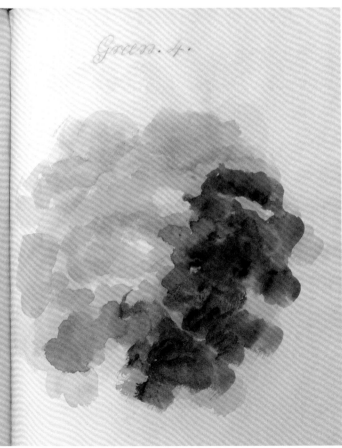

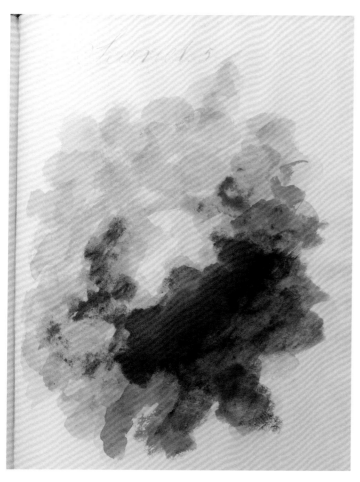
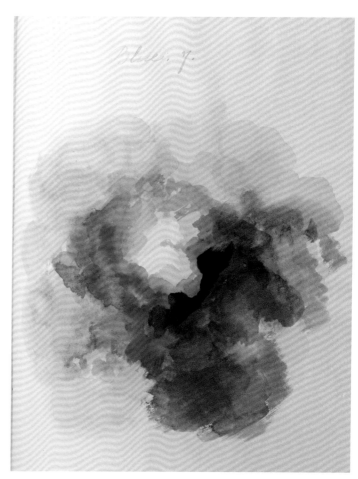
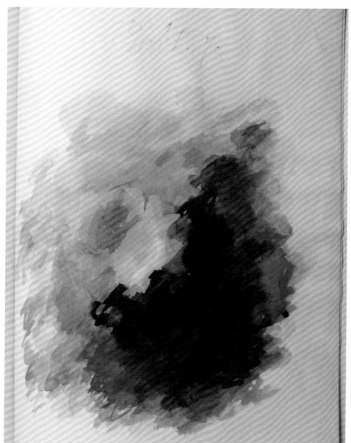
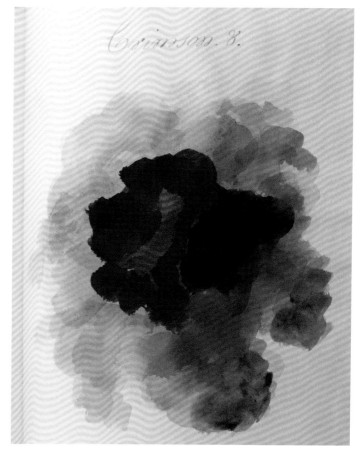

Popular Manuals for Amateur Painters

The ease of use, portability and affordability of watercolor paints and tools meant that working in and with color became a popular pastime for many in the nineteenth century. This led to an increased demand for drawing and coloring lessons at all levels. Many girls and young women learned how to draw, and giving lessons in painting or writing instructive books about it was a welcome source of supplementary income for professional artists. The arrangement of colors and their relation to line drawing and tonal shading of a composition was considered highly complex, resulting in hundreds of instructive manuals being published in Britain in the first three decades of the nineteenth century.

An early example of an instructive manual to painting in watercolor is English landscape painter David Cox's *A Series of Progressive Lessons, Intended to Elucidate the Art of Landscape Painting in Water Colours* (1811). Cox acknowledged a basic order of three primaries and three secondaries in painting, and recommended a reduced palette of subtle, mixed colors, though the focus of his book is on available pigments, composition and paint mixture rather than color theory. Cox's "progressive method" of painting involved the gradual development of a picture from the first rough sketch to the final thing through several stages of increasingly complex and detailed color application. In the instructions for making a picture, the text is actually interspersed with watercolor samples painted into small outlined rectangles next to the pigment names (see above right). Cox's popular manual went into nine editions until 1845, with ever-increasing quality and variety of illustration, and he published other books in a similar style.

In the 1820s the Scottish painter and engraver John Burnet published a series of artists' manuals that would go into many editions in the nineteenth century and be translated into other European languages. Like others before and after him, he drew on examples from Dutch, Flemish and Venetian masters when explaining and illustrating his methods. Having moved on from William Oram (see pages 48–49), using colored illustrations when discussing the topic of color was now non-negotiable. Utilizing his engraving skills, Burnet provided most of the copperplate engravings, along with extensive hand-coloring, himself.

The first plate of eight in a volume dedicated entirely to color, *Practical Hints on Colour in Painting* (1827),

DUTCH BOATS ON THE SCHELDT, OFF ANTWERP.

The sky cobalt [] ; the clouds yellow ochre, and a little vermilion [] ; the darker tint upon the clouds, cobalt, and vermilion [] ; when quite dry, the whole of the sky may have a very light wash of yellow ochre passed over it, the water indigo, and yellow ochre [] ; the sails ; one burnt sienna, and vermilion [] ; the other yellow ochre, and Vandyke brown [] ; the barges with burnt sienna, and yellow ochre [] [] ; the darker parts with a little Vandyke brown.

includes five color diagrams, plus two figurative scenes depicting light and shade, which are colored entirely by hand. While delivering practical advice was Burnet's main concern, by including these five small diagrams he also provides a short and useful overview of color order, beginning with Isaac Newton's seven-hue range (red, orange, yellow, green, blue, purple and violet) roughly reflecting Newton's proportions. As in other diagrams, indigo is sacrificed, here replaced by purple. Fig. 2 shows Leonardo da Vinci's tetrachromatic system (yellow, green, blue and red) with the addition of white and black as essential colors for the painter. The next diagram shows the system proposed by the eighteenth-century German painter Anton Raphael Mengs comprising five primaries (white, yellow, red, blue and black) and five secondary mixtures (orange, green, purple, gray and brown—still with white but now excluding black). The other two diagrams show the arrangement of warm (yellow, red and brown) and cold (gray, green and blue) colors between white and black. Burnet's practical treatises on painting remained in print in various editions until the 1850s and were reissued again later in the nineteenth century, long after his death.

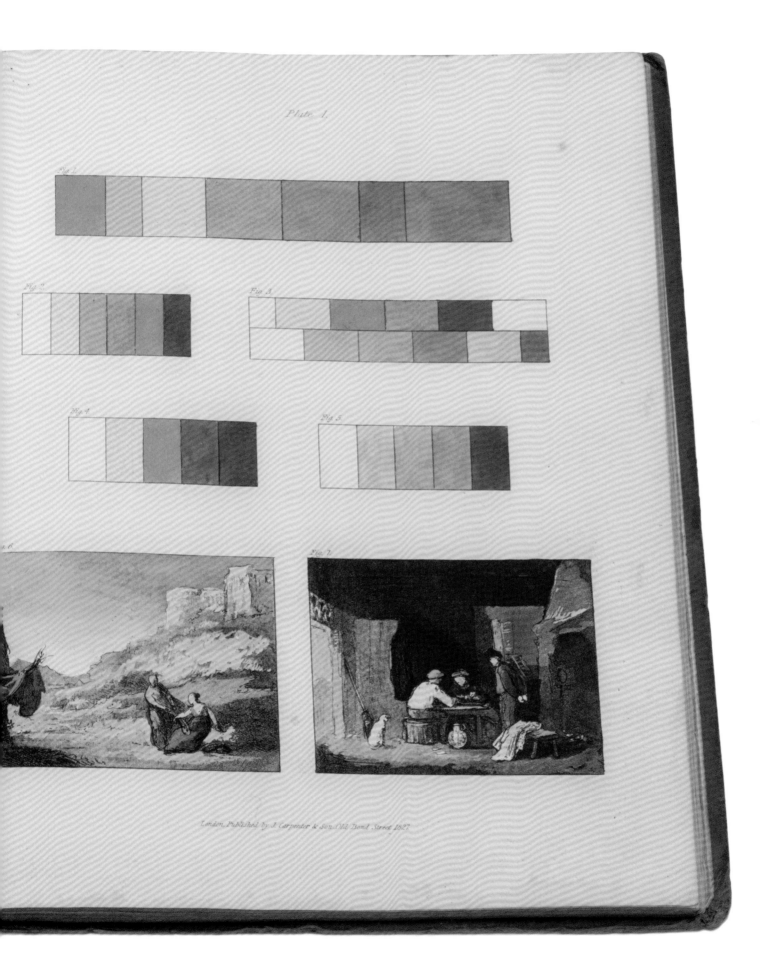

A Taxonomy of Colors:
Werner's Nomenclature

A young Charles Darwin took this book with him on the HMS Beagle *and used Syme's color names and descriptions in his notebooks*

Werner's Nomenclature of Colours is a good and rather curious example of the renewed interest in color in the early nineteenth century. It is a new edition and interpretation of the 1774 nomenclature *Von den äusserlichen Kennzeichen der Fossilien (*On the external characteristics of minerals*)* by German geologist Abraham Gottlob Werner, published in 1814 and reprinted in 1821 in London. Its full title is *Werner's Nomenclature of Colours, With Additions, Arranged so as to Render it Highly Useful to the Arts and Sciences, Particularly Zoology, Botany, Chemistry, Mineralogy, and Morbid Anatomy. Annexed to Which Are Examples Selected From Well-known Objects in the Animal, Vegetable, and Mineral Kingdoms.* The editor of the new edition, Patrick Syme, a flower painter at the Wernerian and Horticultural Societies in Edinburgh, illustrated the book with detailed color lists, comprising numerous shades and variations of the colors green, orange, yellow, blue, purple, red, black, white, gray and brown. The total number of colors listed and depicted in Syme's new edition is 110, an extension from Werner's original 79 tints. Syme presented them in strict chart format (see opposite and overleaf) and added short descriptions of equivalents for each particular tint in the plant world (mostly flowers), animal world (insects and birds feature heavily) and the mineral kingdom. In his choice of color names Syme did not always refer to pigments but instead focused on the appearance and recognizability of a color, as the main purpose of this publication was to help with taxonomical identification and representation.

Some color names are wonderfully evocative, such as "Gallstone Yellow," "Veinous" and "Arterial Blood Red," "Leek Green," "Liver Brown" and "Skimmed Milk White." Perhaps not surprisingly, a young Charles Darwin took a copy of Syme's *Werner's Nomenclature* with him on the HMS *Beagle* voyage to South America and Australia between 1831 and 1836, and used Syme's color names and descriptions in his notebooks. Small, handy charts like these were of use to both scientists and artists, as they could fit into a small bag and be consulted while observing nature, whether it was for the purpose of identification, accurate visual representation or artistic inspiration. Although simpler in design than complex color wheels or similar diagrams, the breakdown of one color into a variety of tints within that color—for example, Syme lists seventeen types of red—with added actual examples from the natural world and individual color swatches, was of great practical use when identifying and recording the many varieties of colors we see around us. This need for detailed color lists was strong in Werner's and Syme's period, but the lists would grow even longer and more detailed in the nineteenth and twentieth centuries.

What makes this little book special in a purely material sense is that the color samples are not painted onto the pages but onto separate sheets of paper, which were then cut into small squares and eventually stuck onto the pages. It is assumed that Syme enlisted the help of his family with this laborious task.

GREYS.

Nº	Names.	Colours.	ANIMAL.	VEGETABLE.	MINERAL.
9	Ash Grey.		Breast of long tailed Hen Titmouse.	Fresh Wood ashes	Flint.
10	Smoke Grey.		Breast of the Robin round the Red.		Flint.
11	French Grey.		Breast of Pied Wag tail.		
12	Pearl Grey.		Backs of black headed and Kittiwake Gulls.	Back of Petals of Purple Hepatica.	Porcelain Jasper.
13	Yellowish Grey.		Vent coverts of White Rump.	Stems of the Barberry.	Common Calcedony.
14	Bluish Grey.		Back, and tail Coverts Wood Pigeon.		Limestone
15	Greenish Grey.		Quill feathers of the Robin.	Bark of Ash Tree.	Clay Slate, Wacke.
16	Blackish Grey.		Back of Nut-hatch.	Old Stems of Hawthorn.	Flint.

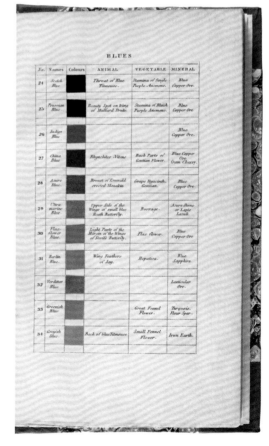

These pages: Some pages from the 1821 edition of Syme's *Werner's Nomenclature*, with the lists of color samples, their names and where they could be found in flora, fauna and geology.

Among the greens is an "Emerald Green," which can be seen on the "Beauty Spot on Wing of Teal Drake." One of the yellows is a "Straw Yellow" that resembles the color of a polar bear, while "Vine Yellow" is supposed to look like the body of a silk moth. "Arterial Red" is the color of the corn poppy, and "Veinous Blood Red" that of a musk flower, according to this list.

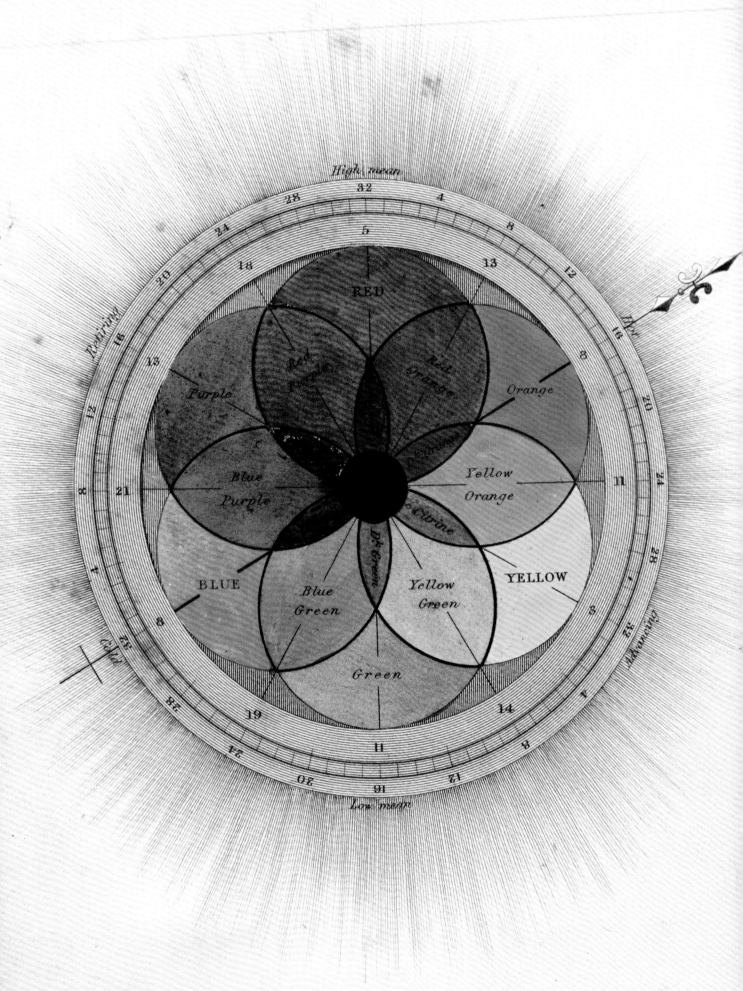

George Field: Science, Art and Symbolism

George Field was a British colorman, pigment-maker, chemist and color researcher. His first book on color, *Chromatics, or, An Essay on the Analogy and Harmony of Colours*, was published in 1817 and he continued to write and publish on color until his death, with further revised and expanded editions of his works being published until the 1880s. His steady output, commercial success, connections with the art world and his wide-ranging research interests make Field's work perhaps the best example of the nature of color literature, and the changing attitudes toward color and pigment use, in the nineteenth century. In style, format and presentation *Chromatics* resembles slightly earlier illustrated books on color and color theory, such as Mary Gartside's *Essay on Light and Shade* (1805) (see pages 50–53) and James Sowerby's *New Elucidation of Colours* (1809). Field follows in the tradition of attempting to present color systems visually, across a wide variety of charts including pyramidal shapes, hexagons, variations on the color circle, various trapezoidal shapes, and overlapping triangles forming stars. His color stars (overleaf) are particularly striking. They illustrate a chapter in which Field examines the harmonious combination of colors at various stages of mixing. At the heart of each star is always a black or a very dark tint, indicative of Field illustrating color systems concerned with subtractive color, that is, paints and pigments, rather than additive colored light.

Field's approach was rooted in his firm belief that the sciences and arts are intrinsically linked and "mutually reflect light upon each other." Like Goethe, Field argued for a basic color principle of duality and also for symbolic, moral or psychological associations of color, where yellow and blue form a polarity associated with light and shade, as well as with activity and passivity. In the same way that Goethe combined the concept of polarity with a symmetrical color system based on three primaries (or primitives) and three secondaries, Field, too, recognized and promoted the concept of three primary colors. A practicing Christian as well as a serious scientist, Field associated the trichromatic concept of three primary colors with Christian concepts of the Holy Trinity, going as far as to identify the purest and most stable pigments as earthly representations of this vision, namely red madders, lemon yellow and ultramarine blue.

Left: George Field's works went into many editions. This is the hand-colored frontispiece from a 1841 edition of *Chromatography*, showing a highly developed version of a color wheel.

Right: Pages from *Chromatics* illustrating Field's concept of primary, secondary and tertiary in practical mixing terms.

Overleaf: Field's color stars are a particularly beautiful representation of the principles of color mixing. The black at the heart of each star is a clear indication that we are dealing with material or subtractive color.

Experimenting with pigments and pigment manufacture from as early as 1804, Field recorded his observations in extensive notebooks and was particularly concerned with the invention of tools and machines for the extraction, filtration and production of pigments. From 1808 he began supplying pigments to artists; other colormen including William Winsor and Henry Newton, who in 1832 founded Winsor & Newton; tradespeople; artists' suppliers; and printers and publishers, including Rudolph Ackermann. Field was responding not only to the need for high-quality pigments, but also to the need for scientifically sound and reliable information on color and pigments. This would explain the continued popularity of Field's publications, all of which went into several expanded or revised editions. Field's pigments literally stood the test of time and were from the 1850s onwards praised by the color researcher Mary Philadelphia Merrifield (see pages 104–105) as well as members of the Pre-Raphaelite Brotherhood, in particular William Holman Hunt and John Everett Millais.

As well as demonstrating the new ways that color was understood in the early nineteenth century, his sheer publishing output throughout the period makes Field's work perhaps the best example of changing methods for illustrating and producing color books in his time. The first edition of *Chromatics* from 1817 was published in a small edition of 250 copies. All seventeen copper plates in *Chromatics* are hand-colored in watercolor and gouache, presumably by Field himself or under his close supervision. Its price of two guineas (£2.2s.0d) reflects the high quality of the illustrations. By contrast, *Chromatography*, Field's substantial main work, published in 1835 in quarto format (33 x 30 cm), has only a hand-colored frontispiece and one further copperplate without color. The format of subsequent editions and other publications by Field continued to decrease in size. A new edition of *Chromatography* from 1841 is noticeably smaller (23 x 15 cm) and illustrated with only a hand-colored frontispiece. Affordability, together perhaps with an expanding market, may be the key to these developments. A shorter version of *Chromatography*, titled *Rudiments of the Painters' Art: Or, A Grammar of Colouring* (1850, 1858), published in the last years of his life, is of an even smaller size (18 x 10.5 cm) and presented like an artists' handbook. It contains one small hand-colored frontispiece in the shape of a simplified color star, as well as two lithographs and three chromo-lithographs, the latter illustrating the three primary colors in the shape of flowers (opposite and below). It was priced at only two shillings—a fraction of what his first book retailed at nearly 40 years earlier.

Left & right: Two of Field's plates from *Rudiments*, depicting primary colors in the form of flowers to represent certain qualities. Red (right) is presented in a formal, roselike image with its complementary, green. Seen left, the colors blue and yellow are presented together in more abstract forms. Field follows Goethe in assigning blue to shade and yellow to light.

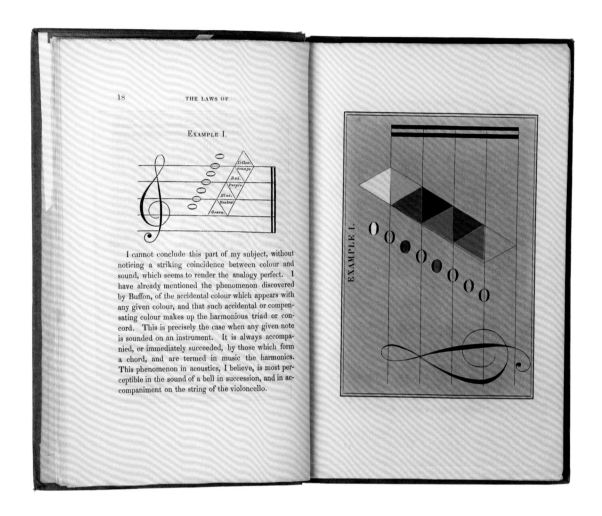

Color and Music

Field's beautiful, harmonious representations of color, exemplified by his stars; the metaphysical connection he makes between his three primary colors and the Christian, Holy Trinity; and indeed the alternative title of his first publication all demonstrate a new focus within color studies in the early nineteenth century. Alongside the need for effective visual color systems, there was a desire to find analogies and symbolic associations. To this effect, Field, like Newton before him (and whom he referenced directly), argued a strong connection between color and music. He saw, for example, a correspondence between the three primary colors and the notes C, E and G. He explored this analogy further in later publications and included a plate illustrating these ideas, combining a colored triangular shape with musical scales (opposite). Just a few years later, the Scottish interior decorator David Ramsay Hay incorporated the analogy of music and color into his publication *The Laws of Harmonious Colouring Adapted to Interior Decorations: With Observations on the Practice of House Painting* (1847) and included a similar illustration (above).

Newton was by no means the first to have made connections between color and music. The Greek mathematician Pythagoras saw a correlation between the two, and it is possible that these associations go back even further. They are certainly a constant theme in color theory and the performing arts. In 1650 the German scholar Athanasius Kircher published *Musurgia Universalis*, in which he discussed the possibility of a musical language based on combinations of musical notes and color and, essentially, synaesthetic experiences.

Newton's first printed color wheel from 1704 (see pages 12–13) followed the arrangement of the Dorian scale, and greatly inspired the French Jesuit monk Louis Bertrand Castel, who in 1734 constructed an ocular harpsichord that played only color, followed later by models that could produce both color and sound simultaneously. The colors of Castel's instruments took the form of pieces of paper or ribbons that would lift when keys were struck. Castel's most ambitious organ was exhibited in London in 1757, the year of his death. It was a huge device that played twelve octaves and had 144 keys and corresponding apertures that would open to reveal colored squares of thin paper.

Above & opposite: Both Hay and Field associated lower musical notes with the darker shades and higher with brighter ones, placing a light yellow at the top of each scale. Field's system is complex and includes a large number of mixtures and what appears to be levels of saturation, while Hay's scale is more clearly based on the three primaries yellow, red and blue and their respective mixtures orange, purple and green.

EXAMPLE XVI.

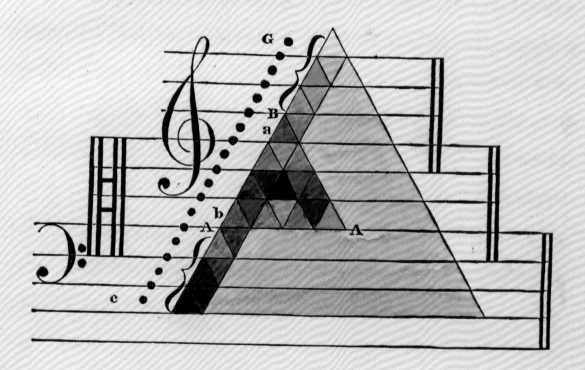

ANALOGOUS SCALE OF SOUNDS AND COLOURS.

Instructive Palettes in Painters' Manuals

From the 1820s onwards we increasingly see images of palettes in painting manuals, to illustrate which colors should be used at what stage in the creation of a painting. There area few earlier examples of instructive rather than decorative or symbolic palettes in print culture, for example the fold-out plate in J. C. Le Blon's *Coloritto* (1756, pages 24–25) and William Hogarth's etching from *The Analysis of Beauty* (1753, pages 30–31). Advances in printmaking technology— aquatinting in the later eighteenth century and the invention of lithography in the early nineteenth century—encouraged ever more literal and elaborate ways of illustrating painting techniques and materials. However, all of the palettes depicted on these pages are lithographs or etchings with the actual blots of paint added by hand in watercolor. One wonders to what extent the pigments supposedly shown were actually used for painting them. Is that "ultramarine" blot really ultramarine, or a cheaper blue posing as ultramarine for the sake of book illustration?

In the introduction to *On Painting in Oil and Water Colours for Landscape and Portraits (1839)*, the author, Theodore Henry Fielding, bemoans the "very small number of practical treatises on Oil Painting," while "works which treat on painting in watercolors have been so multiplied that none can complain of their scarcity." His offering is a long and entirely practical book on the use of both media. Like John Burnet (see pages 54–57) he based his manual on his own observation as well as study of established artists, and he promoted the progressive method of painting, which he illustrated by ten etched plates, some of them hand-colored.

The frontispiece (opposite) in particular stands out as an illustration that is both decorative and useful.

Two realistic palettes are depicted: the upper one with tints recommended for landscape painting, and the lower with tints for portraits. Underneath the palettes Fielding depicts suitable brushes. In the text, he notes that at the commencement of a painting, a palette would hold fewer tints—"not more than two or three"—as large quantities of a few base colors must be mixed and placed initially. The contents of these two palettes are appropriate for a work in progress, when the artist requires a smaller quantity of paint but a greater range of tints. Fielding's palette frontispiece is visually pleasing and instructive, but his contemporary John Cawse had included printed and colored palettes to illustrate his painting manuals several years earlier, and turned them into works of art in their own right.

Cawse's first publication, *Introduction to the Art of Painting in Oil Colours* (1822), was modestly illustrated but included colored images of painters' palettes. A new and much extended edition from 1840 contained eleven expertly lithographed and then hand-colored palettes (overleaf). They provide considerable detail about which tints should be used for the various stages of preparing backgrounds, painting portraits, landscapes and skies, and depicting fabrics such as satin in oil paint. Like Fielding, Cawse decided to illustrate these tints on a drawn palette in order to best indicate their ideal placement on the palette, for ease of mixing and to prevent certain tints from contaminating each other. The paints and pigments are remarkably accurate and brilliantly preserved in the copy shown here, but this is still an instance of watercolor and gouache being used to depict oil paint: one paint medium pretending to be another.

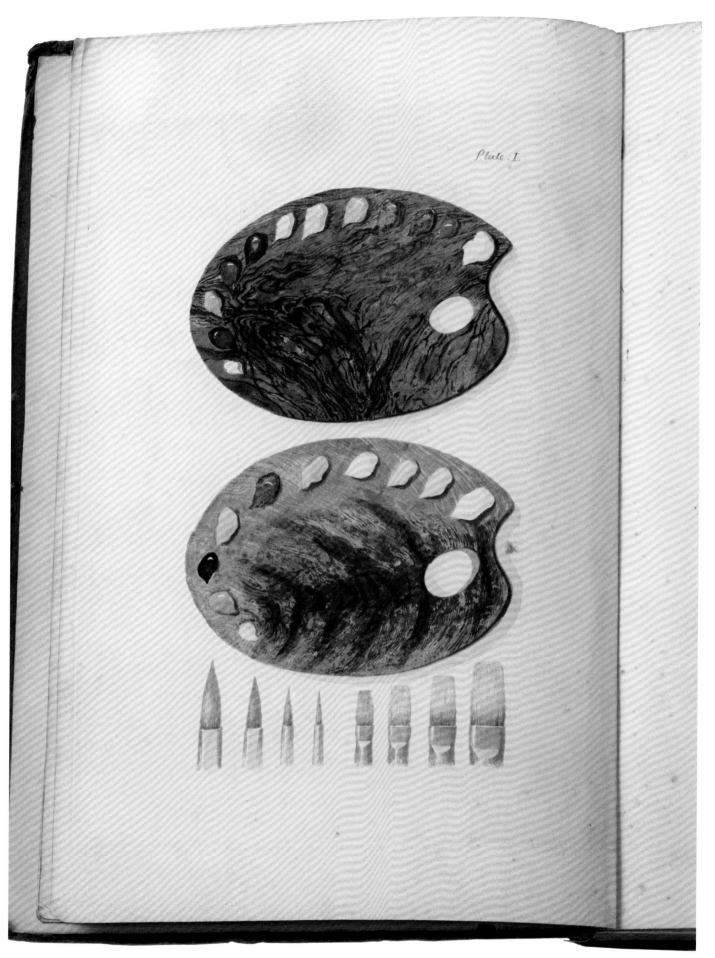

Plate. I.

These pages: A selection of palettes from John Cawse's *Introduction to the Art of Painting in Oil Colours* (1840).

Top Left: "A palette for painting Skies, Clouds, &c. in Landscape painting."

Left: "A palette containing the principle tints used in Landscape painting."

Top right: "A palette for painting Scarlet or Crimson Satin."

Right: "The palette of colours for finishing the Portrait. Containing the tints laid as in the first, with the additional ones made from Lake, Brown pink, Ivory black, and Prussian blue."

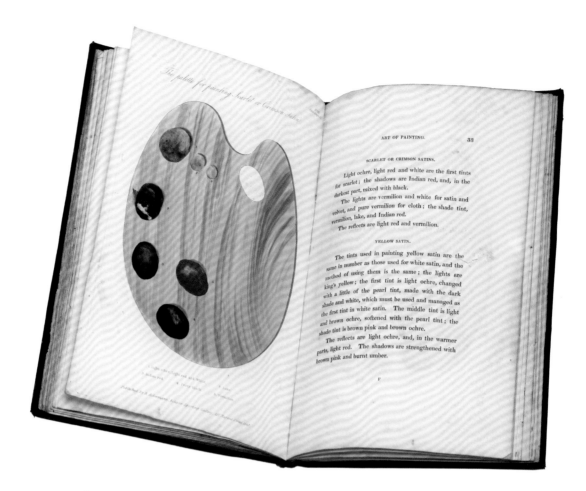

SCARLET OR CRIMSON SATINS.

Light ochre, light red and white are the first tints for scarlet; the shadows are Indian red, and, in the darkest part, mixed with black.

The lights are vermilion and white for satin and velvet, and pure vermilion for cloth; the shade tint, vermilion, lake, and Indian red.

The reflects are light red and vermilion.

YELLOW SATIN.

The tints used in painting yellow satin are the same in number as those used for white satin, and the method of using them is the same; the lights are king's yellow; the first tint is light ochre, changed with a little of the pearl tint, made with the dark shade and white, which must be used and managed as the first tint in white satin. The middle tint is light and brown ochre, softened with the pearl tint; the shade tint is brown pink and brown ochre.

The reflects are light ochre, and, in the warmer parts, light red. The shadows are strengthened with brown pink and burnt umber.

F

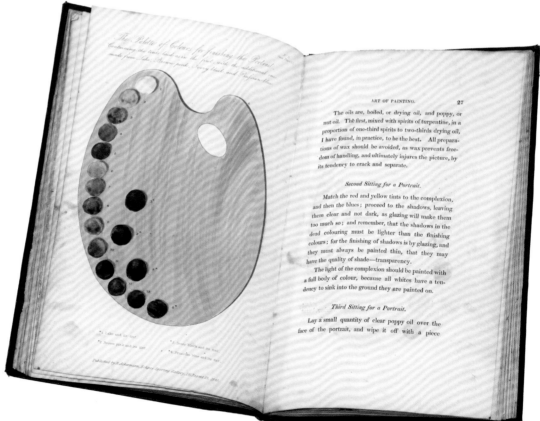

The oils are, boiled, or drying oil, and poppy, or nut oil. The first, mixed with spirits of turpentine, in a proportion of one-third spirits to two-thirds drying oil, I have found, in practice, to be the best. All preparations of wax should be avoided, as wax prevents freedom of handling, and ultimately injures the picture, by its tendency to crack and separate.

Second Sitting for a Portrait.

Match the red and yellow tints to the complexion, and then the blues; proceed to the shadows, leaving them clear and not dark, as glazing will make them too much so; and remember, that the shadows in the dead colouring must be lighter than the finishing colours; for the finishing of shadows is by glazing, and they must always be painted thin, that they may have the quality of shade—transparency.

The light of the complexion should be painted with a full body of colour, because all whites have a tendency to sink into the ground they are painted on.

Third Sitting for a Portrait.

Lay a small quantity of clear poppy oil over the face of the portrait, and wipe it off with a piece

The "Painter's Compass": Color Wheels for Artists

In the wake of the reissue of Moses Harris's *The Natural System of Colours* (1811; see pages 26–29) and the new scientific theories of color emerging in the early nineteenth century, many art professionals were inspired to publish handbooks that attempted to develop or adapt these color systems in order to make them more useful to artists. The resulting books were beautifully illustrated and popularized color theory. When it came to choosing a form in which to present a color system, geometric designs dominated, usually in the form of wheels, disks and circles, with few figurative or fanciful depictions.

In 1826 Charles Hayter, an art teacher to the British royal family, published a practical application of color theory that was clearly informed by Moses Harris. It also references Leonardo da Vinci's mid-sixteenth century tetrachromatic system, as proposed in his *Trattato della Pittura* (first published in English in 1721 under the title *A Treatise on Painting*). Hayter's *A New Practical Treatise on the Three Primitive Colours* (1826) proudly announced itself as "a perfect system of rudimental information," stressing, as is typical of paint manuals of the time, its usefulness for painters.

The second plate of his book (opposite, top) is particularly appealing and meticulously colored. Titled "The Painter's Compass" it depicts three color wheels of consecutive paint mixtures, divided into eighteen tints each, with three levels of brightness. They are accompanied by two white-to-black scales of warm (yellow, orange, red, purple and indigo) and cold (indigo, blue, green, yellow and pale yellow) colors. The visual and conceptual similarities to

Harris are obvious, and he is indeed mentioned in the accompanying text. Perhaps referring to Newton, Hayter suggests "the number of circular divisions may be considered as allusive to infinite, by imperceptible gradation between full color and its total evaporation into light." While the number of colors may in theory be infinite, Hayter was well aware of the practical and financial restrictions of depicting this in a small-format publication intended for general use. In a footnote he remarks that he had more ambitious plans regarding the images but held back, as this would have made the book too expensive.

A much simpler color wheel, also hand-colored, was published a few years later by French artist and chemist Jean-François-Léonor Mérimée in his treatise *De la peinture à l'huile* (1830). Mérimée focused predominantly on materials and techniques of the old masters, but he also attempted to visualise color order, harmony and contrast with his *échelle chromatique* (color scale). Six colored disks are arranged in a circle: the primaries red, yellow and blue depicted slightly larger than the secondaries orange, green and purple, all of them connected by narrow bands, with a grayish-black central disk denoting the mixture of all tints. The black disk at the center of the wheel indicates subtractive or material color, where the result of mixing the hues is black. Possibly, we might also see the position of black as being outside the range of color, while the grading toward white of the bands connecting the color circles suggests that a three-dimensional model of Mérimée's system might place white opposite the black disk.

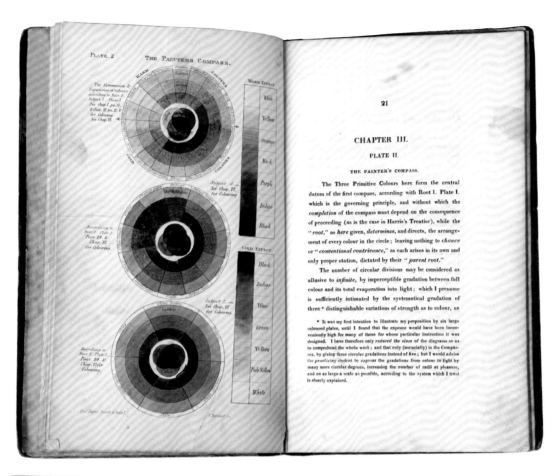

21

CHAPTER III.

PLATE II.

THE PAINTER'S COMPASS.

The Three Primitive Colours here form the central datum of the first compass, according with Root I. Plate I. which is the governing principle, and without which the *completion* of the compass must depend on the consequence of proceeding (as is the case in Harris's Treatise), while the "*root*," as *here* given, *determines*, and directs, the arrangement of every colour in the circle; leaving nothing to *chance* or "*conventional contrivance*," as each arises in its own and only proper station, dictated by their "*parent root*."

The number of circular divisions may be considered as allusive to *infinite*, by imperceptible gradation between full colour and its total evaporation into light; which I presume is sufficiently intimated by the systematical gradation of three * distinguishable variations of strength as to colour, as

* It was my first intention to illustrate my proposition by six large coloured plates, until I found that the expence would have been inconveniently high for many of those for whose particular instruction it was designed. I have therefore only *reduced the sizes* of the diagrams so as to comprehend the whole work; and that only (materially) in the Compasses, by giving three circular gradations instead of five; but I would advise the *practising student* to *express* the gradations from colour to light by many more circular degrees, increasing the number of radii at pleasure, and on as large a scale as possible, according to the system which I trust is clearly explained.

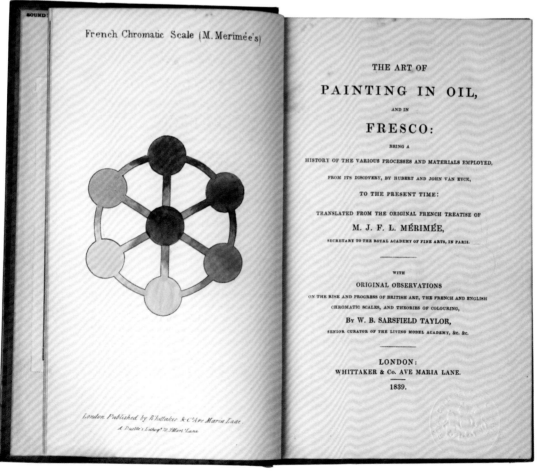

THE ART OF

PAINTING IN OIL,

AND IN

FRESCO:

BEING A

HISTORY OF THE VARIOUS PROCESSES AND MATERIALS EMPLOYED,

FROM ITS DISCOVERY, BY HUBERT AND JOHN VAN EYCK,

TO THE PRESENT TIME:

TRANSLATED FROM THE ORIGINAL FRENCH TREATISE OF

M. J. F. L. MÉRIMÉE,

SECRETARY TO THE ROYAL ACADEMY OF FINE ARTS, IN PARIS.

———

WITH

ORIGINAL OBSERVATIONS

ON THE RISE AND PROGRESS OF BRITISH ART, THE FRENCH AND ENGLISH CHROMATIC SCALES, AND THEORIES OF COLOURING,

By W. B. SARSFIELD TAYLOR,

SENIOR CURATOR OF THE LIVING MODEL ACADEMY, &c. &c.

———

LONDON:
WHITTAKER & Co. AVE MARIA LANE.

1839.

Rudolph Ackermann Colors Fashionable Society

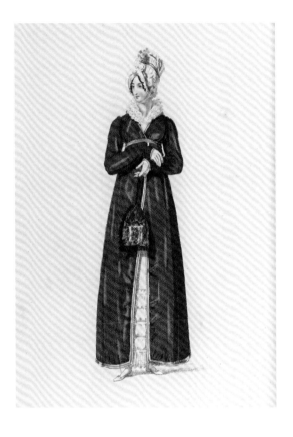

In 1796, the young coach and carriage designer Rudolph Ackermann opened a shop in the Strand in London, producing and selling prints. A year later he also took over a small art school nearby, which he ran until 1806. This was the beginning of one of the most popular and long-lived art retail establishments in Georgian London: Ackermann's Repository of Arts. Here, Ackermann achieved huge success by combining his knowledge of design and print with advertising skills and an astute insight into fashionable London society. Within a few years the shop would also sell decorative objects and artists' materials. Ackermann also began producing some of these materials himself; for example, pressed watercolor cakes.

Ackermann also pioneered new techniques in color printing and book illustration, and he became the leading publisher of color plates in Britain in the early nineteenth century. He published books on a wide range of popular subjects such as design, fashion and travel. Most of these were illustrated with high-quality colored aquatints, for which he employed the best engravers of the period. He was one of the earliest promoters of lithography and in 1819, shortly after having met its inventor, Alois Senefelder, in Germany, published the translation of Senfelder's autobiographical treatise on this revolutionary new printing method.

Between 1809 and 1829 Ackermann published the popular monthly magazine: *The Repository of Arts, Literature, Commerce, Manufactures, Fashions and Politics*, named after his famous shop (in 1829 it was renamed *Repository of Fashion*). It was dedicated to the fashion-conscious Prince of Wales (later King George IV) and was illustrated with mostly hand-colored plates depicting the latest dress fashions (see above right), London buildings and their interiors, and furniture designs. The early issues included "Allegorical Wood-Cut" plates, which included real samples of paper and textiles for use in design, printing, dressmaking, soft furnishing or upholstery, allowing the reader not just to see but also to feel the materials (opposite). The accompanying text for these plates helpfully informed the reader of where to purchase them. Ackermann's costume plates, fabric samples and their descriptions provide a vivid image of fashionable colors and designs, and commerce in Georgian England.

Ackermann was an astute businessman and entrepreneur who tapped into an emerging shopping culture. Shops, including his own, are frequently depicted in the magazine and shown as elegant social spaces. In the very first issue, readers were treated to a detailed interior view of Ackermann's Repository of Arts, then in 101 Strand (overleaf). Fashionably dressed men and women peruse print racks and paintings displayed on walls. Signs below the skylight advertise what can be purchased here, including "Embossed White and Gold Ornaments" and "Colors and Requisites for Drawing." Behind a large serving counter are glass-fronted cabinets containing many small boxes. This is quite probably where the paints, pigments, papers and artists' tools were stored.

The business moved within the Strand a number of times and Ackermann also opened outlets in South America in the 1820s. His sons continued the Strand shop under the name Ackermann & Co. until 1861. A plate from one of the last issues of *The Repository of Arts* shows the elegant exterior of the new and enlarged premises in 96 Strand in 1827, with well-to-do Londoners flocking to it. The text informs the reader that "It was to be expected that a place so peculiarly devoted to the arts, should, in outward appearance and internal arrangement, correspond with the nature of its establishment."

Above right & opposite: Ackermann's Repository of the Arts magazine included hand-colored plates depicting the latest fashions (above right), as well as woodcut plates with stuck-in samples of real fabrics (opposite).

Overleaf: Not above self-promotion, the magazine also featured images of his London shop, where it was presented it as an attractive and fashionable space.

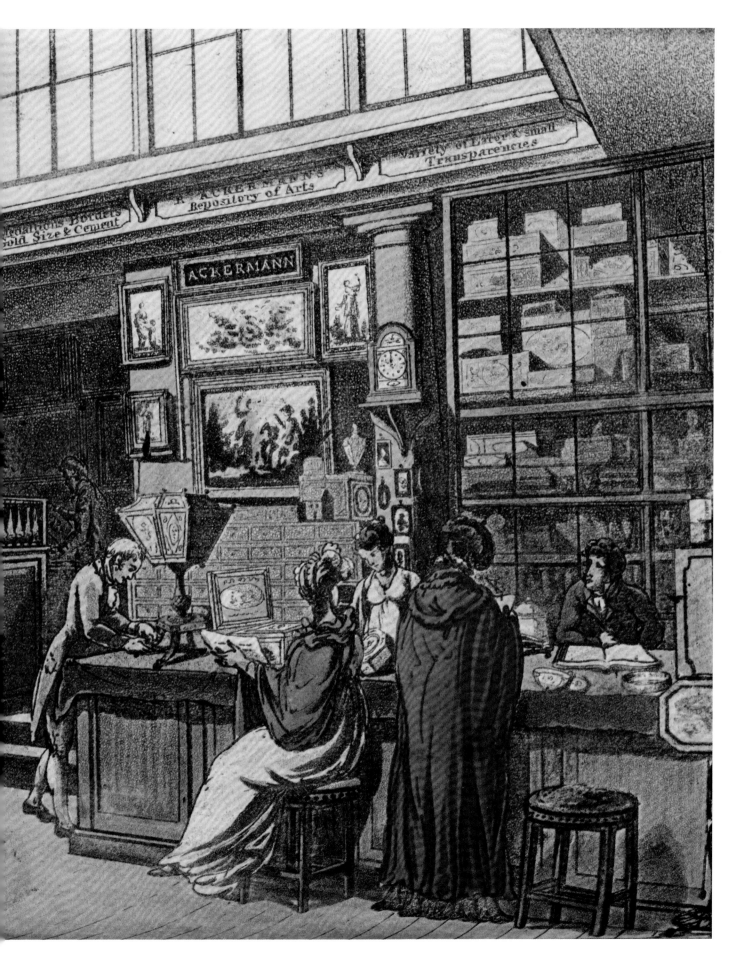

Frank Howard Breaks Down the Masters

Himself the son of a painter, Frank Howard studied at the Royal Academy and later became an assistant to one of the most famous portrait painters of his time, Sir Thomas Lawrence. He pooled his experiences into writing artists' manuals in the smaller octavo format that was beginning to replace the quarto-format publications of the earlier nineteenth century. His manuals were mainly aimed at amateur artists but marketed as containing first-hand information from Royal Academy circles. Howard's first book on art, *The Sketcher's Manual*; or, *The Whole Art of Picture Making Reduced to the Simplest Principles*, published in 1938, deals with perspective, the pictorial arrangement of a picture, and the use of light and shadow in a drawing, but doesn't mention color until the very last page, where he explains its omission in this book: "Colour is reserved for a future work; both on account of its requiring more proficiency in the amateur, and on account of the extent of illustration necessary to do justice to the subject."

The following year a volume on color was indeed published in the same style and format, although by a different publisher. *Colour as a Means of Art: Being an Adaptation of the Experience of Professors to the Practice of Amateurs* is an important example of a painters' manual illustrated with small but high-quality color lithographs, when lithography was still in its infancy but quickly replacing the costlier technique of aquatinting. The plates in the copy of Howard's *Colour as a Means of Art* shown here and overleaf have additions in watercolor, body color, pencil and ink, making some of them appear almost like original paintings. We do not know who embellished the lithographs, but the hand-coloring varies greatly in each copy.

In this book, Howard provides examples of paintings by old and contemporary masters particularly noted for their use of color, such as Titian, Rubens and Turner, and provides short chapters on their styles and "principles." The eighteen accompanying plates are not reproductions of works by these artists, but show images reduced to their chromatic layout. Almost all recognizable detail is omitted, giving the images an abstract quality. A similar idea was employed by several other authors of paint manuals before and after Howard, but usually in the context of describing the various stages of creating a painting (that is, the progressive method) and not for the sole purpose of illustrating color use and layout. Howard's images stand out because they deconstruct completed oil paintings, as if we are looking at a well-known painting through a haze or with myopic eyes. From these master examples, he explains, can be derived "certain abstract principles, which may be made the foundation for other and different arrangements, as the taste or talent of the artist or amateur may dictate. Pictures may be made up of a balance, or harmonic arrangement of Tones . . . or of Colours." These "abstract principles" are not dissimilar to Mary Gartside's color blots from 1805 (see pages 50–53), in which she proposed harmonious color layouts for painting flowers in watercolor.

Opposite, top: "Rubens' Principle." In this plate, the lithographic layers of blue and brown are clearly visible under the added watercolor and gouache.

Opposite, bottom: "Ludovico Caracci's Principle." This Venetian example is described as omitting white and black altogether, having no shades darker than a rich brown or brighter than a creamy yellow.

Above: "Another Principle of
Titian's." Howard describes
Titian's principle as "pure greys
interspersed among masses
of bright crimson, opposed
to some pure white and blue,
broken by flesh tints."

Above: "Modern Manner."
This example is clearly in the
style of Turner, with emphasis
on the "white cloud which is
graduated with purply greys"
relieving upright and darker
objects of the composition.

Color, Light and Shade: Turner's *Deluge* Paintings

In or just before 1843, Joseph Mallord William Turner painted two canvases in which he explored aspects of light and shade and the spiritual dimensions of color in painting. Turner paired the biblical narrative themes of Noah's covenant and of Moses writing the book of Genesis with contemporary discourses on color theory, in particular Goethe's *Zur Farbenlehre.* In fact he references Goethe directly in one of the titles: *Light and Colour (Goethe's Theory): The Morning after the Deluge, Moses Writing the Book of Genesis.* The corresponding canvas was called *Shade and Darkness—the Evening of the Deluge.*

Shade and Darkness (above) has sometimes been interpreted as a criticism of Goethe's writing, since it appears to negate light; however, one of Goethe's key arguments was that color is created not from light, but where light and darkness meet. Where the light emanating from the center of the canvas meets the deluge the colors are all cool blues and browns. *Light and Colour (Goethe's Theory)* (opposite), in contrast, visualizes of the warm and light side of the spectrum, where the colors are predominantly red and yellow, showing a swirling and glistening splendor of light typical of Turner in his late phase. It is highly likely

that Turner was contemplating this argument when creating his dualistic pair of canvases.

There is evidence that Turner participated in the intellectual discourse on color from at least the early 1800s and read widely on the subject. He owned copies of the new edition of Moses Harris's *Natural System of Colours*, George Field's *Chromatography*, Charles Hayter's *Introduction to Perspective, Drawing and Painting* and many other publications on color and color theory. Some of these books contain notes in Turner's hand on the margins, including, crucially, his friend Charles Lock Eastlake's translation of the first volume of Goethe's *Farbenlehre* (overleaf), providing vital information on Turner's immersion in the subject matter. Eastlake's translation was published in 1840 as *Theory of Colours*, but it is thought he had finished it by 1820, and aspects of Goethe's color studies were discussed in academic circles soon after its publication in German.

Art historian John Gage studied Turner's marginalia in *Theory of Colours* and came to the conclusion that Turner thought Goethe's concept of complementary colors for harmonious compositions was "far too rigid a framework within which to understand and express the diversity of natural coloration." Gage warned, too, that the presence of the notes as such does "not [. . .] represent the painter's endorsement of Goethe's ideas of colour."

From the evidence of his engagement with the subject, there is little doubt that over time Turner began developing his own distinct ideas about color, color order and use of color appropriate to its expressive qualities. It seems likely that he was inspired by aspects of Goethe's theory while rejecting others, and these paintings are ultimately a better testament to Turner's own ideas about color than they are an homage to Goethe.

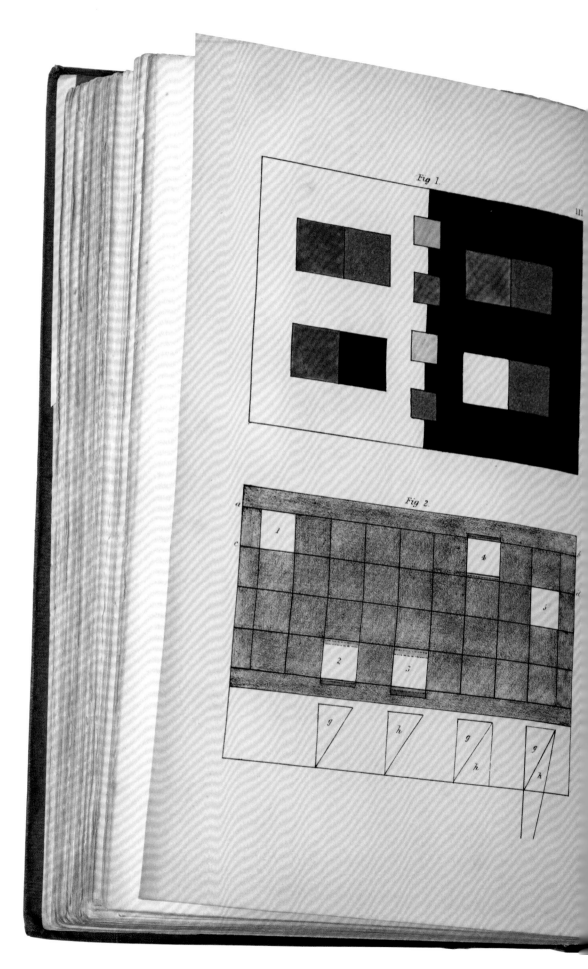

ROMANTIC IDEAS AND NEW TECHNOLOGIES: THE EARLY NINETEENTH CENTURY

260.

If we displace a coloured object by refraction, there appears, as in the case of colourless objects and according to the same laws, an accessory image. This accessory image retains, as far as colour is concerned, its usual nature, and acts on one side as a blue and blue-red, on the opposite side as a yellow and yellow-red. Hence the apparent colour of the edge and border will be either homogeneous with the real colour of the object, or not so. In the first case the apparent image identifies itself with the real one, and appears to increase it, while, in the second case, the real image may be vitiated, rendered indistinct, and reduced in size by the apparent image. We proceed to review the cases in which these effects are most strikingly exhibited.

261.

If we take a coloured drawing enlarged from the plate, which illustrates this experiment,* and examine the red and blue squares placed next each other on a black ground, through the prism as usual, we shall find that as both colours are lighter than the ground, similarly coloured edges and borders will appear above and below,

* Plate 3, fig. 1. The author always recommends making the experiments on an increased scale, in order to see the prismatic effects distinctly.

Left: Charles Lock Eastlake's translation of Goethe's *Farbenlehre, Theory of Colours*, was one of the books on color that Turner consulted. While Turner approves of Goethe's concept of polarities, his notes are peppered with short, critical and challenging comments, such as "what advance," "prove it," "this is doubtful" and many simple "nos."

Industrialism to Impressionism: The Later Nineteenth Century

Left: The beautiful dot formations from William Benson's *Principles of the Science of Colour* look like works of art in their own right, reminiscent of Damien Hirst's spot paintings, but they are in fact designed to illustrate the positions of the various colors on Benson's ambitious color cube. This is a photograph of a page from the original 1868 book (see pages 118-119), so the warping effect here is due to the impossibility of completely flattening the pages.

The latter half of the nineteenth century was a time of unprecedented technological advances and inventions that affected every aspect of life. The speed with which production methods, transport, fashion and ideologies were changing was breathtaking. Steam power, chemical processing, and eventually electricity changed the way people lived, worked and how things were produced. Cities expanded dramatically and quickly, while the manufacturing of goods was taking place on an ever-increasing scale as machine-production in factories continued to replace hand-production in smaller businesses. The Industrial Revolution, which had begun in the second half of the eighteenth century, reached an exciting, if sometimes threatening, peak.

The shift toward large-scale manufactured production also affected the worlds of color, art and print culture. On a material level new technologies meant that pigments could be produced in greater quantities, and the paint and dyes created from these pigments were applied using new, industrial methods. In 1851 many of these new inventions could be seen at the Great Exhibition of the Works of Industry of All Nations in the Crystal Palace in London. In many ways, the Great Exhibition was a showcase for the new age of mass production, consumerism and industry; and use and understanding of color were intrinsically linked to these developments. The great colorman George Field (see pages 60–67) gracefully declined to be involved on the grounds of advanced age, but a couple of his followers, the color researcher Mary Philadelphia Merrifield and the architect and designer Owen Jones, were invited to take part and contributed to the Great Exhibition.

In book publishing, illustrators were moving away from hand-colored metal-plate engravings toward lithography and multicolored woodblock printing, although hand-coloring continued to be employed when maximum accuracy and precision were desired, which was frequently the case with color diagrams and charts. The mechanical production of color illustrations arguably led to a high degree of diversification and fragmentation in writings and publications on color, but this was not necessarily a negative development: while we see far fewer examples of individually painted color diagrams, many books were produced in much higher print runs than a generation or two before and therefore became affordable to a much wider readership. Among them were some of the most striking examples of color literature ever published, such as the brilliantly executed lithographic plates by Day & Son in Owen Jones's *The Grammar of Ornament* from 1856, or

Books were produced in higher print runs and became affordable to a much wider readership

the 1850s and '60s editions of Chevreul's atlas of color circles, with engraver and printer René-Henri Digeon's spectacular plates, produced using a four-color aquatint printing process.

In the later nineteenth century, thinkers realized that colors can mix and influence each other optically as well as physically

In 1841 the American artist John Goffe Rand invented collapsible metal tubes for oil paints. The patent for the UK was quickly acquired by Winsor & Newton, who added the screw top to Rand's design, and other European companies. This may sound like a minor improvement, but being able to take a selection of paints with you without having to worry about first preparing them and transferring them to small bags made of pigs' bladders, instead simply squeezing moist color from a tube, had a profound effect on how and where painters worked.

The biggest impact of this development was felt in France when, from the 1860s to the close of the century, Claude Monet, Edgar Degas, Auguste Renoir, Camille Pissarro and a few other artists took their canvases outdoors and made light their subject. This was the birth of Impressionism. Working *en plein air*, the artists worked quickly, as was necessary to capture the fleeting effects of the sunlight. The resulting canvases were strangely rough in appearance, leading early critics to rubbish the new art movement. Indeed, the term "Impressionist" was first used as an insult, delivered by critic Louis Leroy after the group's 1874 Paris exhibition, implying that the artists offered only a sketch of a scene, rather than the full and developed artworks they were expecting. The characteristic rapid brushstrokes in dabs of pure hues that give the Impressionist paintings their "unfinished" look was, however, integral to the artists' aims.

The artists were responding to their situation, accurately translating in paint what they observed with their eye, and benefitting from the new, artificial and ready mixed colors that were ever more available as the century progressed. The extent to which they were also directly responding to the color theories of the time has been contested, but it is certain that the work of the Impressionists aligns with the prevailing ideas about color of the time. In earlier centuries, writers on color typically focused on either material or immaterial color, frequently seeming to muddle the two, as though the different and contrary aspects of material/immaterial color were a circle they were trying to square, and they couldn't quite make sense of how they should or could work together. In the later nineteenth century, however, we begin to see a fusion as thinkers realized that colors can mix and influence each other optically as well as physically. The optical effects of color became the predominant concerns for thinkers like Michel Eugène Chevreul and Ogden Rood, and the Impressionists too were experimenting with the application of color toward producing convincing representations of light.

Color was beginning to truly infiltrate art—and it was only the beginning.

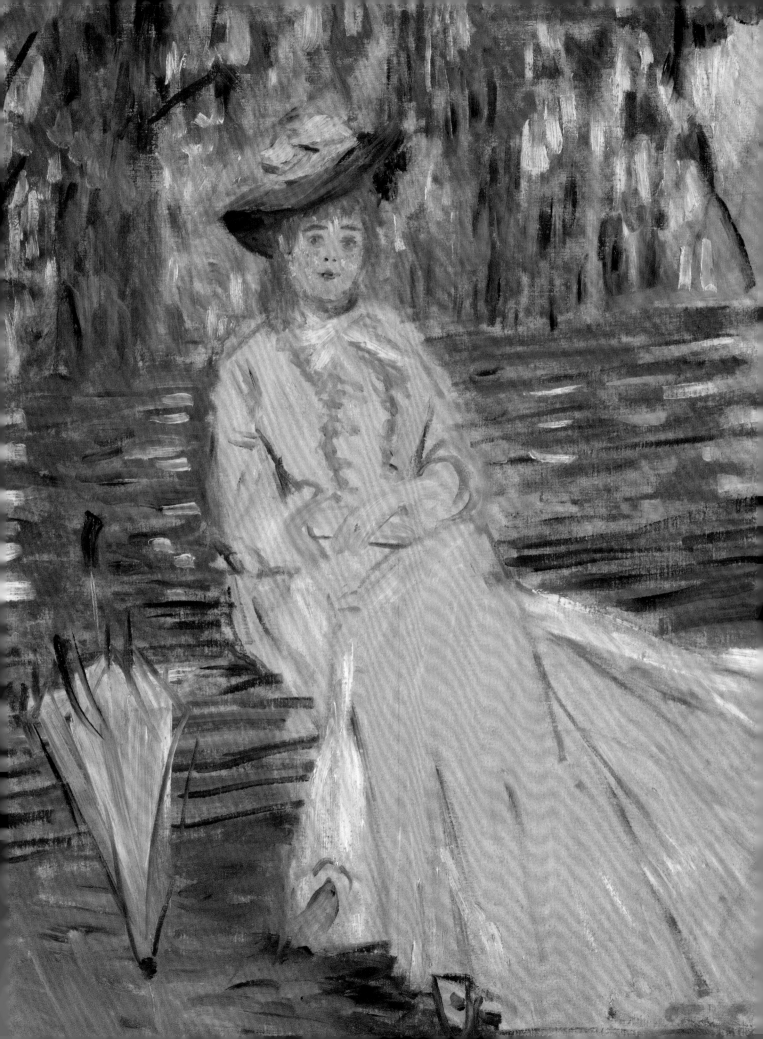

Into Darkness: M. E. Chevreul's Beautiful Science

The French chemist Michel Eugène Chevreul was the most important and influential European color theorist of the later nineteenth century and his publications on color contain some of the most ambitious and beautiful illustrations of the period. In the early nineteenth century he had been the assistant of Louis Nicolas Vauquelin, the Professor of Chemistry at the Museum of Natural History in Paris, who had invented a number of new pigments and dyes, including Chrome Yellow. He later succeeded Vauquelin in his role as Professor of Chemistry. In the 1820s Chevreul was employed by the Gobelin tapestry factories to investigate the quality of dye materials and problems concerning the lack of brilliance in the color schemes of the woven tapestries. Chevreul realized that it wasn't the quality of the dyestuffs that had resulted in a dullness of the appearance of some designs, but the way in which colored strands of wool were combined and placed close to each other. It was here that he formulated his "laws of simultaneous contrast" that would influence and inspire designers, artists, scientist, architects and manufacturers as no other theory since Newton's had done before. Unlike most other color researchers, he was concentrating on how

Above: One of the many impressive color plates from the *Atlas* that accompanied Chevreul's *De la loi du contraste simultané des coleurs* from 1839. This diagram shows the effect that neutral tones—the backgrounds and the gray and black dots—have on the appearance of the colors.

colors were perceived by humans, rather than their material aspects: "In the case where the eye sees at the same time two contiguous colors, they will appear as dissimilar as possible."

In 1828, a lecture at the Academy of Science in Paris on how colors enhance or diminish each other depending on how they are combined brought Chevreul renown throughout Europe. He finally published his findings in his main work, *De la loi du contraste simultané des couleurs* (*The laws of simultaneous contrast of color*) in 1839. Within a year it was translated into German, and an English edition was published in 1854 under the title *The Principles of Harmony and Contrast of Colours, and Their Applications to the Arts: Including Painting, Interior Decoration, Tapestries, Carpets, Mosaics, Coloured Glazing, Paper-staining, Calico-printing, Letterpress Printing, Map-colouring, Dress, Landscape and Flower Gardening, Etc*. The lengthy title of Chevreul's book in its English edition makes it clear that his main aim was always to make color

theory applicable to a wide range of disciplines and areas of creative use of color. The usefulness of his work is one of the main reasons for his success.

The first edition of *De la loi du contraste simultané des couleurs* comprised an impressive 735 pages of text, making it the most comprehensive treatise on color since Goethe's *Farbenlehre*. It was accompanied by an *Atlas* of illustrations with around 40 plates, many of them colored and some folding out to three times the width of the atlas, like the one above, depicting an "assortment of the simple and binary colors of artists with white, black and gray." They include relatively simple lithographed plates showing contrasts of light and dark and a number of colored circles of hues influencing each other when placed together. Chevreul introduces an uncolored 72-part chromatic circle (overleaf), based on the subtractive trichromatic system of yellow, blue and red as primaries. This has a flap added along its radius, which can be lifted to indicate the amount of black in each tint, a ten-part achromatic grayscale. It was an

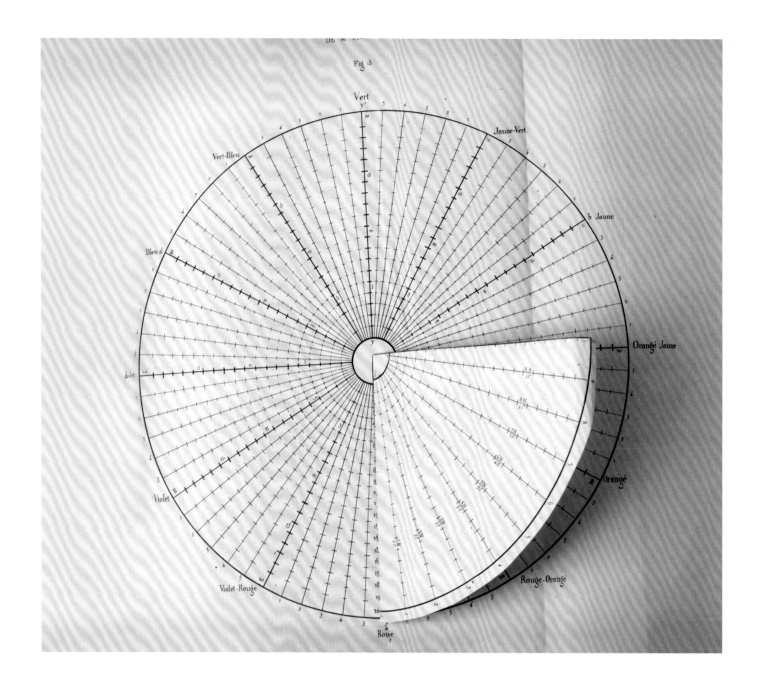

Above & opposite:

Some of the plates from the 1839 *Atlas*, including Chevreul's 72-tone color wheel with a pop-up flap, the first plate showing rectangles of light and dark grays, a seemingly random elliptical arrangement of flowers to illustrate color harmony, and one of two plates illustrating basic color interaction.

effective way of creating a three-dimensional color model in two-dimensional print format.

On other plates Chevreul shows hundreds of colors in the shape of small disks, grouped to illustrate color contrasts and harmonies. These are shown against different colored backgrounds and painted by hand, on heavily inked lithographed plates. The 1839 *Atlas* is a most meticulous and experimental exploration of Chevreul's laws of color contrast, expressed in the still relatively young print medium of lithography, combined with hand-coloring.

Above: One of the huge fold-out plates from Chevreul's 1861 *Atlas*, the "spectre solaire" presents the visible spectrum. A disclaimer at the top right corner of the plate notes that Chevreul can vouch for the accuracy of only fifteen of the colors, those marked with dotted lines down to the base.

M. E. CHEVREUL ne peut répondre que de l'exactitude de 15 couleurs, à savoir:
Le rouge, le 5.^e rouge, le 4.^e rouge-orangé, le 5.^e orangé, le jaune, le 4.^e jaune, le jaune-
vert, le 3.^e jaune-vert, le vert, le 3.^e vert, le 3.^e vert-bleu, le bleu, le 2.^e bleu, le 5.^e bleu
et le bleu-violet __ Ces couleurs sont distinguées des autres par des points...

The Atlas

Visually and technically, a later and larger edition of an atlas illustrating Chevreul's writings on color is one of the most sophisticated and impressive publications on color ever printed. In 1855 Chevreul began working with the gifted engraver René-Henri Digeon, who created color wheels and other color plates for Chevreul, using the 1839 chromatic circle as a guideline. They published a large volume set of color plates together, the *Cercles Chromatiques de M. E. Chevreul*. In 1861 the *Atlas* was published again as *Exposé d'un moyen de définir et de nommer les couleurs (Proposal for a way of defining and naming colors)*, as an addition to the 33rd volume of the *Mémoires de l'Académie des Sciences, Paris*, and once again on its own in 1864, under the title *Des couleurs et de leurs applications aux arts industriels à l'aide des cercles chromatiques (On colors and their applications to the industrial arts with the aid of chromatic circles)*.

In the 1861 edition, shown here, the large-format *Atlas* contains twelve graded color circles, engraved and printed in color by Digeon (see overleaf). A preceding vertical fold-out plate, *Couleurs d'un Spectre Solaire* (above), displays the full prismatic spectrum of visible colors on a linear diagram against a dark background and can be used as a standard or reference for the hues found on the circles. Another plate with three columns of blue, *Gamme chromatique bleu*, acts as an example of the gradation according to the amount of white and black in it. In the 1864 edition of the *Atlas*, many more *gammes de couleurs* were included. But the most important element of the *Atlas* is Digeon's group of magnificent full-page color circles. The first two show the pure colors at their brightest stage, one with and the one without the division into 72 sections that is included in the other circles. The following ten circles show the development from this state of maximum brightness to almost complete darkness, with an increasing addition of black to the tints. They offer a detailed visualization of that first pop-up color wheel from the 1839 edition. The last few circles show astonishingly subtle shades of gray and black, with just a suggestion of color in each of them. The total number of tints in these color wheels is 14,420, which makes these plates masterpieces of color-printing in the later nineteenth century.

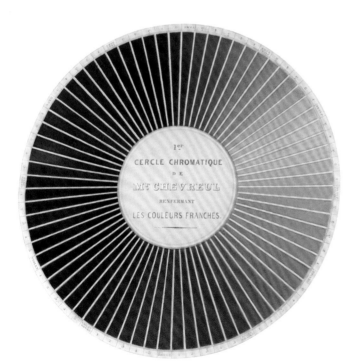

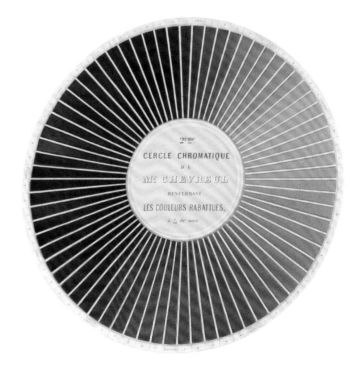

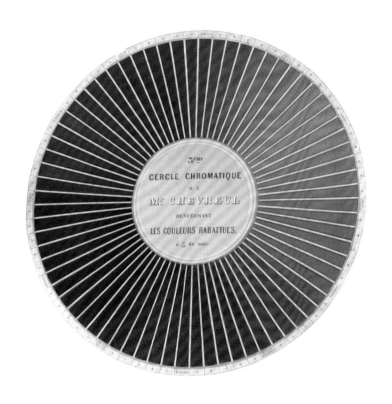
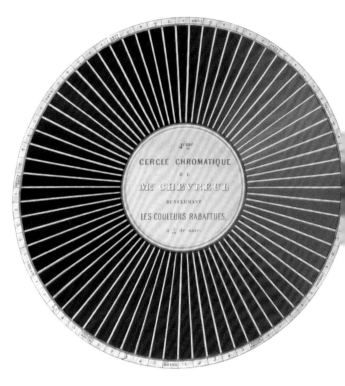
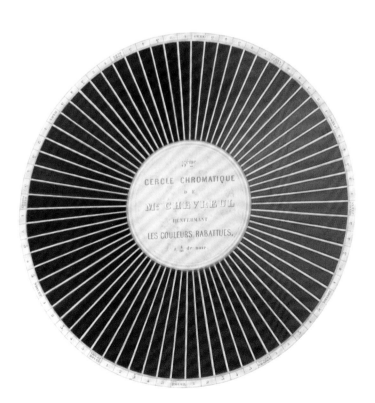
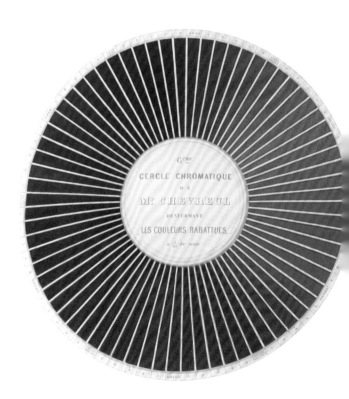

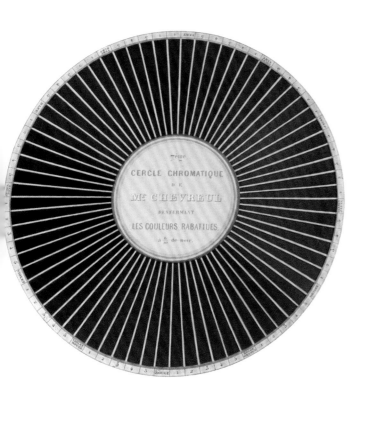

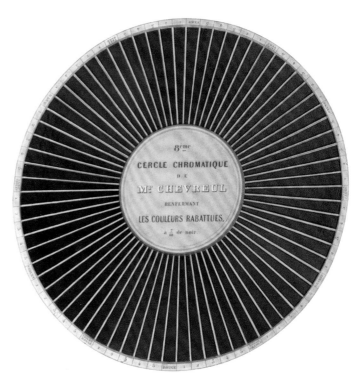

From Science into Art: Chevreul and the Birth of Impressionism

Chevreul's work had a profound influence on many painters in the later nineteenth century, especially among the Impressionists and Post-Impressionists, who compared the use of strands of dyed wool to the application of brush strokes on a canvas. The French artist Georges Seurat was particularly interested in how colors blend optically. He studied Chevreul and other color theories carefully, even copying out passages from their texts, and adopted their ideas into his practice by placing small strokes or dots of largely pure pigments next to each other in sometimes very large compositions. The method is often called Pointillism or Divisionism, but Seurat himself preferred the term "chromo-luminarism."

His paintings and his surviving palettes are a reflection of Seurat's interest in optics. Nearly all of his paintings are concerned with the changing appearance of light and color in landscapes with figures. At least one of the many studies for his famous *Bathers at Asnières* includes a rainbow, possibly in reference to Newton, or perhaps more generally to optical studies and how they translate into painting. Seurat's working palettes seem to reflect his methodical approach to color arrangement. On at least one of his palettes the paints are arranged in an orderly fashion along the upper edge of the square palette, in a range from dark greens and blues via reds to yellows. Each color has been mixed carefully with white, descending halfway down the palette in brightness. A small blot of white lead paint is placed like a marker for brightness in a neat line under every color, similar to many of his remarkably geometrical compositions, such as the one depicted here.

This painting by Seurat entitled *Seascape (Gravelines)* from 1890 clearly shows that the artist experimented with the optical blending of pure color by means of placing distinguishable blots next to each other. Here Seurat even includes the frame in his composition and, as is typical of the Impressionist style, avoids the use of black entirely. Shades and darker areas, of which there very few, are created by color alone, with the main focus being on the depiction of light.

Opposite: Seurat's 1890 painting, *Seascape*, transposes Chevreul's dots into a landscape painting that draws strongly on the optical color ideas explored in Chevreul's oeuvre.

A Poet's Philosophical Color Categories

Ten years after Michel Eugène Chevreul's groundbreaking work on color contrast *De la loi du contraste simultané des couleurs*, in 1849 another Frenchman, the relatively unknown J. C. M. Sol, published a short (61 pages) treatise on how optical theory could be applied to painting. The resulting *La palette théorique: ou, Classification des couleurs (The theoretical palette: or, Classification of colors)* was never translated from French into any other language and in academic circles it has been described as an incomplete color system, but it is a good example of Chevreul's influence on color literature. Sol's approach is both logical and subjective. In his various categorizations of color he applies characteristics such as "sad" and "attractive" to colors, as well as ordering them in accordance with Immanuel Kant's "table of judgments"—the concept of how we think about and understand objects according to categories such as "quality," "relation" and "modality," as first formulated in 1781 in *Kritik der reinen Vernunft (Critique of Pure Reason)*.

This integration of diverse concepts into color theory is highly reminiscent of Johann Wolfgang von Goethe's approach (see pages 42–45). Sol is known to have tried (and failed) to obtain a copy of Goethe's *Farbenlehre* and it is obvious that he was following the critical discussions concerning the German poet's color theory. Like Goethe, Sol is critical of Isaac Newton and, incidentally, he also published poetry.

His short treatise, derivative and incomplete as it may be, stands out with regard to an unusually large plate that illustrates his proposed color categories. In the style of maps often found in many eighteenth- and nineteenth-century publications, the plate is tipped in at the back of the book and unfolds to a sheet measuring 46.5 x 65 cm, more than double the size of the book's print block. The lithographed plate contains linear tables, charts and a starburst diagram, with tints depicted as small disks, colored by hand. Sol's idea was perhaps similar to Newton's more than 130 years earlier: that the reader could consult the fold-out sheet while reading the main body of the text. The example shown here is inscribed and signed by Sol in the top right corner.

LA PALETTE THÉORIQUE

ou
CLASSIFICATION DES COULEURS.
par J.-C.-M SOL.

Comme un gage de l'amitié de l'auteur à M. Victor Guilmer.

Tableau Synthétique

1re Catégorie	2ème Catégorie			3ème Catégorie				
Sphérus	Couleurs connéxitives.			Teintes Hybrides.				
principe vierge	Primaire	Binaire	Ternaire	Les primaires et le blanc combinés	Les binaires et le blanc combinés	Le ternaire et le blanc combinés	Les nuances d'ordre ternaire et le blanc combinés	
1re Colonne.	2ème Colonne.	3me Colonne.	4e Colonne.	5e Colonne.	6e Colonne.	7e Colonne.	8e Colonne.	9e Colonne.

2e Catégorie. Nuances d'ordre ternaire.

2e Catégorie
Nuances d'ordre binaire.

3e Catégorie
Nuances d'ordre hybride.
(trois exemples.)

I Nuance initiatrice
NN Nuances
TT Termes de l'évolution de la nuance.

A Woman Travels in Search of Color

Opposite: Regrettably, Merrifield's works on color and painting techniques are only sparsely illustrated with a few line engravings or monochromatic lithographs— as was usual for small handbooks on painting practice. However, the engraving and decorated initial letter adorning the beginning of her essay for the 1851 Great Exhibition are delightful takes on the common motifs of painters' palettes and rainbows, representing color as a source of inspiration and creativity.

Until well into the twentieth century, few women published works on color; Mary Gartside was one of them (see pages 50–53). Born around the time Gartside was first publishing, Mary Philadelphia Merrifield left a significant mark on color research and literature in the nineteenth century. It is not known how Merrifield acquired her education at a time when it was not possible for women to attend university, but, like Gartside, she must have moved in sufficiently privileged circles to receive a solid home education and be able to pursue self-directed study at her leisure. There are some examples of women participating in scientific research in the eighteenth and nineteenth centuries, but it is notable that their methods tend to be observational rather than experimental, and frequently, as we have seen in Gartside's case, their publications took the form of artistic manuals for other middle- or upper-class ladies, rather than serious scientific treatises. Merrifield's work falls partly into the latter category, although she obviously enjoyed not only financial freedom but also an unusual level of support, both morally and practically, from her husband and children. Merrifield is best known for the first English translation of Cennino Cennini's *Libro dell'arte* (*A Treatise on Painting, Written by Cennino Cennini in the Year 1437*), published in 1844. In it she refers to the famous colorman George Field, and praises the high quality and permanence of his pigments. Following the success of her translation, Merrifield was promptly commissioned by Prime Minister Robert Peel's government to travel to France and Italy in order to identify and transcribe medieval and Renaissance manuscripts on color, and research the make-up of early pigments and Italian methods of painting. The trip resulted in several important publications, including *Original Treatises, Dating from the XIIth to XVIIIth Centuries on the Arts of Painting* (1849).

Although Merrifield is best known for translating historical color literature, she also wrote about the color theory as applied to art and architecture, for example a critical essay about Owen Jones's color scheme for the interior of Joseph Paxton's Crystal Palace, site of the Great Exhibition of Industry of All Nations, in 1851. The essay was titled "The Harmony of Colours as Exemplified in the Exhibition," suggesting that Merrifield was responding to ideas about color and color arrangement developed a generation earlier. In the essay she not only explains Jones's scheme but also touches on ways in which shapes and objects in interior design influence the use of color and choice of pigments. She concluded that the same principles apply to painting a picture and designing an interior or decorative objects:

> *The attainment of a good and harmonious style of colour in painting is the result of much observation and study, not only of nature, but of the works of other artists: the same steps must be followed in Art-manufactures, or the same results will not be attained. When the principles by which the harmony of colour is regulated are clearly understood, they are easily carried into practice.*

From the early 1850s, Merrifield also authored several guidebooks giving practical advice on painting and drawing in a series published by Winsor & Newton, including one titled *Light and Shade*—perhaps in reference to Gartside's first publication on color. In these books she condensed her remarkable knowledge of many aspects of color, gained largely through self-directed study and observation. These books went into many editions and were still being reissued by Winsor & Newton after her death. In fact, some of them are still in print now. Like the posthumous shorter and smaller editions of George Field's works on color, they are typical examples of concise and affordable handbooks on art that began to appear in the mid-nineteenth century and appealed to a large readership.

The Harmoury of Colours as exemplified in the EXHIBITION

By Mrs. MERRIFIELD.

George Barnard
Cuts Up Pages

George Barnard was a British drawing teacher whose intention was to provide a comprehensive and richly illustrated guidebook about the art of painting landscapes in watercolor for amateur artists as well as students of art. His substantial *The Theory and Practice of Landscape Painting in Water-Colours* was first published in 1855 and contains 69 small woodcuts and 30 high-quality colored lithographs using the Leighton Brothers' "Chromatic Process." George Cargill Leighton had been trained by the printer George Baxter and greatly improved Baxter's highly successful method of multicolored printing combining a variety of inks, colors and printing plates.

Many of the images in the book illustrate the different stages of picture composition and execution, but there are also several plates on the basics of color theory. One, for example, shows the prismatic range against a dark background and another one visualises the principle of primary, secondary and tertiary colors by means of overlaid strips of color (see overleaf). As this plate suggests, Barnard's s color system is firmly material—relating color always to the mixing of pigments. The color diagrams he included are relatively simple in design but printed with heavily inked plates, which gives them a marked solidity and glossiness.

In the diagram on the opposite page, Barnard has arranged "twenty-five of the most useful pigments" in a diamond formation. The diagram was designed as a more schematic alternative to the paintbox depicted in a woodcut on the book's preceding page (above), having "an order approximating to that which [the pigments] occupy in the box, and at the same time extended in such a manner as to present to the eye, at one view, an harmonious arrangement of colours." Greens are noticeably absent in the diagram. Although essential in the genre of landscape painting, they would have been mixed from high-quality yellows and blues like those included at the top and bottom of the diagram.

It is significant that Barnard places this image not in the opening chapter on "The Nature of Colour" but in the second, on "Materials," stressing the applicability of color theory to the painter's art. Order and a systematic approach to tools are advocated by Barnard: "The pigments should always occupy the same position in relation to each other, in order that there may be no hesitation in dipping the brush into the colour required."

Barnard dedicated the second edition of his book (from 1858, pictured on these pages) to the great scientist Michael Faraday, who had discovered the effects of magnetism on light and created the first

Above & opposite: The diamond-shaped diagram seen opposite is a graphic representation of a paintbox ordered harmoniously, as seen in the woodcut illustration seen above.

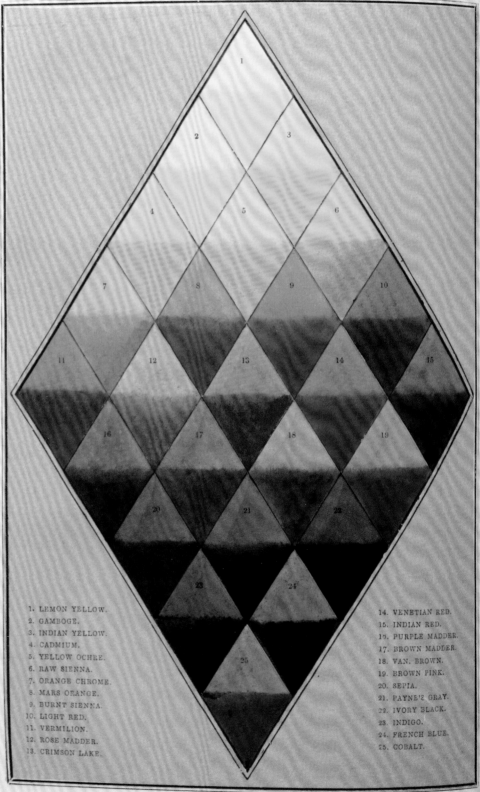

1. LEMON YELLOW.
2. GAMBOGE.
3. INDIAN YELLOW.
4. CADMIUM.
5. YELLOW OCHRE.
6. RAW SIENNA.
7. ORANGE CHROME.
8. MARS ORANGE.
9. BURNT SIENNA.
10. LIGHT RED.
11. VERMILION.
12. ROSE MADDER.
13. CRIMSON LAKE.

14. VENETIAN RED.
15. INDIAN RED.
16. PURPLE MADDER.
17. BROWN MADDER.
18. VAN. BROWN.
19. BROWN PINK.
20. SEPIA.
21. PAYNE'S GRAY.
22. IVORY BLACK.
23. INDIGO.
24. FRENCH BLUE.
25. COBALT.

LEIGHTON, BROTHERS.

PLATE 4.

Above: Simple overlaid translucent strips neatly demonstrate the principles mixing primary colors and secondaries.

Opposite: Reminiscent of Mary Gartside's color blots, Barnard includes a plate showing the effects of combinations of colors on each other.

Overleaf: A plate faced with a blank page, cut horizontally in half, allows the reader to view one part of the plate at a time, or both at once, in order to better compare the effects of the contrasts that the plate depicts.

electric current, thus paving the way for the new age of electricity. Barnard's interest in science, research and theory is obvious in his writing. He was strongly influenced by George Field, whose pigments he praised, as well as the Scottish physicist David Brewster, who had experimented with polarized light and in 1816 invented the kaleidoscope; the mathematician and astronomer John Herschel, who had been researching colorblindness and experimented with early photography; Johann Wolfgang von Goethe and Michel Eugène Chevreul. Goethe's and Chevreul's main works on color had been published in English translation in the years before Barnard wrote his book. He may also have been one of the few writers who were influenced by Mary Gartside's lesser-known color blots in her *Essay on Light and Shade* (see pages 50–53), as a plate of "Contrasts of Colour" (opposite), illustrated with twelve abstract blot-like images, might suggest. Barnard's blots are one of several plates in a chapter "Contrasts of colour." They show the effects of colors placed together in a number of combinations, beginning with "the simplest of contrasts" of black and white in figure 1 and graduating to more complex ones

comprising black, white and secondary (figs. 7, 8 and 9) and tertiary colors (figs. 10, 11 and 12). Their main purpose is to encourage students "to make experiments from which he may draw inferences by himself," meaning to create similar sample color combinations in the preparation of a painting.

Two plates in the same chapter illustrate simultaneous color contrasts and here Chevreul's influence is particularly obvious. Each plate depicts a gray ornamental shape against two different colored backgrounds. The plates are overlaid with a blank page that has been cut horizontally in the middle, so that the reader can look at each color combination in isolation as they carry out simple experiments that show how the appearance of the gray shape changes in tone when seen against either blue, yellow, orange or green. The neutral gray appears in the complementary color to the one in the colored background. In the example shown overleaf, an orange background makes the gray appear blue and a green background results in a reddish gray figure.

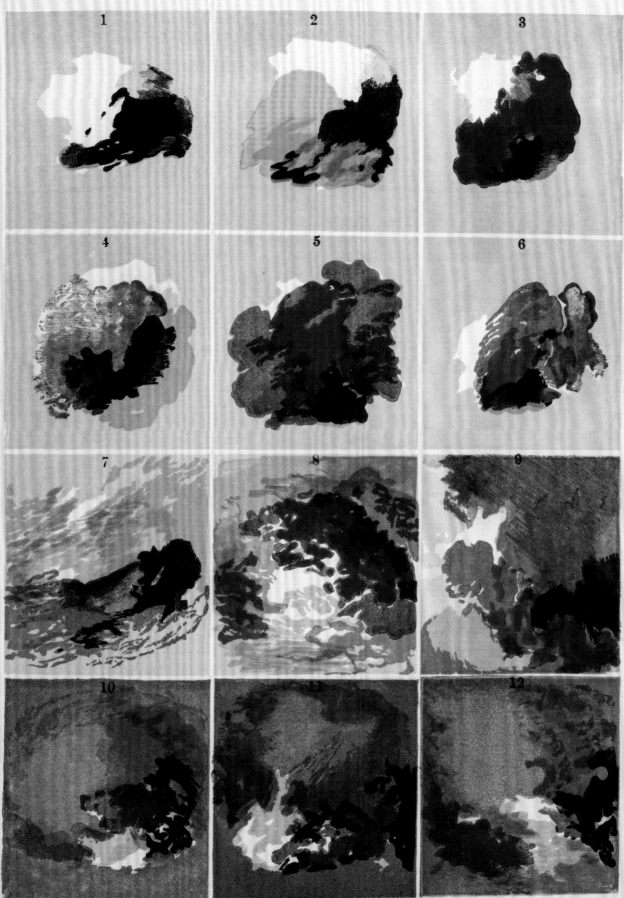

CONTRASTS OF COLOUR.

PLATE 26.

3

ORANGE CAUSES THE GRAY TO APPEAR BLUE.

4

GREEN CAUSES THE GRAY TO APPEAR RED.

LEIGHTON, BROTHERS.

PLATE

It would be as well, in experimenting upon these contrasts in large, to place one of the figures cut out of the same gray paper on a ground of white, that it may be used as a reference, and the real colour of the figure may be seen. In the accompanying plates the neutral gray is exactly the same in each diagram, being printed with the same colour. In Plate 29, Fig. the ground colour is yellow; the neutral gray will in this case appear or purple. In Fig. 2, the blue ground will cause the gray t golden orange, although the tone of the complementary c deducts from the distinctness of the Fig. 1, the ground being orange, the figure appears red. ground being green, the figure appears e tried on a large scale, the complement round the edge of the figure; and it colour approaching in some de matic spectrum.

Carrying out t gard to t

and is almost ly painted panorama

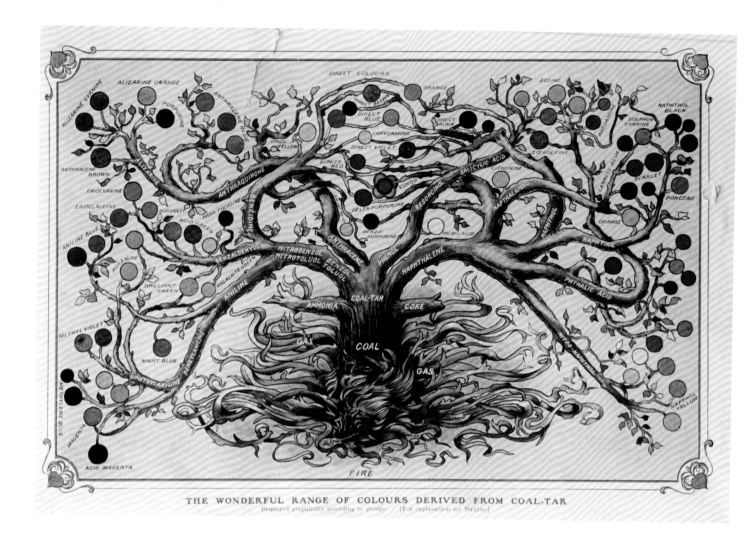

THE WONDERFUL RANGE OF COLOURS DERIVED FROM COAL-TAR
Displayed graphically according to groups (For explanation see Dyeing)

Trees and Butterflies Represent Latest Color Advances

In 1856 the eighteen-year-old aspiring London chemist William Perkin discovered a dye color that would change the face of fashion and the textile industry. In his quest to derive quinine—a possible medicinal cure for malaria—from coal tar, he stumbled across an aniline substance that turned fabrics a brilliant purple. He called it mauveine, but it was also known as Perkin's Mauve. The inventor had it patented, and the color quickly became hugely popular and was produced commercially on a large scale in the later nineteenth century. It was effectively the first synthetic, inorganic dye, composed of carbon, hydrogen and nitrogen, and it was an excellent substitute for expensive natural purple dyes, such as Tyrian purple, which was made

from sea snails. (Incidentally, Perkin called his new color Tyrian purple for a while.) Coal tar, a gooey dark substance, was available in great quantities in Victorian London, as it was a waste product from coal gas street lighting. Mauveine became such a popular color in fashion that a deep shade of it was even used as an alternative to black in mourning dress, after the period of wearing black clothes for the first year after the bereavement (as was proper) had finished.

Mauveine was only the beginning. By the end of the nineteenth century many more dye colors had been created from coal tar, which is one of the reasons why we see so many intensely colored dresses and other textiles in the later Victorian period. This image (left)

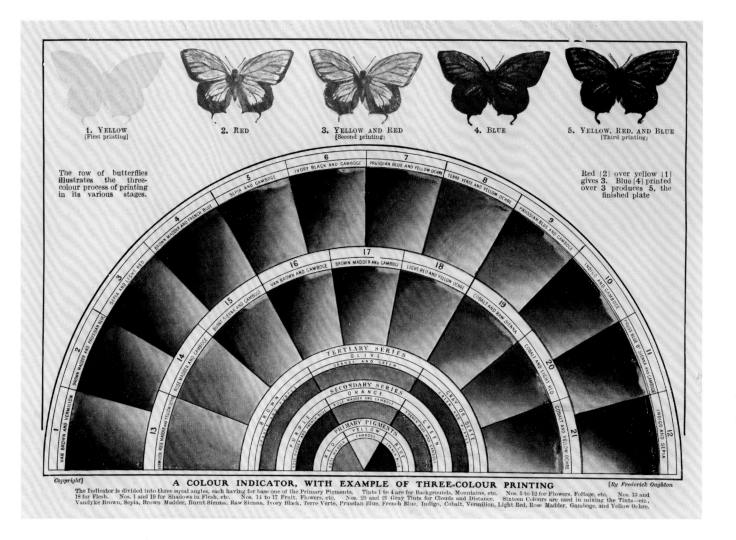

1. YELLOW
[First printing]

2. RED

3. YELLOW AND RED
[Second printing]

4. BLUE

5. YELLOW, RED, AND BLUE
[Third printing]

The row of butterflies illustrates the three-colour process of printing in its various stages.

Red [2] over yellow [1] gives 3. Blue [4] printed over 3 produces 5, the finished plate

[Copyright]

A COLOUR INDICATOR, WITH EXAMPLE OF THREE-COLOUR PRINTING

[By Frederick Oughton]

The Indicator is divided into three equal angles, each having for base one of the Primary Pigments. Tints 1 to 4 are for Backgrounds, Mountains, etc. Nos. 5 to 12 for Flowers, Foliage, etc. Nos. 13 and 18 for Flesh. Nos. 1 and 19 for Shadows in Flesh, etc. Nos. 14 to 17 Fruit, Flowers, etc. Nos. 20 and 21 Gray Tints for Clouds and Distance. Sixteen Colours are used in mixing the Tints—viz., Vandyke Brown, Sepia, Brown Madder, Burnt Sienna, Raw Sienna, Ivory Black, Terre Verte, Prussian Blue, French Blue, Indigo, Cobalt, Vermilion, Light Red, Rose Madder, Gamboge, and Yellow Ochre.

Left: The "wonderful range of colours derived from coal tar" is depicted on an elaborate family tree.

Above: Not only does this plate show the effects of color mixing, but the dial-shaped diagram that encompasses it also advises on the appropriate uses of the tints—for "Backgrounds, Mountains, etc." (1–4), "Flowers, Foliage, etc." (5–12), "Flesh" and "Shadows in Flesh, etc" (13 and 18, and 1 and 19), and so on.

from a late-nineteenth-century encyclopedia shows "the wonderful range of colours derived from coal-tar" in the shape of a tree. The tree motif may allude to the origin of the raw material coal in fossilised plant matter. Allowing the artist to depict colors in their chemical "families," the inspiration for this kind of depiction may alternatively have been images of evolutionary trees or diagrams of taxonomical classification that were popular at the time. But either way, it is also simply an image that expresses the excitement of all these brilliant and relatively cheap new colors.

Another colored plate (above) from the same encyclopedia revels in new developments in color printing. Here the designer, Frederick Oughton, has used the image of a butterfly to graphically illustrate the various stages of three-color printing. Underneath

is a simple but effective semicircular "colour indicator," which shows the three primaries red, yellow and blue at the base, from which their secondary and tertiary mixtures fan out, followed by 21 further mixed tints on the semicircle's outer perimeters. The indicator is divided into three equally proportioned angles created from each primary color at the base. The caption advises on which tints to employ for specific uses and areas of an image. As in many eighteenth- and nineteenth-century color manuals, pigments have been assigned to every tint, in order to make this diagram a practical tool for paint mixing in printing and painting. Beginning with gamboge for yellow, rose madder for red and French blue (an artificial ultramarine) for blue, the outer mixed tints are created, for example, from Prussian blue and brown madder, or terre verte and yellow ocher.

Ornamental Color for Cosmopolitan Tastes

Owen Jones was the designer and architect responsible for the interior polychromatic color scheme of the Great Exhibition in 1851. In 1856 he further left his mark on contemporary taste with the publication of his *The Grammar of Ornament*. This lavish and expensive volume of design patterns contained 122 chromolithographed plates by royal lithographers Day & Son and reflected the tastes, as well as production methods, of the Victorian era. Many of the largely geometric, flat and brightly colored designs were inspired by Jones's travels in Greece, Italy, Spain, Turkey and Egypt, giving many of the designs an exotic and oriental feel. Although not strictly a book on color, it is a masterpiece in color reproduction and a mirror to the fast-changing tastes and production methods in the age of steam power. In turn, *The Grammar of Ornament*—which has never gone out of print since its first publication—was an inspiration for other writers and designers.

Sir John Gardner Wilkinson's *On Colour and the necessity for a General Diffusion of Taste among all Classes* was published just two years after *The Grammar of Ornament* and its colored illustrations (see overleaf) bear a striking resemblance to the plates in Owen Jones's design sourcebook. The book's smaller, uncolored illustrations are woodcuts, while its eight colored plates are lithographs, executed by West & Co. At least three of the lithographs were carefully hand-colored. One must assume that author and publisher wanted to achieve the best possible color representation and ensure that they resembled the high-quality lithographs produced by Jones and Day & Son.

Wilkinson was primarily an Egyptologist who had traveled widely and published many early books on the study of Egyptian culture. He also had a general interest in antiquities and was a collector of Greek vases, which explains his familiarity with aspects of historic design and ornament, including architecture, interiors and garden design.

The subtitle to Wilkinson's book, "With remarks on laying out dressed or geometrical gardens," explains the stylistic similarities to *Grammar of Ornament*. Formal layouts of ornamental gardens and multicolored flower beds are depicted in all the colored plates as abstract shapes and arrangement. At the beginning of the nineteenth century the landscape designer Humphry Repton (see pages 46–47) had discussed the impact of

This page & opposite:

Plates from Jones's influential The *Grammar of Ornament* (first published in 1856), including the luxurious title page (top) and plates depicting Turkish style (bottom) and Medieval motifs (opposite).

Above left: For a gardener, Wilkinson includes surprisingly little green in the design on the frontispiece to his book. The intention is to show "how green may be used to light up other colours."

Above right: A geometric pattern showing the layout of seven colors, offered as an example of harmonious color proportions. Like the frontispiece, this plate demonstrates how little green is needed to make other colors seem more vivid.

color theory on garden design, but more in respect of light effects, including reflections in water and the use of colored glass, in garden architecture. Wilkinson, on the other hand, applied geometrical color designs to equally geometrical flower beds, much like coloring in a flat sheet. Whereas Repton had considered the many subtle varieties of green created by careful planting of shrubs and trees, Wilkinson did not follow in this Picturesque manner, noting that "artificial grounds can never resemble nature." He included very little green in his actual garden designs, focusing instead on brightly colored flowers, stressing the importance of "proper selection of the colours for harmonious combinations," of which he gave many examples in the last section of his book. Here, green is merely the ground color to his principal colors blue, red, scarlet, pink, purple, lilac, yellow, orange and white. But this also being a book about taste in general, he explains his dislike of green in other areas: "I have

been particular in censuring the common error of introducing great quantities of green into coloured ornamentation . . . It abounds when people become artificial. But in those periods when taste in colour was pure, the primaries were always preferred." A traditionalist at heart, Wilkinson's comments on green may well have been caused by the numerous green pigments and dyes that had recently been invented, which were used lavishly in wallpaper design and fashion.

The frontispiece of his book (above left) shows a geometric design in red, blue, white, black and green, intended to illustrate how a small amount of one color can brighten other colors. The design itself was inspired by the border ornaments of Giotto's fourteenth-century frescos in the Scrovegni Chapel in Padua, Italy.

Plates II and III, shown opposite, are the most interesting in the book with regard to general color order, since they show arrangements of principal

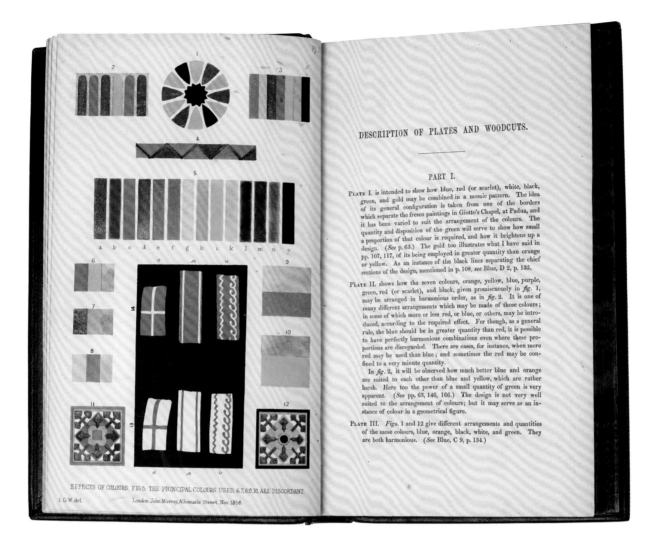

colors, referencing a variety of cultures and styles, including Egyptian and Jewish, similar to Owen Jones's approach.

Plate II (opposite, right) is the one where the pattern, in respect of the proportional arrangement of colors, most resembles Jones's ideas of color in design. Here, and in some of the following diagrams, Wilkinson roughly follows the Newtonian seven-color spectrum, with black replacing indigo. However, his aim is not to provide one all-encompassing color diagram that represents his color theory. The focus is always on the combination of and quantitative relation between colors, whether there are three or seven or more. Again, Wilkinson's notes remark on how a small amount of green brightens the whole design. This is one of the plates colored by hand in thickly applied watercolor. Plate III (above) shows twelve examples of harmonious or discordant combinations of principal colors, omitting any intricate patterns. What is

interesting is that he also includes examples of "discordant" color combinations (figs. 6, 7, 8, 9 and 10 on this plate). This "how not to arrange your design patterns" is conceptually related to Repton's method of showing his client a dull and uninspiring image of their gardens before his proposed improvement.

Wilkinson discusses many other aspects of color, design and taste, and the book is a curious but interesting mixture of philosophical musings, practical advice on color combinations, color in classical antiquity and applied to contemporary architecture and design.

Immaterial to Material: Bridging the Gap between Science and Art

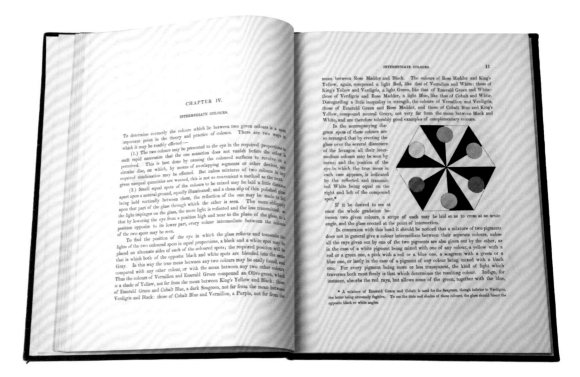

Right: The purpose of this striking and playful-looking diagram is to allow the reader to discover the "intermediates" between any two colors, using a piece of glass to reflect one spot on top of another.

Opposite, top: Benson's color cube is a complex and comprehensive device that visualises his primaries (red, blue and green) at three corners of the cube, with the addition of black, and his secondaries (seagreen, pink and yellow) at the opposite three corners, along with white. On every face, edge and connecting axis are every variation and gradation in between.

Opposite, bottom: Although the cube is intimidating in its complexity, the five plates illustrating the colors found at various sections of it are of an elegant simplicity.

In 1868, the London-based architect William Benson published *Principles of the Science of Colour*. Benson stressed the scientific nature and basis of the book—which was dedicated to the physicist and mathematician George Gabriel Stokes, who had researched fluorescence and ultraviolet light—while aiming to create a color system that could also be a useful tool in art and design.

Benson's book focuses on material color—his intention was to help artists to understand "beautiful" color arrangements—but he was also concerned with how we translate what we see into physical form; that is, a painting. His color system was, therefore, based on immaterial color. In this system, red, green and blue become primaries, yielding the secondaries and complementaries seagreen, pink and yellow. These colors are illustrated (above) as disks on a hexagon against a split black-and-white background.

From these colors Benson developed a complex model to illustrate his system, which was clearly informed by his work as an architect: a tilted "Cube of Colours" (opposite top). He was the first color theorist to introduce a cube design to represent a "natural system of colour," although he does note that it was

inspired by a system described in Herschel's *Treatise on Light* from 1830. He also acknowledges Philipp Otto Runge's proposed color globe from 1810 (see page 144) and Chevreul's efforts. The "Cube of Colours," depicted early in the book, is uncolored, but the location of tints and their mixtures are indicated by letters and numbers along the thirteen principal axes. A black-to-white line forms a central axis, with gray at the center of the cube so that in each cross section of the cube the tints become lighter toward the top and darker toward the bottom. The six colors mentioned above form the corners of the cube, with all other hues located along the axes connecting the main colors. A later edition of the book includes an image of two surface views of the cube with colored spots indicating the location of 38 hues. Illustrations of the distribution of colors in the sections of the cube are provided in the form of five full-page lithographs (see opposite, bottom) showing groups of colored spots, all painted by hand, against a heavily inked black printed background except for one of the five plates, which has a background color of very light brown. There is no lettering on the color plates themselves,

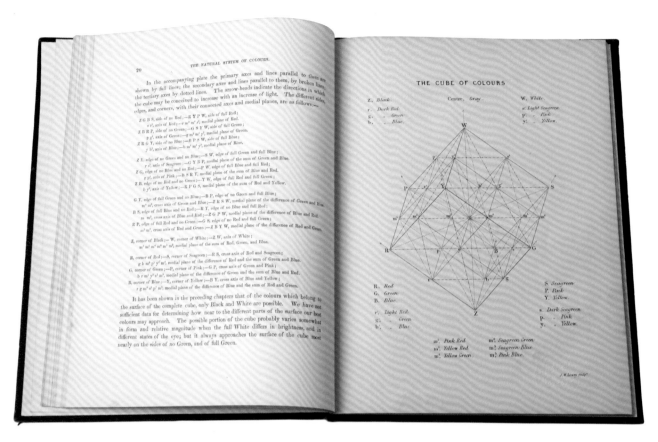

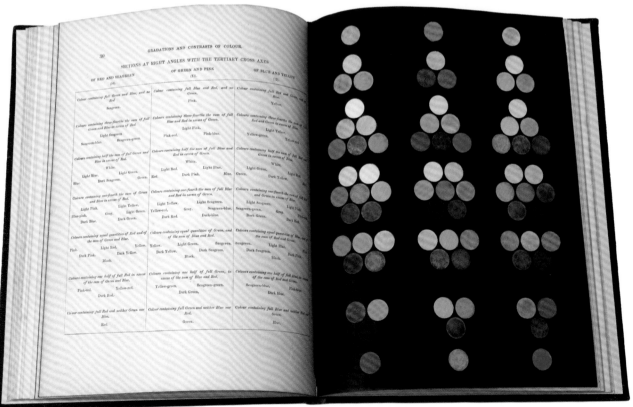

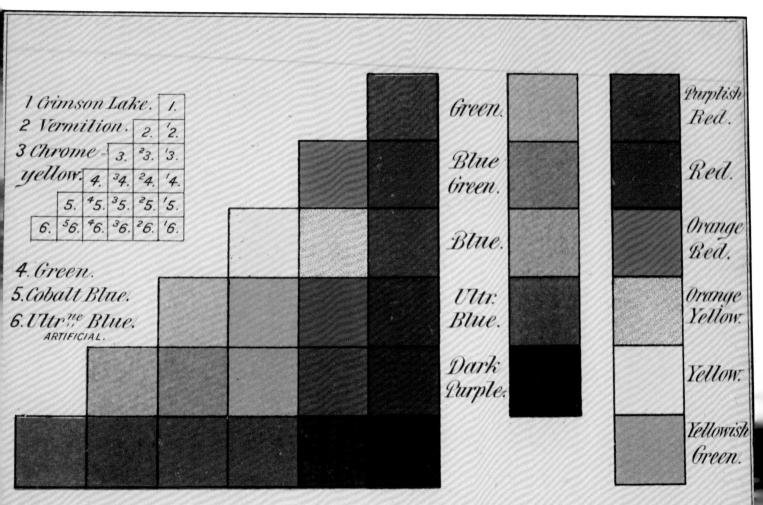

1 *Crimson Lake.*
2 *Vermilion.*
3 *Chrome-*
 yellow.

4. *Green.*
5. *Cobalt Blue.*
6. *Ultr.*^{ne} *Blue.*
 ARTIFICIAL.

Green.

Blue Green.

Blue.

Ultr. Blue.

Dark Purple.

Purplish Red.

Red.

Orange Red.

Orange Yellow.

Yellow.

Yellowish Green.

Effects produced by mixing pigments.

COMPLEMENTARY COLOURS.

MIXTURE CHART.

but the hues are named and identified in tables on their opposite pages. The effort that went into coloring in these spots must have been considerable, as is the case with every hand-colored color diagram. The color spots appear especially intense against the black background and have a timeless abstract appeal.

Just over a decade after Benson published his book, the American physicist Ogden Nicholas Rood published a substantial book on color science that proved to be tremendously successful in America, Germany, France and English-speaking European regions. *Modern Chromatics, with Applications to Art and Industry* seemed to encapsulate the, by then, very close relationship between art, design, science, commerce and production. Himself a practicing painter, mainly in watercolor, Rood was in constant exchange about color with other artists and his intention was to provide a book of great practical value to artists and designers, as well as those with a general interest in the subject. His interest in optical studies and immaterial color was perhaps the reason that he was especially well received by Impressionist and Post-Impressionist painters, helped by the almost immediate translations of his work into German and French.

Over 350 densely printed pages, Rood dealt with many aspects of color and paint, referring to past color theorists as well as presenting the current state of color studies. The book's 130 illustrations are small woodcuts, many of them depicting optical experiments, tools or machinery, as well as some simplified diagrams and color systems. The only colored plate in the book is the frontispiece (opposite), on which are shown a number of small color diagrams, including a triangular "mixture chart," based on the red-green-blue optical system advocated by the scientists Thomas Young and Hermann von Helmholtz. Also included are three color wheels containing six "complementary colors" each, and three tables showing the "Effects produced by mixing pigments," along with a key of numbers assigned to each tint. He also devised a systemic color wheel, which assigns varying degrees and proportions, or "angular distances," as he calls them, to the colors, similar to what we saw on Newton's asymmetric wheel from 1704. This was represented as a simple uncolored line engraving with the names of 22 colors on the unevenly represented radii emanating from a center. Like Benson before him, Rood derived a material color system of practical use to artists and designers that was based on spectral colors and optical studies. Although many of his 22 colors bear pigment names, they are also defined by their spectral equivalent, meaning they represent wavelengths. The success of Rood's work lies in his meticulous research and his clear, logical and structured prose style. He was less concerned with complex or aesthetically appealing illustrations of his color systems.

Left: Unusual for books of this period, Rood's *Modern Chromatics* included only one colored plate, and the diagrams on it are simple in their conception.

Vincent van Gogh Immerses Himself in Color

Above: A surviving palette gives an impression of how Van Gogh painted: the strokes of a broad brush are clearly visible, the arrangement of the paints doesn't seem to follow a particular order and much of the mixing took place on the palette.

Opposite: A self-portrait from 1888 displays Van Gogh's ideas about color. The colors are more vivid than life, helped along by a bold interplay of blue and orange complementaries.

Few other artists of the nineteenth century combined such a radical, at times obsessive, approach to the use of color with an academic interest in color theory as Vincent van Gogh. Van Gogh was painting in a time when a multitude of new synthetic paints were becoming available, packaged in collapsible metal tubes, ready mixed, some of them cheap, many of them toxic or at least not stable—but always brilliant.

In his color choices, Van Gogh was not concerned with naturalism but used color instinctively, as an expression of mood and feeling rather than an accurate depiction of the world around him.

Many of Van Gogh's early paintings (from around 1880–1882) are composed with a predominantly black and brown palette. But in 1882 he announced a change in a letter to his brother Theo: "As you see, I'm immersing myself in painting with all my strength—I'm immersing myself in color—I've held back from that until now, and don't regret it." While we, with good reason, imagine Van Gogh as an impulsive and passionate painter, he was methodical in his approach. He practiced the rudimentaries of picturemaking for years, studying artists' manuals and copying the works of the Masters before embarking on his own brief career. Similarly, he was studying color theory in great depth while painting in those somber hues, until it was veribly ready to burst out of him. In a letter to Theo from June 1884 he noted that "The laws of color are inexpressibly splendid precisely because they are not coincidences." A few months later he bought himself a copy of Charles Blanc's color

theory *Grammaire des arts du dessin: architecture, sculpture, peinture* (1867) and it is highly likely that he was familiar with other treatises on color. Blanc's views on color were critical and thought-provoking. He considered color an inferior and difficult element of art, something that needed to be either avoided or controlled. Van Gogh was clearly piqued by this and became obsessed not only with color itself, but also concepts of color order. He told Theo in November 1885, "I am utterly preoccupied with the laws of color. If only we'd been taught them in our youth!"

We see the dramatic shift to the expressive, non-naturalistic use of color that we associate with Van Gogh's most famous works from around 1886. While this may largely have been triggered by his move to Paris and exchanges with the artistic avant-garde, studying color literature may also have been a significant factor. He retained his passion for color throughout the rest of his short life, working feverishly and rapidly on paintings that have now become iconic. Musing on Blanc's writings, he once suggested that "a painter does well if he starts from the colors on his palette instead of starting from the colors in nature." In *Self-Portrait as a Painter* (right) from 1888 we can clearly see the pure color he has squeezed onto the palette, ready to be mixed, wrestled with, enjoyed and transformed into a painting.

Van Gogh often had a very clear idea about the chromatic layout of a painting before applying it to the canvas, and frequently commented on the characteristics of certain pigments. He considered black and white to be colors in their own right, noting that "their simultaneous contrast is as striking as that of green and red, for instance." But personal observation, reflection and perception of color were what informed his paintings more than anything else. Contemplating painting one of his best-known motifs, the starry sky, he said, "It often seems to me that the night is even more richly colored than the day, colored in the most intense violets, blues and greens. If you look carefully you'll see that some stars are lemony, others have a pink, green, forget-me-not blue glow. And without laboring the point, it's clear that to paint a starry sky it's not nearly enough to put white spots on blue-black."

Palettes as Mirrors:
Artists and Their Colors

*A palette can be the mirror
of an artist's style and personality*

As we saw in the example of Vincent van Gogh on the previous page, painters' palettes can tell us much about the materials and pigments available at the time and, perhaps more importantly, about the artist's color preferences. Sometimes they even give insight into the creation of a specific work of art. Among other things, they reveal how the painter ordered colors for their immediate use in a painting, in a more fluid and organic way than the arrangement of colors and other materials you find in a paint box. In short, a palette can be the mirror of an artist's style and personality, especially when included as an iconographical element in a painter's work. Making visual statements about your choice of materials, studio space and color preferences in self-portraits is not uncommon and often these painted palettes can provide fascinating information about an artist's painting and color mixing techniques, as we have seen in the simple but expressive self-portrait of Gabriele Münter on page 6, or William Hogarth's depiction of the palette as the compositional center of his self-portrait on page 31. As part of the composition of a painting, palettes are frequently attributed a heightened symbolic meaning and can become powerful emblematic tools of self-expression.But palettes are also objects of beauty and design in their own right. There is a solidity and often symmetry to palettes themselves, which is broken up and brought to life by the soft, malleable and constantly changing paints applied to them. Many palettes have acquired an almost fetishist quality, especially when having belonged to a famous and revered artist. They are among the most tactile and intimate of artists' tools. We can gaze at each one and imagine how the artist chose it, prepared it for painting, held it tight during the creative process, then cleaned it and prepared it for its next use.

The Exemplary Palette of Eugène Delacroix

On this palette that belonged to the French Romantic painter Eugène Delacroix we find dozens of small patches of pre-mixed paint placed in three orderly rows. The meticulous layout of paint samples gives us an insight in how the artist thought carefully about the color composition of a painting. Delacroix was known for taking great care and finding joy in mixing new colors and experimenting on palettes to see how they would work when placed next to each other. In his diaries the artist himself confirms what this object reveals. In 1850 he commented on his palette as a source of artistic energy: "My freshly arranged palette, brilliant with contrasting colors, is enough to fire my enthusiasm." It is likely that he used this and similarly arranged palettes not for the actual painting process, but instead as a visual template. Delacroix's minutely arranged palettes became objects of desire and admiration in artistic circles. The poet Charles Baudelaire thought they resembled carefully arranged bouquets of flowers, and in 1930 the painter Léon Piot even made them the subject of a 100-page long book, *Les Palettes de Delacroix.*

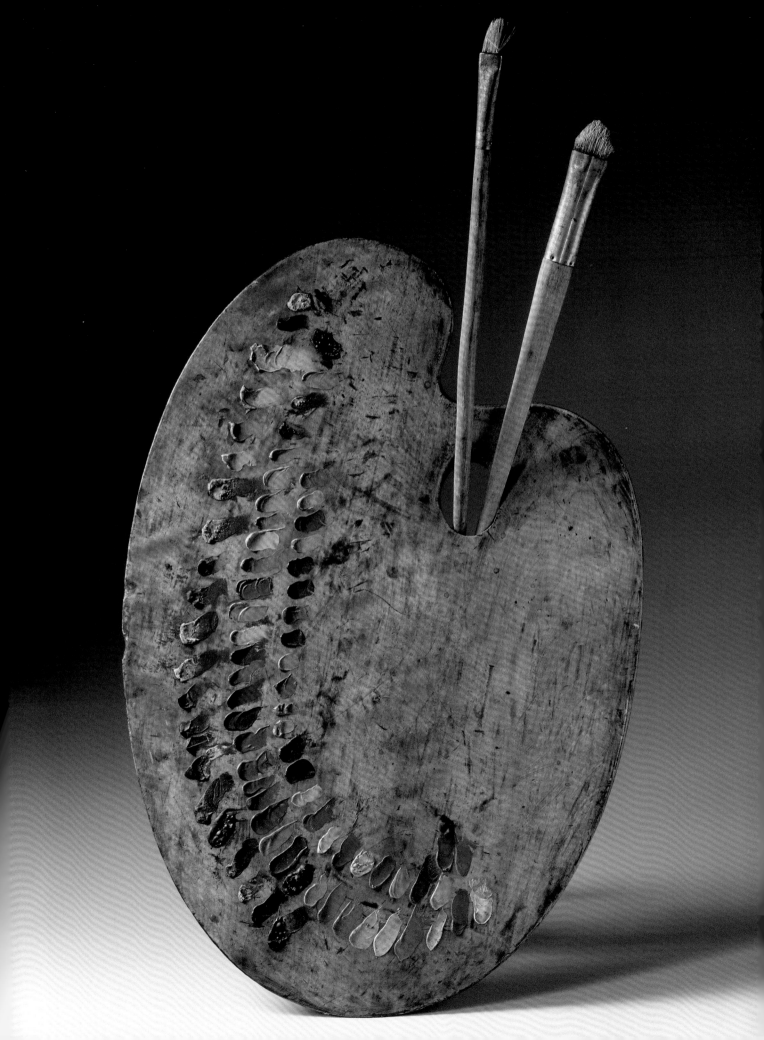

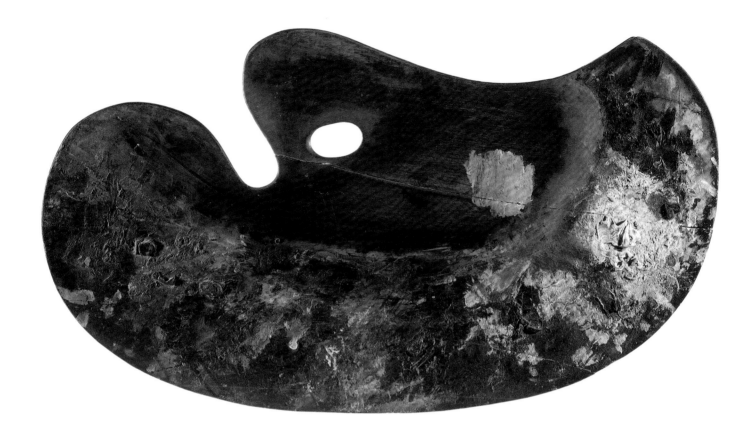

The Luminous Palette of Edgar Degas

This palette by the French painter Edgar Degas is of a particularly ergonomic shape that allows the artist to rest it gently in the folds of an arm or on the body. Degas is often described as a typical Impressionist and did indeed form many friendships with Impressionist artists, but he was as much concerned with the careful studying and copying of Old Masters (Dutch and Italian) as he was with painting *en plein air*—in the open, capturing fleeting moments and impressions. He became most famous for painting ballet dancers on stage and behind the scenes, drenching the figures in a luminous light and giving them fuzzy contours to add to the sensation of movement, often depicting them from unusual angles. With regard to composition, he was possibly inspired by early photography; he used color as a subtle but powerful tool to create a particular sensuousness and brightness. In this he was much influenced by the work of contemporaries he admired, such as Édouard Manet and Eugène Delacroix (see previous page), while developing his own distinctive style. This palette reflects both Degas' spontaneity and discipline: there is a clear order and tidiness to the arrangement of the oils on the board, yet we also see much mixing on the palette and the creation of subtly contrasting tints. The most prominent color is white, which gives his work its typical luminosity.

Above: Less orderly than Delacroix's palette though still beautiful, Edgar Degas' palette is notable for the great quantity of white on its right-hand side.

Camille Pissarro's *Figurative Palette*

Here, we have a quite different palette from the French Impressionist painter Camille Pissarro. It appears to be a playful take on the concept of the painter's palette: the artist's tool has been used as a paint surface carrying a figurative work of art in its own right. Pissarro treats the wooden palette like a canvas, without attempting to incorporate the ergonomic shape of the thumbhole or the curved edges, covering it with a rural scene of peasants with a cart in a field, under an expansive sky. Yet, Pissarro references the intended purpose of the palette by including thick daubs of unmixed paint, the colors red, blue and yellow, as well as white, a dark brownish-purple tertiary, and a green that blends into the painted foliage, around the top and side edges of the

image. Around the time this palette was created (c. 1878–1880) Pissarro was known to have worked with a reduced range of primary and secondary colors, augmented only by white, so this palette, although an artificial construct, does indeed reflect his personal color choices and arrangements.

It may look like a whimsical object, but Pissarro was responding to a popular trend among art collectors to buy and commission palettes from established artists, both as an investment and for their decorative value. This particular palette was created for a Monsieur M. Laplace, a restaurateur in Paris. He paid 50 francs for it, which was more than the price of a small canvas by Pissarro, and it is likely that he intended to display it in his brasserie La Grande Pinte. Pissarro excitedly wrote about Laplace's interest in ornamented artists' palettes to Claude Monet, but it is not known whether Monet was ever commissioned to produce a similar object.

Above: A palette from Camille Pissarro is like a working example of his ideas about color order. We get the pure pigments arranged around the edge, and a picture demonstrating their use.

Elisabeth Louise Vigée Le Brun's Elelegant

Self-Portrait in a Straw Hat

In Elisabeth Louise Vigée Le Brun's *Self-Portrait in a Straw Hat*, painted after 1782, we see an artist proudly posing with her palette and brushes. Her pose is idealised and expresses composure, serenity and beauty. There is no attempt to show the messiness of a painter's work or a studio environment; Le Brun depicts herself dressed extremely fashionably. Her costume may appear loose, rustic and slightly casual, but the large earrings and fine fabrics indicate that she is a relatively wealthy, distinguished and successful woman. She is facing the viewer and looking out of the picture, against a backdrop of a landscape with a vague low horizon and a cloudy sky, holding her palette and paint-dipped brushes casually in her left hand while leaning on a column. Everything about this self-portrait is elegant and measured, and the colors on the palette reflect the careful and deliberate composition of the painting, and thus her art in general. Le Brun arranges her colors neatly along the top edge, with white closest to the thumbhole, followed by light shades of yellow, moving to oranges and reds and then darker tints. Two shades of blue, which feature in many of her works, and a pink tint are placed in a second row, close to her thumb. While conveying an image of taste and professionalism, Le Brun also wittily self-references with her palette: the prominent pink shade is very similar to the color of her dress, and the flowers that are pinned to her straw hat seem to mirror the tints on her palettes almost exactly.

Above: Briefly traveling back in time, we can see how in the eighteenth century artists were far more concerned about accurate (albeit emblematic) depictions of life.

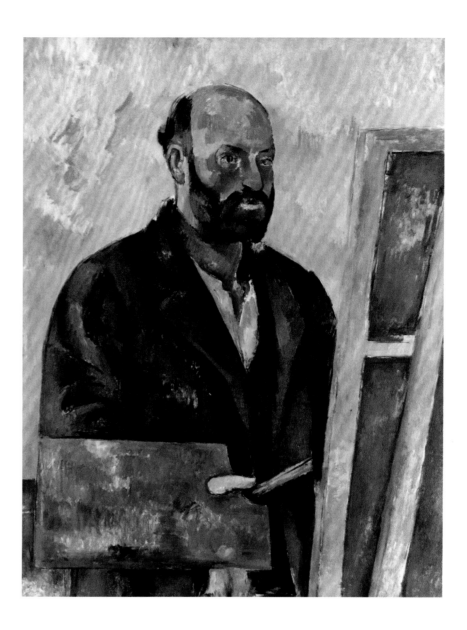

Paul Cézanne's Structural

Self-Portrait with Palette

Above: Compared with Le Brun's self-portrait (opposite) Cézanne's painting has a distinctly unpolished feel. But it is vivid and alive, and demonstrates the radical new ideas informing art toward the end of the nineteenth century.

Just over a hundred years later, Paul Cézanne created an almost exact mirror of the colors he favored, on the palette included in his 1890 *Self-Portrait with Palette*. The sumptuous shades of green that are so prominent in many of his works occupy much of the board, including the top edge, where there is evidence of mixing and creating darker shades of green. It is highly likely the pigments used here were highly toxic emerald green and a chromium-based viridian. Small blots of intense yellow and red paint are placed at either end of the top edge, all against a background of earthy browns and ochers.

Expressive and to a certain extent non-naturalistic in his use of color, Cézanne was particularly concerned with structure and solidity in his paintings, in stark contrast to many of his Impressionist contemporaries. This self-portrait and the palette within it are perfect examples of achieving a strong visual structure in a painting by combining line and color masterfully. The solidity of Cezanne's work is represented in his own upright posture and the clear verticals, diagonals and horizontals of his easel and palette, the latter placed at an unnatural but perfect 90-degree angle to the easel and the picture's side edges. The almost geometrically arranged palette is presented full frontal, almost like a painting within a painting, part advertising the painter's art, part forming a defensive shield.

A Rose for Chevreul: Charles Lacouture's *Répertoire chromatique*

Opposite: Lacouture's "Trilobe synoptique" depicting various mixtures of the primaries red, yellow and blue, including tonal variations.

Overleaf: An elegant color flower: the twelve petals of the "Rose synoptique" show different hues and their tonal gradation. The fine protective paper separating it from the title page provides a key to the hues.

At the end of the nineteenth century, the French botanist Charles Lacouture, Professor of Natural History at the University of Metz, published a scientific treatise on color dedicated to Chevreul's work. Lacouture's *Répertoire chromatique, solution raisonnée et pratique des problèmes les plus usuels dans l'étude et l'emploi des couleurs (Chromatic repertory: logical and practical solution to the most frequent problems in the study and employment of colors)*, published in 1890, is an expensively produced book, comprising 144 pages of text and 29 chromo-lithographic plates, plus additional uncolored diagrams. Despite his admiration for Chevreul, the author argued that Chevreul's system was not easy to apply by artists, designers, and so on. Lacouture aimed to provide a simplified and extended version of Chevreul's work, in which he would elaborate on factors such as surface finish, materiality of colored objects and light conditions. We can argue about whether or not Lacouture achieved his aim of making Chevreul's theories easier to understand and apply, but he certainly created an aesthetically impressive new book on color, with full-page (32.5 x 25 cm) colored lithographs of the highest quality. Among these are a couple of particularly beautiful and inventive color diagrams.

The frontispiece is the "Rose synoptique" (overleaf), a fan-shaped variation on a color circle, consisting of six principal colors and six mixtures of those. The colors are shaped like flower petals and the saturation increases toward the center of the diagram, where overlapping triangular shapes are placed. There is no letterpress on the rose, but a key to the diagram, with references to the other color plates in the book, is printed onto the tissue guard of the frontispiece and can be placed over it.

The second color plate is Lacouture's "Trilobe synoptique" (right), which forms a reference diagram visualising the range of mixtures and grayscales of the primaries red, blue and yellow. Unusually, Lacouture did not opt for a conventional representation of overlapping circles. Instead, each primary color forms a bow or wing shape, with its brightest range along the outer edge of the wing. Interestingly, the darker shades of each tint were not created by changing the color of the printing ink but the thickness of the fine parallel lines of color against the white background of the paper.

Despite the ambitious nature of the treatise, it was never translated into other languages and remained influential only in French-speaking circles.

TRILOBE SYNOPTIQUE

N. B. Fermer l'atlas pour soustraire ces planches à la lumière aussitôt qu'on n'a plus besoin d'en faire usage.

ROSE SYNOPTIQUE

N. B. Fermer l'atlas pour soustraire ces planches à la lumière aussitôt qu'on n'a plus besoin d'en faire usage.

Chromolith. G Severeyns.

RÉPERTOIRE

CHROMATIQUE

SOLUTION RAISONNÉE ET PRATIQUE

DES PROBLÈMES LES PLUS USUELS

DANS LA TEINTURE ET L'EMPLOI DES COULEURS.

DIAGRAMME DE LA ROSE SYNOPTIQUE

R représente le rouge ; V̶ représente le vert ;

RO ″ le rouge-orangé ; BV̶ ″ le bleu-vert ;

O ″ l'orangé ; B ″ le bleu ;

JO ″ le jaune-orangé ; BV̶ ″ le bleu-violet ;

J ″ le jaune ; V̶ ″ le violet ;

JV̶ ″ le jaune-vert ; RV̶ ″ le rouge-violet.

Les chiffres romains désignent les n°s des planches qui correspondent aux diverses parties de la rose synoptique.

COLOR FOR COLOR'S SAKE: THE RADICAL EARLY TWENTIETH CENTURY

Color for Color's Sake: The Radical Early Twentieth Century

The Impressionist movement of the latter nineteenth century proved a a catalyst for changing not only how we thought about color, but also how we thought about art in a much wider sense. It was a truly radical movement, upsetting traditional artistic conventions and emboldening artists to push their field's boundaries ever further. The ideas propagated by the French Impressionists spread quickly throughout Europe, and the decades that followed Impression's inception saw a raft of new, related movements, including Post-Impressionism, Expressionism and fFauvism, swiftly follow. Often, these new movements enjoyed only brief lives, but each one left a distinctive mark on the face of the brave new, technicolor world.

Painters not only experimented with pure and intense colors but also wrote about the spiritual and symbolic meaning of color

Left: A Fauvist color wheel, of sorts; Henri Matisse created *The Snail*—a huge and joyful example of his cut-out technique—in 1953, only the year before he died. Matisse stayed true throughout his life to the colorful principles of the movement he'd founded with André Derain at the turn of the twentieth century.

In the wake of Impressionism, color became much more than just a necessary aspect of painting (and an inferior one at that, according to classical standards); it developed into a powerful expressive tool. Many early-twentieth-century artists, especially from French and German avant-garde groups, such as Les Fauves and Der Blaue Reiter, freed of the concept that the goal of art was to reproduce reality as beautifully and accurately as possible, made color a driving force and distinct subject matter of their work.

As with Impressionism, the term "Fauvism" was coined as a slight by an art critic. Like many of his peers, Louis Vauxcelles objected to the new work shown by Henri Matisse and André Derain at their 1905 salon d'automne exhibition in Paris. Comparing their seemingly incomprehensible modern art to a Renaissance statue that shared the exhibition space, he disparaged Matisse and Derain with the memorable phrase, "Donatello parmi les fauves," or "Donatello among the wild beasts." The Fauvists were directly inspired by color theory, particularly the effects of complementary colors. Taking up where Van Gogh and Seurat had left off, they celebrated pure, bright pigments, and, beginning a move toward abstraction, they simplified their subjects, lending the colors themselves even more importance. Fauvism was not a long-lasting movement, as many of the artists involved in its conception soon turned to other things, including the largely monochrome Cubism. Matisse, however, celebrated color throughout his life.

In Germany, just a few years later, Der Blaue Reiter, a group of painters including Wassily Kandinsky, Franz Marc and Paul Klee not only experimented with pure and intense colors but also wrote about the spiritual and symbolic meaning of color. The results were important new interpretations of what Goethe and other writers had begun discussing 100 years earlier: the idea that color signified more than its physical form, and that individual colors might point to distinct meanings.

The aims and innovations of both groups eventually resulted in the creation of the Bauhaus, a group or

school of which both Kandinsky and Klee were members; it embraced new materials and technologies and combined these with a new philosophy of aesthetics, in which color theory played a big part. Their aim was for minimalism, clarity and functionality.

As the western world continued to become wealthier, and products and paints became increasingly available in wider ranges, the first half of the twentieth century saw an abundance of books published on the use of color in interior decoration and architecture. It is in this century that we first begin to see books illustrated with colored photography. The Polish-born British photographer Carl Hentschel had recently invented the new photographic three-color printing process that would radically change the look, style and quality of illustrated books. Hentschel's method of photographic printing effectively replaced the messy, wasteful and complicated process of woodblock or metal plate printing in color. While this accurate and exciting new way of copying artists' works led to the rise of the gift book, often in the form of lavishly illustrated travel books and collections of fairy tales and folklore, the new method was at first only cautiously used in books concerned with color theory. Authors such as the German chemist Wilhelm Ostwald still opted for pasted-in hand-colored color chips in his instructive publications in the 1910s and '20s.

In the twentieth century, we still see a number of charts and lists that wouldn't look too out of place in books from centuries past. On the one hand, there were the more experimental schemas, for example Emily Noyes Vanderpoel's beautiful color analyses. On the other hand, various organizations were attempting to standardize colors for use in manufacturing and industry, and for this purpose a number of expensive color charts were produced, including one by the newly founded British Colour Council. Smaller and cheaper versions of color charts were also produced as advertising materials by private companies, in a continuation of the tradition of lists of colors and

pigments printed in nineteenth-century books on color. The paint charts you can pick up today in most shops that sell architectural paint or artists' materials have their origin in the early twentieth century, when advertising became much more aggressive and color printing became cheaper.

It is interesting that the exponential rise of consumer culture was occurring during a time of intense spirituality, manifesting not only in the intellectual works of Der Blaue Reiter and Bauhaus, but also in

It is in this century that we first begin to see books illustrated with colored photography

a heightened interest in the paranormal or supernatural, and the popularity of esoteric religious movements such as theosophy. Charles Webster Leadbeater, a key proponent of the latter, made the connection between color and intangible qualities, which Goethe had been considering in 1799 with his *Temperamenten-Rose* (see page 45), even more literal. Leadbeater's beliefs led him to publish a book that explained the interpretation of auras—colorful emanations of inner qualities—for which purpose he included in his book a table of 25 colors and their specific meanings.

With the outbreak of the Second World War, the western world began to turn away from its fascination with mysticism. Perhaps it seemed more important to focus on practical and material things. But the ideas promoted in the early twentieth century have left a legacy of some of the most fascinating works of art, design and literature the world has ever seen.

Blots & Grids:
Emily Noyes Vanderpoel

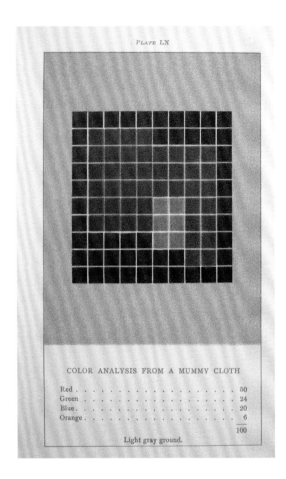

PLATE LX

COLOR ANALYSIS FROM A MUMMY CLOTH

Red . 50
Green . 24
Blue . 20
Orange . 6
————
100

Light gray ground.

Above: An example of Vanderpoel breaking down a colored object into its chromatic components: A mummy cloth she has studied comprises 50 parts red, 24 parts green, twenty parts blue and six parts orange.

Opposite: Vanderpoel's plates were printed on high-quality and slightly textured paper, and illustrate a wide range of color aspects. Here she depicts color harmonies in a blot-style similar to Mary Gartside and George Barnard in the nineteenth century.

Examples of women publishing on color in the eighteenth and nineteenth centuries are rare. In the early twentieth century, coinciding with the rise of avant-garde groups, the opening of a number of art colleges for women and the advent of Modernism and Expressionism, women gained a stronger voice, both with their art and in publishing, although men still dramatically outweighed women in public visibility and the intellectual establishment in general. In the very early years of the twentieth century, the New York-born painter Emily Noyes Vanderpoel published an intriguing book on color: *Color Problems: A Practical Manual for the Lay Student of Color* (1902). Like other women color writers before her, such as Mary Gartside (see pages 50–53) and Mary Philadelphia Merrifield (see pages 104–105), Vanderpoel was born into privileged circumstances and enjoyed a private education. She was an active member of several societies and organizations that supported women, including the Daughters of the American Revolution and the Litchfield Female Academy, Connecticut, where she lived for most of her life.

Vanderpoel appears to have been widowed young and lost her only son and daughter-in-law around the time of the publication of *Color Problems*, which may explain her sudden and intense publishing output. A chronological list of color literature at the end shows how widely Vanderpoel had read on the subject: beginning with Leonardo da Vinci, she further lists

Goethe, Chevreul, Field, Jones, Rood, Wilkinson and Lacouture, among many others. A number of titles are German and French, and a particular interest in color vision and color in other cultures is apparent.

The weighting of text and images in *Color Problems* is almost equal (137 text pages and 117 plates). "Color cannot be fully appreciated by any written description, the text has been made as brief as possible, the plates full and elaborate," Vanderpoel explained in her introduction. The plates include some predictable images of the optical range, color contrast, gradation and tables of complementary colors; others are more experimental. The book even included transparencies, some of them colored, to be used as overlays. Most plates are highly abstract, such as one illustrating color harmonies (right) that recalls the color blots of Gartside and George Barnard (see page 109), while some plates illustrating color contrasts appear like precursors of Josef Albers's color squares from *Interaction of Color* (see pages 180–181). A number of freer compositions which she calls "color notes" resemble Turner's color notations from his many sketchbooks—simple brushstrokes of no more than a handful of colors, largely based on the observation of nature. For example, "Color note from a bluebird —A harmony of cobalt and light red," or "Color note from leaves on a tree—The sun glancing across the smooth leaves makes a cool gray, and shining through them makes a warm green. The shaded leaves are a deep green."

The most remarkable plates in the book are dozens of "color analyses," in which Vanderpoel breaks down an image, an object or a design pattern into its chromatic components and presents the resulting color key on a 10 x 10 square grid, with the proportional distribution of each color noted below to the total of 100 squares. Vanderpoel's way of visualising color order and layout was measured, methodical, mathematical and abstract, but also surprisingly simple. It is likely that these images had some influence on the development of abstract art and design in the twentieth century, but as yet the author is under-researched and *Color Problems* is now an extremely rare book.

PLATE XXXIII

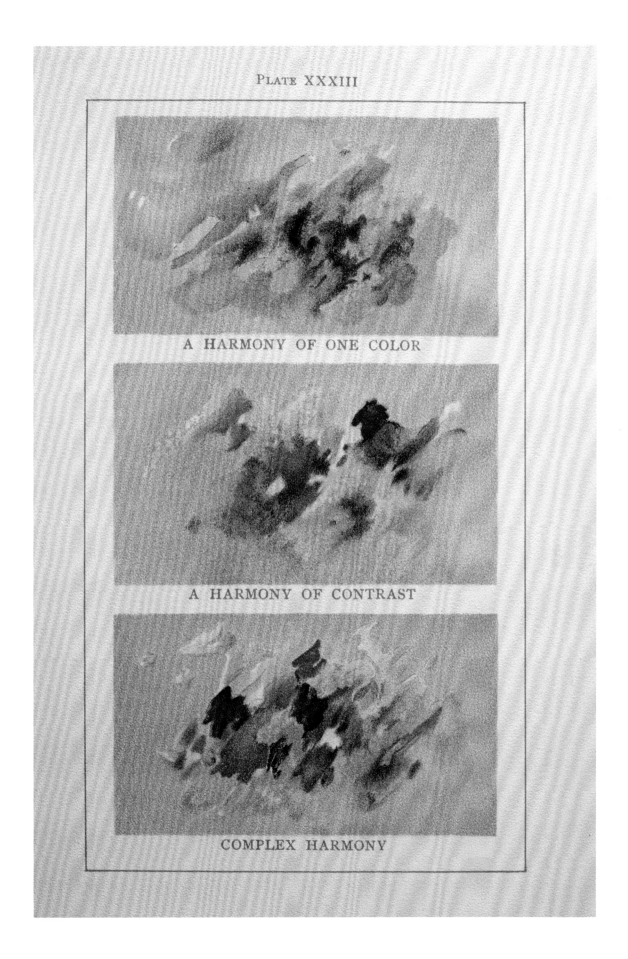

A HARMONY OF ONE COLOR

A HARMONY OF CONTRAST

COMPLEX HARMONY

Albert Henry Munsell's Hue, Value and Chroma

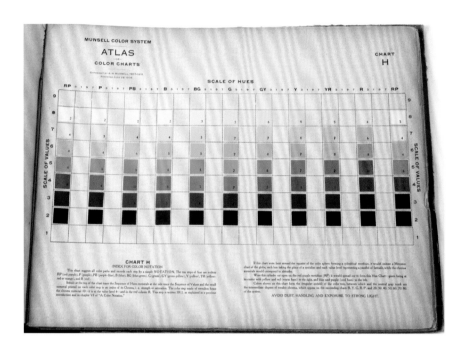

Above & opposite: Three diagrams from Munsell's *Atlas* (1915), detailing a ten-hue system, with notation for chroma and value (Chart H, above); an explanation of "chroma," or "the strength of pigment colors" (Chart C, opposite, top) and an explanation of "value," or "the amount of light reflected from pigments" (Chart V, opposite, below).

Albert Henry Munsell was an American teacher and artist whose lifetime ambition was to create and perfect a color system that was easy to understand, accurate, and based on how color is perceived by humans. He wanted his system to be a useful tool for color choice, matching and identification, as well as being suitable for teaching at all levels. Although it appears complex, his system was based on the principle that any visualization of color order needed to be three-dimensional. Munsell was, of course, not the first to suggest this, but he turned this central idea into a numerical system based on three identifiable and measurable qualities of color: hue, chroma and value. Hue is the color or tint itself, to which we could give a name, such as red, yellow blue, and so on. Value refers to the lightness or darkness of a color. The third attribute, chroma, denotes the saturation or brilliance of a color. All colors are arranged in relation to a central axis of neutral colors, ranging from white at the top to black at the bottom. The result was a flexible, three-dimensional model in which each color could be identified by its location on the spatial model, referred to numerically as HVC and known as the "Munsell color space."

Munsell introduced his ideas of a color sphere and color space in his first publication, *A Color Notation: A Measured Color System, Based on the Three Qualities Hue, Value and Chroma* (1905). This was a short, small format and concise treatise, intended for use in education, and an attempt to standardize color teaching at school level. Later editions were published with a loosely inserted "Munsell Student Chart" and a set of 26 colored "Munsell chips," for students to arrange on the chart. The early editions of this popular work contained a colored frontispiece showing a painted color globe, after a pastel by Munsell, created in 1900 (see page 145). Munsell was also known to have used simple models of color globes made of tin and wood in teaching, which are the earliest known examples of an actual color globe. He soon developed his three-dimensional model further, realizing that color space could not be perfectly represented in a spherical form. In all his publications, the symbol of a color sphere appears as a decorative logo on the covers, but the preferred representation of his color system is a color tree, with chromatic branches of different lengths extending from the central neutral trunk (see overleaf).

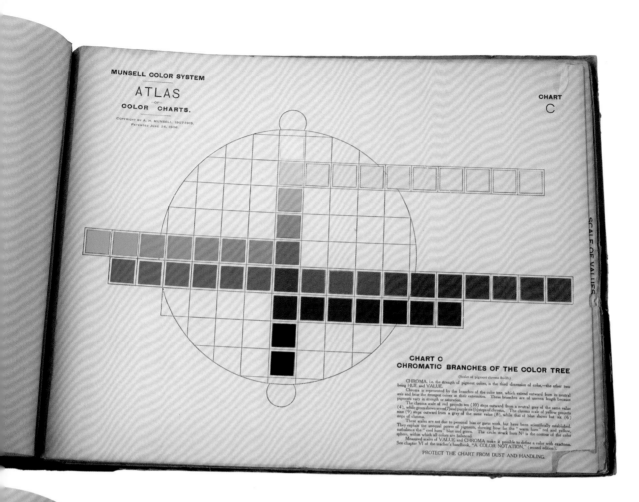

MUNSELL COLOR SYSTEM

ATLAS
—OF—
COLOR CHARTS.

COPYRIGHT BY A. H. MUNSELL, 1907-1915.
PATENTED JUNE 26, 1906.

CHART
C

SCALE OF VALUES

CHART C
CHROMATIC BRANCHES OF THE COLOR TREE

(Scales of pigment chroma 0o–II.)

CHROMA, i.e. the strength of pigment colors, is the third dimension of color,—the other two being HUE, and VALUE.

Chroma is represented by the branches of the color tree, which extend outward from its neutral axis and bear the strongest colors at their extremities. These branches are of uneven length because pigments vary in strength or saturation.

The chroma scale of red projects ten (10) steps outward from a neutral gray of the same value (4), while green shows seven (7) and purple six (6) steps of chroma. The chroma scale of yellow projects nine (9) steps outward from a gray of the same value (8), while that of blue shows but six (6) steps of chroma.

These scales are not due to personal bias or guess work, but have been scientifically established. They explain the unequal power of pigments, showing how far the "warm hues" red and yellow, outbalance the "cool hues" blue and green. The circle struck from N° is the contour of the color sphere, within which all colors are balanced.

Measured scales of VALUE and CHROMA make it possible to define a color with exactness. See chapter VI of the teacher's handbook, "A COLOR NOTATION," (second edition).

PROTECT THE CHART FROM DUST AND HANDLING.

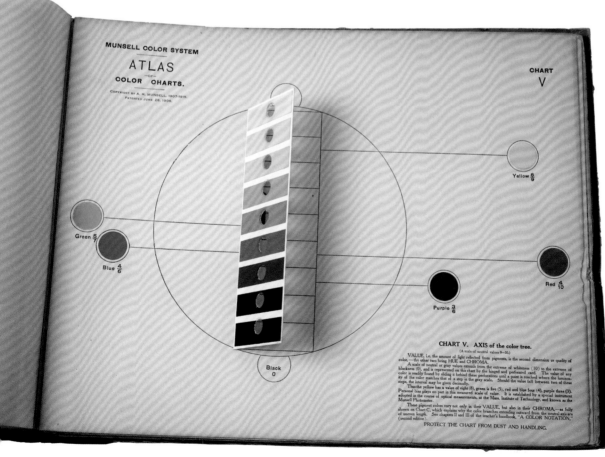

MUNSELL COLOR SYSTEM

ATLAS
—OF—
COLOR CHARTS.

COPYRIGHT BY A. H. MUNSELL, 1907-1915.
PATENTED JUNE 26, 1906.

CHART
V

Yellow 8/9

Green 5/7

Blue 4/6

Red 4/10

Purple 3/6

Black 0

CHART V. AXIS of the color tree.

(A scale of neutral values 0–10.)

VALUE, i.e. the amount of light reflected from pigments, is the second dimension or quality of color,—the other two being HUE and CHROMA.

A scale of neutral or gray values extends from the extreme of whiteness (10) to the extreme of blackness (0), and is represented on this chart by sliding it behind these perforations until a point is reached where the luminosity of the color matches that of a step in the gray scale. Should the value fall between two of these steps, the interval may be given decimally.

Thus the yellow has a value of eight (8), green is five (5), red and blue four (4), purple three (3). Personal bias plays no part in this measured scale of value. It is established by a special instrument adopted in the course of optical measurements, at the Mass. Institute of Technology, and known as the Munsell Photometer.

These pigment colors vary not only in their VALUE, but also in their CHROMA,—as fully shown on Chart C, which explains why the color branches extending outward from the neutral axis are of uneven length. See chapters II and III of the teacher's handbook, "A COLOR NOTATION," (second edition).

PROTECT THE CHART FROM DUST AND HANDLING.

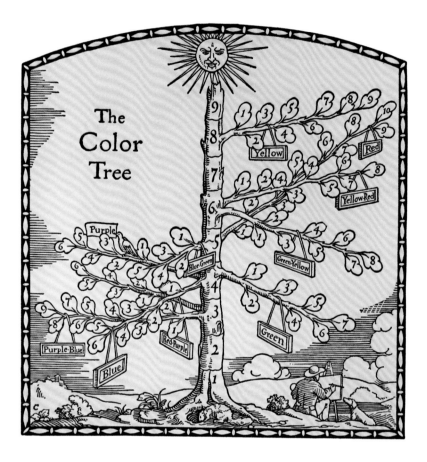

Above & opposite: Although
Munsell frequently represented
his ideas in the form of a globe
(see overleaf), the tree design,
represented on these pages
as a figurative, traditional-
style woodcut (above) and a
schematic form (opposite),
seems to have been his
favored mode for presenting
his ideas about color.

Munsell's most beautiful and elaborate book, the *Atlas of the Munsell Color System* was published in 1915. Its format was an impressive 29 x 38 cm and it is reminiscent of the ambitious atlas of Chevreul's work published in 1861 (see pages 94–101). Munsell's *Atlas* contains fifteen color chart plates, some with overlays that can be lifted, for example on Chart V (previous page, bottom), depicting the grayscale "Axis of the color tree." The colors are pasted-in squares or spots of colored paper, similar to the early publications by Munsell's contemporary Wilhelm Ostwald (see pages 166–169). This was certainly an expensively produced book, and the delicacy of the plates is pointed out to the reader. Each one comes with a printed instruction in capital letters at the bottom of the page: "PROTECT THIS CHART FROM DUST AND HANDLING."

In 1917 Munsell, whose color system had quickly been internationally accepted and would become the basis of other color systems, such as the 1976 CIELAB, founded the Munsell Color Company, but he died just a year later. His son Alexander E. R. Munsell took over the company and continued publishing and promoting his father's work. In 1942, after the sale of the company, the Munsell Color Foundation was established in its place. This was closed in 1983.

A third book authored by Munsell was published posthumously in 1921 by The Strathmore Paper Company. *A Grammar of Color—Arrangements of Strathmore Papers in a Variety of Printed Color Combinations According to the Munsell Color System*, was supposedly prepared by Munsell shortly before his death. It is as much a celebration of his life's work as it is a masterpiece of book design. It looks elegant in its tall oblong format (32 x 22 cm) and is printed on a range of different colored matt papers produced by the Strathmore Company. It was of course also a great advertising object for the company, who proudly announced that this was "the first presentation of [Munsell's] system to the Printing, Advertising and Paper Trade." The decorations and typeface of the introductory text that explains Munsell's color system and its application to print culture were designed by T. M. Cleland. Cleland was also responsible for the letterpress of the nineteen fold-out color sheets that follow the text. These tactile sheets were printed with numerous color combinations, using many of Munsell's by then well-known diagrams.

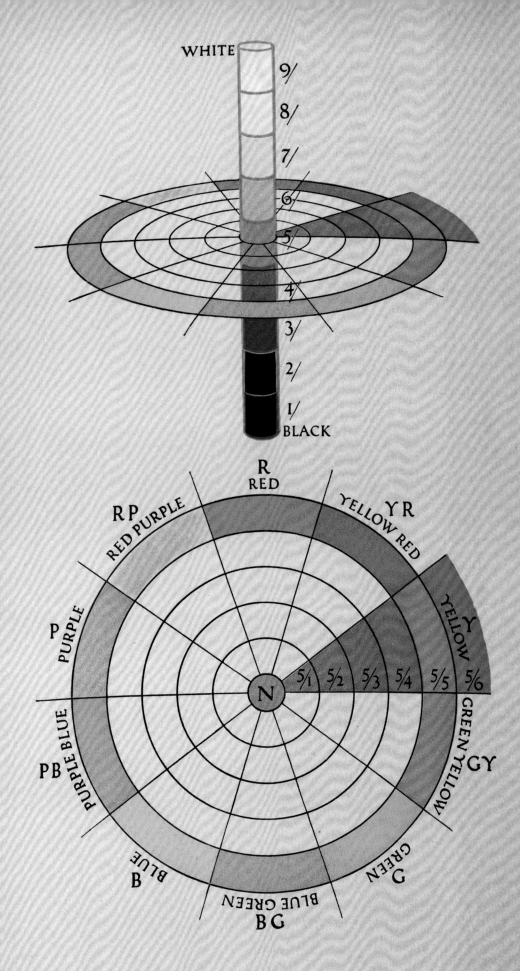

WHITE

9/
8/
7/
6/
5/
4/
3/
2/
1/

BLACK

R
RED

RP
RED PURPLE

YR
YELLOW RED

P
PURPLE

Y
YELLOW

PB
PURPLE BLUE

GY
GREEN YELLOW

N

5/1 5/2 5/3 5/4 5/5 5/6

B
BLUE

G
GREEN

BG
BLUE GREEN

Color into Three Dimensions

From the middle of the eighteenth century, color theorists began to tackle the problem of how to represent the different dimensions of color in a color system. Drawn or painted visualizations of color systems, such as charts and wheels, struggled for decades to show more than hues and a number of their mixtures. A major problem was how to depict color saturation, or the amount of black and white in a color. In his color wheel from 1704 Isaac Newton intended a third dimension to the diagram by marking a central white point, toward which the spectral colors of his wheel would decrease gradually in intensity of hue (see pages 12–15). In 1810 the German painter Philipp Otto Runge visualized a three-dimensional color globe with a point of pure black at one pole and pure white at the other, between which all hues developed (right). Other theorists and artists made similar attempts at conveying a three-dimensional system in a two-dimensional medium, with varying degrees of both success and complexity. Mary Gartside, for example, had used the term "ball" in relation to a color circle in 1805, suggesting that she wanted the reader to imagine it as a three-dimensional object, while William Benson drew a three-dimensional color cube in 1868 (see page 119). In the early twentieth century, Munsell used the simplified image of a color globe as a decorative logo on many of his publications. His fully developed color system was considerably more complex than this little image, resembling a not perfectly spherical "color tree" (see pages 142–145), but the most important aspect was the idea that color occupied space in several dimensions.

The frontispiece of Munsell's *A Color Notation* (opposite) is an image of a pastel drawing, dated 1900, of an actual color globe. It looks astonishingly like Runge's etching of a color ball from 90 years earlier. We know that Munsell used simple models of color globes, possibly made by himself, in teaching color theory, and it is highly likely that other three-dimensional models were designed in the eighteenth and nineteenth centuries, but no significant examples survive.

In recent years, a number of creative attempts have been made to produce three-dimensional color models. Munsell's color tree, complete with detachable color chips mounted radially on plastic panes, is available via Pantone®, while in 2011 artists Daniel E. Kelm and Tauba Auerbach created a digitally printed *RGB Colorspace Atlas* in book form. This fascinating object takes the form of a cube (20 x 20 x 20 cm) and presents every variation of the RGB model of color. The concept of printing RGB is in fact somewhat misleading; reminiscent, in fact of the confusion of material with immaterial color common to in the eighteenth century. RGB (based on the colors red, green and blue) is an additive model, intended for electronic devices such as computer screens. At some point during the creation of this book, the colors would have been converted to a subtractive model—probably CMYK (based on cyan, magenta, yellow and black)—for printing.

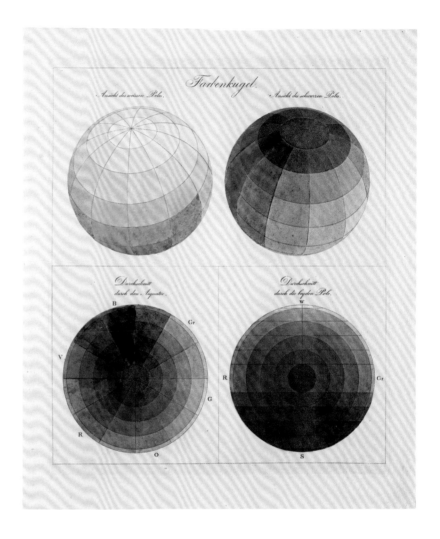

Above: Philipp Otto Runge's theoretical "Farbenkugel" (color globe) from 1810, with views of the white and black poles (top, right and left), an 'average through the equator (bottom left) and average between the poles (bottom right).

Right: Munsell's color globe from 1900, as the frontispiece to *A Color Notation*. Munsell was known to have used real color globes in his teaching, but, unfortunately, none appear to have survived.

PLATE I

A BALANCED COLOR SPHERE
PASTEL SKETCH

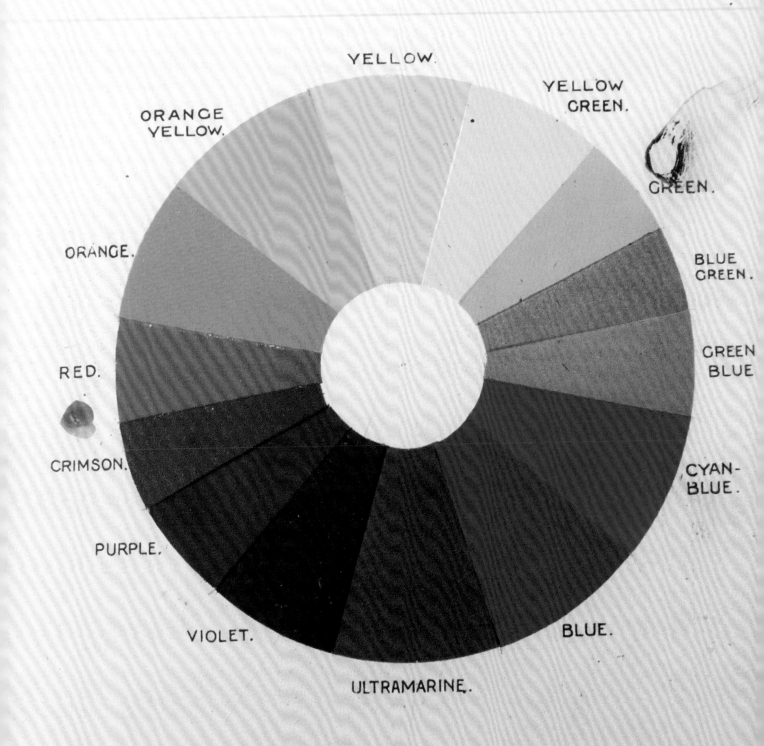

YELLOW.

YELLOW GREEN.

ORANGE YELLOW.

GREEN.

ORANGE.

BLUE GREEN.

GREEN BLUE

RED.

CRIMSON.

CYAN-BLUE.

PURPLE.

VIOLET.

BLUE.

ULTRAMARINE.

Owing to the impossibility of obtaining colours of sufficient depth at the time of printing, the tints marked "Green Blue" and "Ultramarine" are too light for their places in the circle.

Beyond Newton's Disk:
New Ideas in Popular Manuals

Apart from theoretical, critical and experimental literature on color, the turn of the twentieth century saw the publication of a wealth of popular, practical and affordable handbooks on color in painting. In contrast to manuals on painting from the early nineteenth century, these books were almost exclusively illustrated using lithographic or photographic image reproductions. But while color printing was now easier and cheaper, some authors bemoaned the limitations and inaccuracy of mechanical color reproduction. In most of these publications text still greatly outweighed image content, and however simplified the various wheels and diagrams may appear, they often reference complex systems developed in the nineteenth century.

Barrett Carpenter's Disk for Artists

One such was the relatively little-known work by Henry Barrett Carpenter, modestly titled *Suggestions for the Study of Colour*, aimed at fine arts students. Barrett Carpenter was the Headmaster of a School of Art in Rochdale in the north of England and he privately published the book in 1915, with a second edition (shown here) appearing in 1923. He gives much practical advice on how to use color in art but puts even more emphasis on color theory and systems in general. The majority of the images illustrating concepts of color contrast, harmony, discord, arrangement and appearance use abstract or semi-abstract shapes, and the first plate—as in so many books on color—shows a color wheel.

In his introduction, the author criticizes Chevreul and his trichromatic concept of color (see pages 94–95) and announces that he wrote his book because he felt a need for new and independent studies of color. While Barrett Carpenter distanced himself from Chevreul's work, he was more complimentary of American physicist Ogden Rood (see pages 120–121) and modeled his own color system on Rood's "natural order of color," where colors scale from light to dark ranging from yellow (nearest to white light) to violet or purple (nearest to black).

Since his chromatic system is based on Rood's table of ten or eleven colors, Barrett Carpenter's color circle is already more segmented than one based on a pure trichromatic one, and he has added a further four intermediate tints to Rood's ten (orange-yellow, yellow-green, blue-green and cyan-blue), resulting in a fourteen-tint color circle. Two things are of additional interest in this little guidebook: firstly, the copy pictured here shows telling signs of use by a painter. Smudges of water-based paint and finger marks can be found on many pages but particularly on the color wheel plate. One can imagine the book placed next to the paint materials of a young art student, the color circle displayed as a handy reference image. Secondly, the author has acknowledged the limits of color reproduction in print culture in the early twentieth century. A pasted-in paper strip (similar to an errata slip) under his color wheel notes: "Owing to the impossibility of obtaining colours of sufficient depth at the time of printing, the tints marked 'Green Blue' and 'Ultramarine' are too light for their places in the circle." Anxious to provide the best possible image of his color system, Barrett Carpenter was faced with the problem of how to picture colors— some of which he named after pure, deep and brilliant pigments—within the limits of image reproduction of his time.

Left: Barrett Carpenter's color wheel is based on the color system of Ogden Rood, albeit with the addition of four extra intermediate tints.

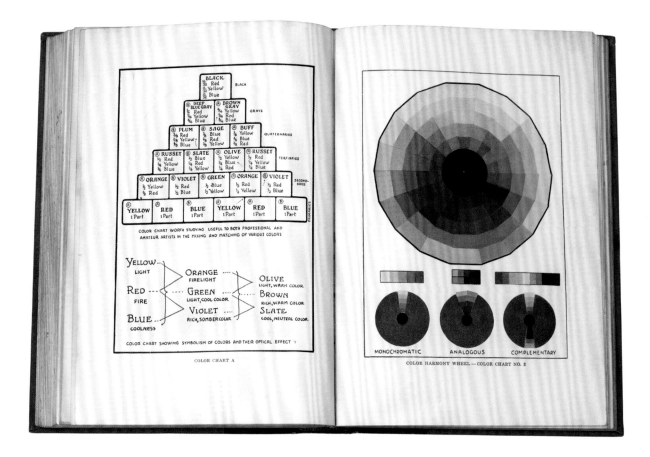

De Lemos's Hands-on Approach

In 1920 the American artist, designer, lecturer and art teacher Pedro Joseph de Lemos published a substantial and practical self-study course on *Applied Art—Drawing, Painting, Design and Handicraft* (first published in 1920 and reissued in 1933), aimed at a very wide range of readers, ranging from children to teachers. It is not strictly a book about color, but de Lemos, a dedicated and hands-on educator, decided to place "Drawing and Coloring" at the very beginning of his book, considering these crucial elements in art and design. He had considerable experience in printing and publishing, having worked for the publisher of his book, the Pacific Press Publishing Association in California, and influenced by Japanese woodblock prints in his own artistic practice. It is no surprise then that the work was richly illustrated in both black and white and color. The text element is structured as a sequence of very short paragraphs in bullet-point style, punctuated by many illustrations, mostly using lithographic printing methods.

Simplicity and clarity were of utmost importance to de Lemos. On the subject of color harmony, he proposed a simple system of adjoining or contrasting tints: "Good Color Harmonies are as follows: yellow and orange, orange and red, red and violet, violet and blue, blue and green, green and yellow; also, red and green, yellow and violet, and blue and orange. If we have a flowerpot in one of the colors, then the flower should be of the other color."

Most importantly, he encourages his readers to play with cut-out color shapes in order to understand how color works. The first color plate of the book (right) illustrates this in a simple, playful and accessible way. Instead of a color wheel he opts for a table of six colors (red, orange, yellow, green, blue and violet), typical of a trichromatic system, and adds examples of so-called "harmony birds" sitting on a branch. These are cut-out shapes of colored paper, which the reader should use to experiment with color combinations. Underneath the birds are shown cut-out pieces of transparent colored paper in the shape of lanterns, which illustrate color mixtures. This, along with many other plates in the book, is an inventive way of applying color theory that makes it easy to understand for children, amateur artists and teachers alike.

Above & opposite: Later in his book, at the "Academic Grades" stage of the course, de Lemos introduces a number of color wheels and diagrams, some designed to instruct his students on color harmony, others on color mixing, matching and symbolism.

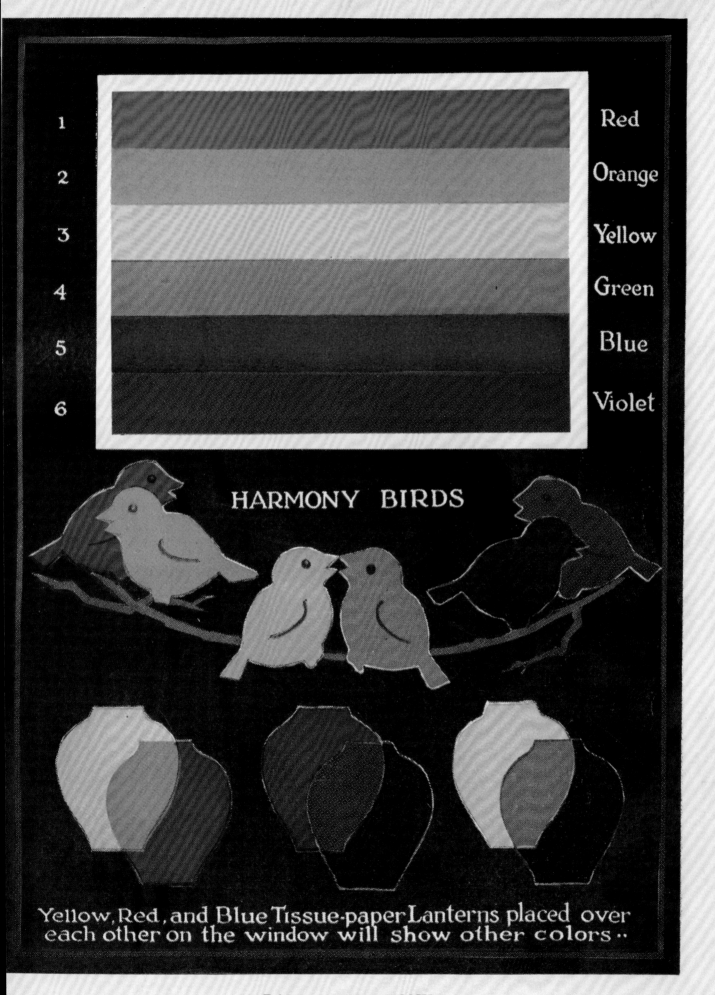

1 Red

2 Orange

3 Yellow

4 Green

5 Blue

6 Violet

HARMONY BIRDS

Yellow, Red, and Blue Tissue-paper Lanterns placed over each other on the window will show other colors··

A RAINBOW HARMONY

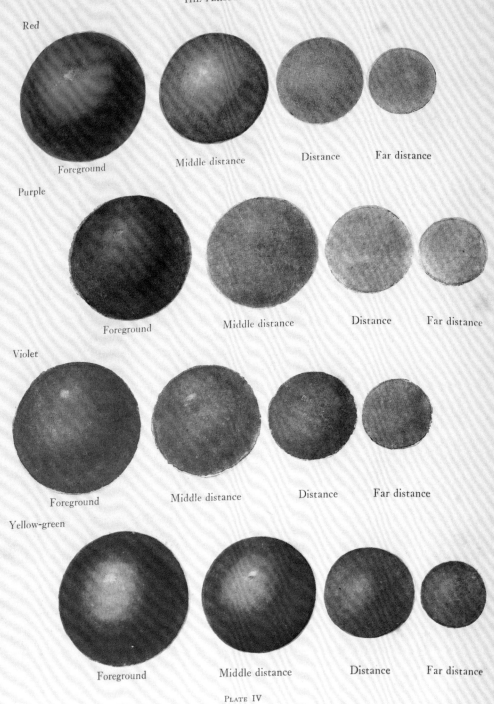

Red

Foreground Middle distance Distance Far distance

Purple

Foreground Middle distance Distance Far distance

Violet

Foreground Middle distance Distance Far distance

Yellow-green

Foreground Middle distance Distance Far distance

PLATE IV

Michel Jacobs's Planets in Space

Michel Jacobs's manual *The Art of Color* from 1923 is similar in approach to de Lemos's instructive guidebook and aimed at a wide and general readership of amateurs and students of art. Color knowledge is here applied to many disciplines, including weaving and textile design, fashion, landscape painting and even gardening. In the foreword Jacobs notes that this "is not a scientific book but is based on scientific knowledge," which explains the short but informed introduction to color theory in the first chapter. He uses a simple color wheel as a guideline, based on the spectrum primaries red, green and violet (following Thomas Young's and Hermann von Helmholtz's theory, based on their discovery of optical receptors) but explains that the "painter's palette need only consist of three colors and white, namely crimson, lemon yellow and blue," from which all other colors can be mixed.

Jacobs was born in Canada but relocated to the United States in 1914, where he worked as an art teacher.

An artist and printer himself, he illustrated his book with many of his own works and put particular emphasis on the possibilities of printing in color in the early twentieth century. Surprisingly though, he criticizes the often obvious "lack of coordination between the color-printer, the plate-maker and the photographic material concerns," especially in America (where the book was first printed). It is clear that Jacobs put a lot of effort into the 43 illustrations of his book, and while they are not of the greatest technical quality by today's standards, they are a valiant attempt at highlighting the importance of accurate color reproduction in print culture.

Many of the plates also show considerable creative thinking where color systems are concerned. Plate IV (opposite), for example, illustrates "The Perspective of Color," or how colors change their appearance depending on their distance from the viewer, which suggests how a painter should depict colored objects in the foreground, middle distance or far distance of a composition. Jacobs provides examples of color balls like planet formations in red, purple, violet and yellow-green, diminishing in saturation and size with increasing distance.

Left: Plate IV: "The Perspective of Color," showing how the intensity of a hue diminishes as the object recedes into the distance.

Above: On the left, Plate XXX: Jacobs's 24-color spectrum and, on the facing page, Plate XXXI: "Color Types," which shows combinations of different inks.

ADAM AND EVE By MICHEL JACOBS
Printed in four colours—yellow-yellow-orange, crimson-scarlet, blue-blue-green, blue-violet-violet

PLATE XXXIV

PROGRESSIVE PROOF OF FOUR-COLOUR PRINTING
YELLOW-YELLOW-ORANGE, CRIMSON-SCARLET, BLUE-BLUE-GREEN
PLATE XXXV

In several other abstract plates Jacobs provides a breakdown of how different inks can be combined in two-, three- and four-color printing (previous page, top), followed by a pictorial example of progressive proofs of four-color printing, depicting Adam and Eve in the garden of Eden (above and opposite, top).

Jacobs uses mostly his own paintings to illustrate aspects of color in art, for example in "The Violet Veil" (Plate XIX, opposite, bottom left), which is composed of "split complementaries of five colors and one mutual complementary: blue-green, blue, blue-violet, violet-purple and orange." However, in his chapters on applied arts, such as costume design and interior decoration, he also borrows from other sources to highlight the adaptability of his color system. "Color in clothes also affects our character," he states in

Chapter 14; and while he recommends a predominantly monochrome palette for men's clothing, he suggests a long and detailed list of different styles and color combinations for women, according to the time of day, season and social circumstances. He adds an intensely bright picture lifted from a fashion catalog, showing three young women, one dressed in red, one in orange with a green sash and collar, and one in a deep blue, with "shadows going toward their complementary" (opposite, bottom right).

The book finishes with an extensive "Dictionary of Colors," possibly of US-American origin, which lists pigments and describes their places in the spectrum, their complementaries, history, chemical properties and psychological or symbolic meaning.

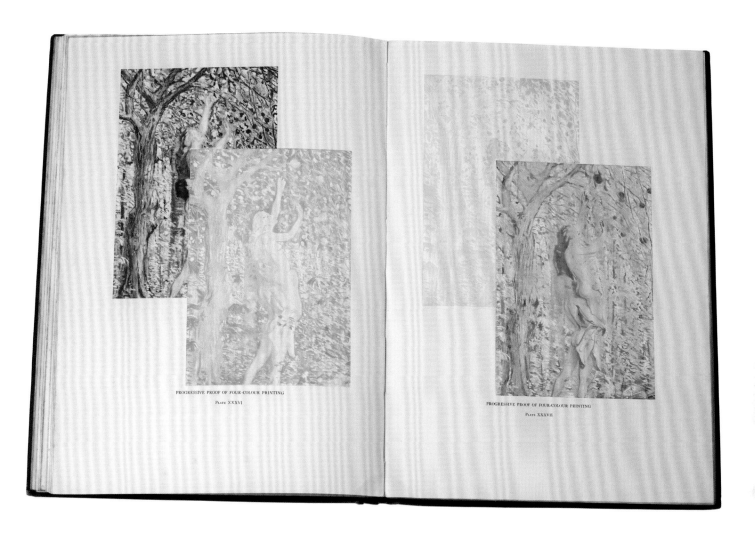

PROGRESSIVE PROOF OF FOUR-COLOUR PRINTING

Plate XXXVI

PROGRESSIVE PROOF OF FOUR-COLOUR PRINTING

Plate XXXVII

Left & above: Here, Jacobs illustrates the advantages of dividing the spectrum into four colors instead of three, for the purpose of lithographic printing. He traces the creation of the image of Adam and Eve backwards through the print process.

Right: Two plates from a section of *The Art of Color* applying Jacobs's theory to art (left) and fashion (right).

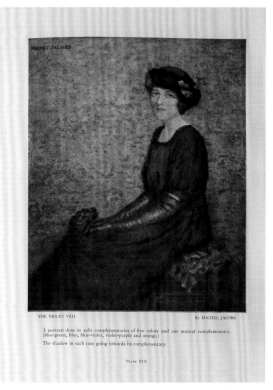

MICHEL JACOBS

THE VIOLET VEIL By MICHEL JACOBS

A portrait done in split complementaries of five colors and one mutual complementary.
(blue-green, blue, blue-violet, violet-purple and orange.)

The shadow in each case going towards its complementary.

Plate XIX

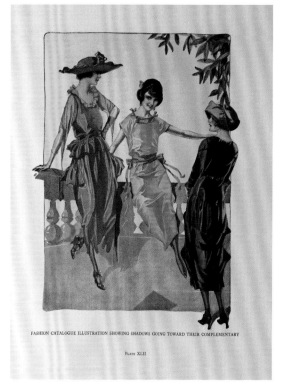

FASHION CATALOGUE ILLUSTRATION SHOWING SHADOWS GOING TOWARD THEIR COMPLEMENTARY

Plate XLII

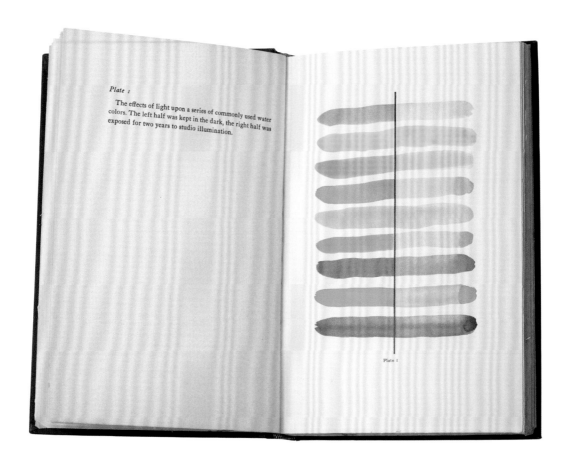

Plate 1

The effects of light upon a series of commonly used water colors. The left half was kept in the dark, the right half was exposed for two years to studio illumination.

Plate 1

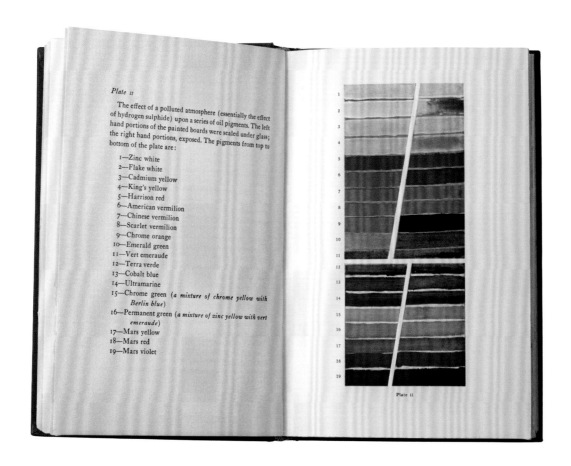

Plate 11

The effect of a polluted atmosphere (essentially the effect of hydrogen sulphide) upon a series of oil pigments. The left hand portions of the painted boards were sealed under glass; the right hand portions, exposed. The pigments from top to bottom of the plate are:

1—Zinc white
2—Flake white
3—Cadmium yellow
4—King's yellow
5—Harrison red
6—American vermilion
7—Chinese vermilion
8—Scarlet vermilion
9—Chrome orange
10—Emerald green
11—Vert emeraude
12—Terra verde
13—Cobalt blue
14—Ultramarine
15—Chrome green (*a mixture of chrome yellow with Berlin blue*)
16—Permanent green (*a mixture of zinc yellow with vert emeraude*)
17—Mars yellow
18—Mars red
19—Mars violet

Plate 11

Martin Fischer's Decaying Palette

In 1930 the American scientist Martin Fischer wrote a handbook and reference work that dealt almost exclusively with painting tools, techniques and the permanence of pigments, *The Permanent Palette*. In his book Fischer identifies several external causes for pigment change: exposure to light and to air, mixing colors (that is, chemical reactions between pigments and binders), reaction to the paint medium and painting ground, reactions to extreme temperatures, as well as atmospheric pollution. While most of these factors were already known to researchers, there had never before been a publication that dealt exclusively with the permanence of color.

Fischer saw the need to publish on the instability of artists' materials because he had noted a significant decline in the color quality of paintings in the nineteenth and twentieth centuries. His book begins with a quote by the Swiss painter Arnold Böcklin, who laments that "modern pictures have not lasted as those of the old masters have lasted centuries." It is a modern malaise, so Fischer argues himself, and with an overtly conservative tone he accuses contemporary and recent artists of putting too much emphasis on the "expression of his emotion in painting," resulting in an impatience concerning the careful choosing and preparation of materials. Sellers of artists' materials and teachers, too, are criticized by Fischer, as being interested only in results, not in good methods. Ready-made materials and lack of knowledge of how grounds are prepared and pigments bound and mixed led to many paintings after 1800 having decayed within a very short span of time, he claimed, citing the dullness of works by James Abbott McNeill Whistler and Frank Duveneck as examples. Given its scientific content and Fischer urging potential readers to engage more with raw artists' materials, it proved hard to find a publisher for *The Permanent*

Palette. One rejection letter from 1929 points out that it is "too scientific in character to hold painters" and that "it is almost impossible to get artists to take time or make the effort to undertake serious study of color."

Two of the four color plates in the book illustrate pigment use in works of art. The other two are lithographic reproductions of photographic images that make a valiant attempt at showing the effect of light exposure on strips of watercolor (Plate I, opposite, top) and of atmospheric pollution on nineteen oil pigments (Plate II, opposite, bottom). While the lithographs are not entirely successful in showing discoloration, they display an unintended abstract beauty and are good examples of experiments carried out by Fischer in his studio.

Fischer owned a meticulously classified and labeled collection of nearly 300 pigments, dye and binder samples and kept notes and lecture transcripts, all of which were donated to the geological collection at Milwaukee Public Museum after his death. The collection includes the panels of oil paints he tested for fading that are reproduced in *The Permanent Palette*, a postcard from German fellow-scientist Wilhelm Ostwald (see pages 166–169) to Fischer and a complete Ostwald color wheel, recreated in powdered pigments. It is tempting to think of Fischer as a twentieth-century American version of nineteenth-century British colorman George Field (see pages 60–67), who was equally concerned with the quality of pigments. Like Field, Fischer made an unprecedented impact on the pigment industry of his country. In contrast to Field, though, he made it clear that he was working strictly within the context of fine art and artists' tools only, without developing or promoting any particular color theory or system.

Left, top: One of four colored plates, this shows the fading effect of light on watercolor.

Left, bottom: Another plate shows the effect of 'a polluted atmosphere (especially the effect of hydrogen sulphide) on a range of pigments.

Orphism: Colorful Music and Musical Color

The Bohemian-born painter and illustrator František Kupka studied and worked in Paris from 1896. He had a great interest in theosophy, mysticism and color theory and began making color the subject of many of his works in the early years of the twentieth century. In his self-portrait from 1907, *The Yellow Scale*, the artist is immersed in the titular color, visually and symbolically, while the title of a semi-abstract female nude from 1909, *Planes by Colors, Large Nude*, reveals his focus on color as the dominant compositional tool. In 1909, Kupka read the newly published *Manifesto of Futurism* and was influenced by the ideas coming out of the Futurist movement as well by Cubism, which he encountered at almost the same time. From this point Kupka embraced abstraction and began to produce paintings that referenced color theory and its relationship with music and movement.

In 1912 he painted *Disks of Newton (Study for a Fugue in Two Colors)*, in direct reference to Isaac Newton's experiments in splitting white light (see pages 12–17). *Disks of Newton* features the seven prismatic colors identified by Newton as well as white, and there is a complete absence of black. The result is a canvas of vivid colors that look utterly infused with light. In the circular arrangement of these pure hues, Kupka plays on the format of Newton's diagram, adding a powerful sense of rhythm and movement, and creating a convincing impression of wheels spinning in bright white light.

Kupka's work almost certainly influenced the much wider known Ukrainian-French artist couple Robert Delaunay and Sonia Delaunay, who joined Kupka in reintroducing pure, spectral color to the muted and monochromatic palettes favored by the cubists, as well as pushing cubism toward greater abstraction. Like Kupka, the Delaunays were deeply interested in color theory, particularly the work of Michel-Eugène Chevreul, as well as spiritual and musical aspects of color. Robert Delaunay's *Simultaneous Contrasts: Sun and Moon* (1912–1913), for example, is a response to Michel-Eugène Chevreul's *On the Law of the Simultaneous Contrast of Colors* from 1839 (see page 90–91). The Delaunays became the champions of the Orphism, the name for the movement as coined by the French poet Guillame Apollinaire in reference to Orpheus, the musical artist-poet of Greek myth.

Orphism drew a connection between the unrelatedness of music to anything but itself, and the intangible, optical quality of color as a quality or property. The Delaunays' compositions, like Kupka's, are full of disks, curving lines and color combinations that give each canvas a distinct rhythm, totally abstracted from reality. Yet though the connection between color and music was a driving force in Orphist work, it was not as literal as the one Newton drew: "the chromatism of music and the musicality of colors have only metaphorical validity," Kupka admitted.

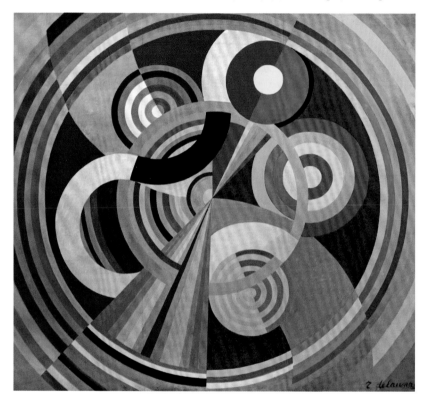

Right: Robert Delaunay's *Rythme n°1* from 1938 has a greater sharpness and clarity than his works from the 1910s but is still occupied with the same themes, with color, music and movement as the interrelated subjects. Several prismatic color ranges, along with achromatic tonal ranges, are incorporated in the square composition.

Opposite: Kupka's *Disks of Newton (Study for "Fugue in Two Colors")* from 1912.

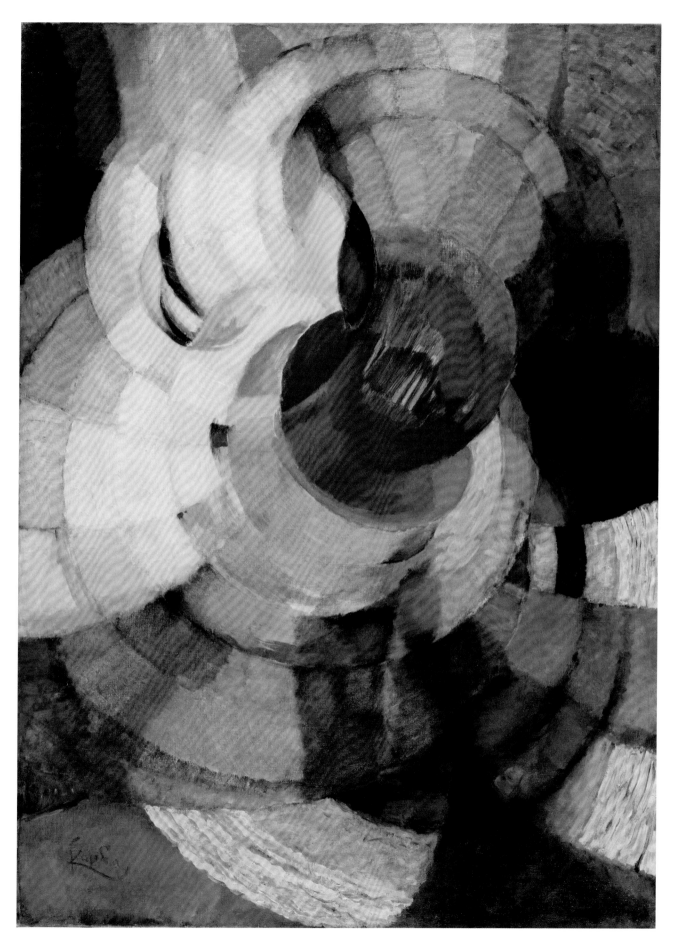

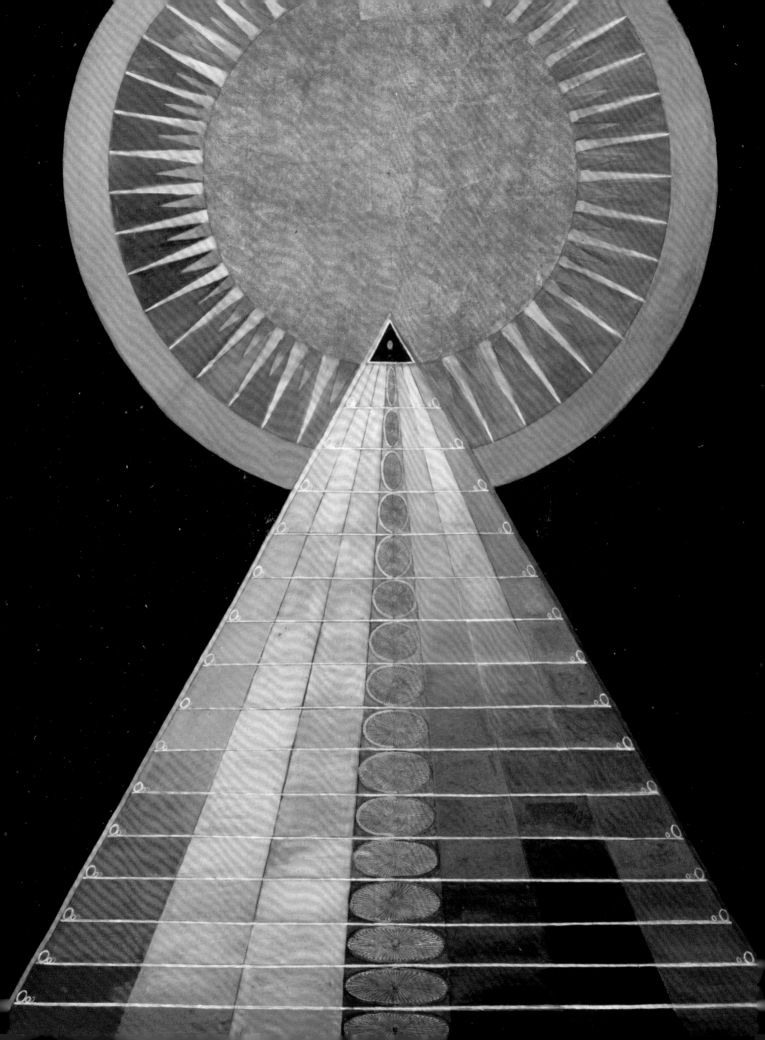

Mystical Colors: Hilma af Klint and Charles Leadbeater

The Swedish artist Hilma af Klint is often described as a pioneer of abstract painting but her work has, until recently, not been well known or researched. This is partly due to the artist deciding not to show any of her abstract works during her lifetime. She even requested for these not to be displayed until twenty years after her death, which explains why her work is not mentioned in many accounts of Modernism, abstraction and women's art. Born into an educated, bourgeois and Protestant family, she studied art at the Royal Academy of Fine Arts in Stockholm. Her early work was strictly representational and included landscapes, flower studies and portraits.

From a young age she developed an interest in esoteric literature, occultism and spiritualism and in 1880 joined the Theosophical Society. She was at some point mentored by the head of the German branch of the Theosophical Society, Rudolf Steiner, who had worked as the editor of a major scholarly edition of Goethe's works (the "Kürschner" edition) at the Goethe Archives in Weimar. In 1896 she formed the group De Fem (The Five) with four other female artists interested in experiencing and expressing the mystical and spiritual in their meetings and their art. A séance attended by the group in 1904 was of particular significance for af Klint, as a spirit supposedly instructed her to paint "the immortal aspects of man." She began painting canvases on a monumental scale—some of them taller than six meters. Her abstract compositions combine sharp geometric shapes with spirals and intertwined lines that bear some resemblance to climbing flowers. Sometimes recognizable symbolic objects or creatures, for example a shell, a dove or a swan, are incorporated. In one of her series, *Evolution*, naked human figures fill the geometric shapes, reminiscent of Leonardo da Vinci's *Vitruvian Man*. Af Klint's colors are bright, comprising mostly primaries and secondaries. They are often complementary, but sometimes deliberately jarring; for example, combining deep blacks and highly saturated reds, yellows and oranges with dusty pinks, pale blues and muddy browns.

For af Klint, color became a main means of both creating visible brightness and expressing the invisible and the spiritual. In many of her large abstract works she depicts a full spectrum in shapes and forms that bear a strong resemblance to color diagrams of the eighteenth and nineteenth centuries. Color wheels appear in several variations in her art, as do rhombic and triangular shapes. A canvas from *The Dove* series (*No. 14, Group IX/UW*, 1915) shows a large circle of the seven rainbow colors against a black background, while the inside of the circle is white, with a miniature color wheel in the center. It is clear that she had considerable knowledge of optical studies and was possibly referring to Newton, Goethe and other color theorists in her work.

The depiction of the Newtonian color range is particularly obvious in her series *Altarpieces* (1915). In *Altarpiece No.1* (opposite) Newton's seven colors form a pyramidal shape whose base commands the width of the canvas. All the colors pale toward white as they reach the black, triangular tip of the triangle, which intersects a circlular formation. The innermost circle is colored gold, and rayed with yellow and violet/pink, in a form suggestive of the sun. The composition is, of course, immediately suggestive of Newton's prism experiment, but it also calls to mind the loaded polarity of Goethe. A deep and even black forms the background: the themes of color, light and darkness are placed here in a strongly mystical and religious context. Af Klint rightly deserves her reputation as a pioneering abstract artist using color as a powerful symbolic tool.

Left: The pure colors and distinct forms are among the most striking aspects of Hilma af Klint's *Altarpiece No.1* (1915). The sun shape atop a prismatic pyramid suggests both spirituality and Newton's optical experiment.

The Colors of Man

While we don't know which historical color theories af Klint may have consulted, we do know that she was familiar with the work of two leading British theosophists: Charles Webster Leadbeater and Annie Besant. In 1901 Besant and Leadbeater jointly wrote the book *Thought-Forms: How Ideas, Emotions and Events Manifest as Visible Auras*, which discusses the color of auras. They proposed that "emotional changes show their nature by changes of color in the cloud-like ovoid, or aura, that encompasses all living beings."

The following year, Leadbeater published his own work on the subject: *Man Visible and Invisible: Examples of Different Types of Men as Seen by Means of Trained Clairvoyance*. The book's frontispiece (left) is a table of 25 colors, each assigned a character trait, or disposition, such as high spirituality, fear, jealously or sensuality.

Leadbeater devoted a chapter to the meaning of colors surrounding astral bodies, and explained the complexity of representing and translating these auras: "Before we can intelligently study the detail of these various bodies, we must familiarize ourselves with the general meaning of the various shades of colour in them, as indicated in our frontispiece. It will be realised that almost infinite variety is possible in their combination . . . [h]uman emotions are hardly ever unmixed, and so we have constantly to classify or to analyse indeterminate hues in the formation of which

many factors have played their part. Anger, for example, is represented by scarlet, and love by crimson and rose; but both anger and love are often deeply tinged with selfishness, and just sofar as that is the case will the purity of their respective colours be dimmed by the hard brown-grey which is so characteristic of this vice." He discusses black, red, brown, greenish-brown, gray, crimson, orange, yellow, green, gray-green and blue in some detail, but assigns to green the widest range of manifestations.

Twenty-three further color plates and three diagrams illustrate the appearance of the aura and astral bodies, depicted as ovoid shapes with fluid masses, swirls and blots of colors, with the outline of a male human figure at the center. The mostly abstract compositions, in which color and form carry heavy symbolic meaning, bear a resemblance to af Klint's work, and it is likely that Leadbeater's publications influenced her art. The illustrations were created by Count Maurice Prozor, whom Leadbeater thanks at the beginning of the book, while he also expresses gratitude to "Miss Gertrude Spink, who spent many days in patiently copying them with the air-brush, in order that they might be more successfully reproduced by the photographic process."

With their focus on spirituality, mysticism and the symbolic meaning of color Leadbeater's and Hilma af Klint's work predates Wassily Kandinsky's hugely influential 1911 publication *On the Spiritual in Art* (see overleaf). Theosophy as a philosophy had (and still has) a considerable following, and with its focus on spiritual and abstract concepts it was particularly applicable to the arts. It can be argued that the functional abstraction employed in the illustrations of Besant's and Leadbeater's publications appealed to early twentieth-century abstract and expressionist artists and bear a remarkable resemblance to compositions by the Russian Constructivists and the formal geometry of many designs by artists of the greater Bauhaus circle. In fact, Kandinsky, who had a great interest in theosophy without ever becoming actively involved with the Theosophical Society, owned a German edition of *Thought Forms*. Like af Klint, he also met with and studied the writings of Rudolf Steiner, who lectured extensively on spiritual and moral concepts of color between 1914 and 1924. Steiner's edition of Goethe's *Farbenlehre* is still in print, which suggests that the connections between art, color literature and theosophical philosophy remain strong.

1				
2				
3				
4				
5				

1. High Spirituality.	1. Devotion mixed with Affection.	1. Devotion to a Noble Ideal.	1. Pure Religious Feeling.	1. Selfish Religious Feeling.
2. Religious Feeling, tinged with Fear.	2. Highest Intellect.	2. Strong Intellect.	2. Low type of Intellect.	2. Pride.
3. Sympathy.	3. Love for Humanity.	3. Unselfish Affection.	3. Selfish Affection.	3. Pure Affection.
4. Adaptability.	4. Jealousy.	4. Deceit.	4. Fear.	4. Depression
5. Selfishness.	5. Avarice.	5. Anger.	5. Sensuality.	5. Malice.

KEY TO THE MEANINGS OF COLOURS.

Opposite: The frontispiece to *Man Visible and Invisible*, featuring 25 colors that can be perceived in auras. Each color is assigned a character trait or emotion.

Above: A figure described as "The Devotional Type" with a "most prominent feature" of "unusual development of the blue, showing strong religious feeling."

Right: Later in the book, Leadbeater illustrates the aura of "The Developed Man," a person who has made spiritual progress and has achieved an evenly balanced state of mind. The figure's "glorious iridescent film is now filled with the most lovely colours, typifying for us the higher forms of love, devotion and sympathy, aided by an intellect refined and spiritualised, and by aspirations reaching ever towards the divine."

From Blue to Infinity: Wassily Kandinsky and the Forms of Colors

The Russian artist Wassily Kandinsky published his treatise *Über das Geistige in der Kunst (Concerning the Spiritual in Art)* in 1911. It became one of the most influential commentaries on abstraction and color symbolism in European avant-garde art, written by one of its key figures. As colorful and large-scale as Kandinsky's art was, this publication was modest in design and scope. It was of small format (22 x 18.5 cm), bound in plain wrappers, and its 125 pages of text were illustrated with only eleven uncolored woodcuts made by Kandinsky himself, including the cover image (opposite). The simplicity was deliberate and underlined one of Kandinsky's key ideas: that complex themes in art could be reduced to simple compositions comprising just a few lines, geometric shapes and pure colors. The treatise was surprisingly popular. Further editions were printed within weeks (the 1912 second edition is shown here) and a first English translation by Michael T. H. Sadler was published in 1914.

Kandinsky's system of color order bears similarities to Goethe's notion of a polarity of blue and yellow, representing darkness and light and cold and warmth. He was also influenced by the German scientist Karl Ewald Konstantin Hering, who had rejected trichromatic color systems by theorists such as Thomas Young, James Maxwell and Hermann von Helmholtz, and from 1878 proposed his theory of color vision based on dualistic oppositions (Hering's pairs were red and green, blue and yellow, and black and white).

A recurring theme among artists and writers in the early twentieth century, and especially those experimenting with abstraction, was the correlation

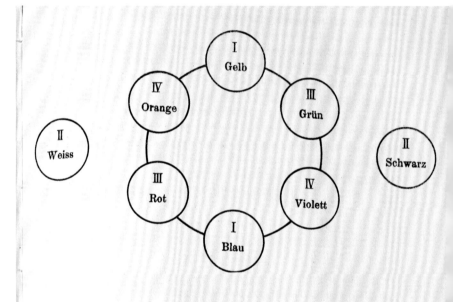

between shape and color. Kandinsky expressed this idea in his publications and later in his teaching, devoting an entire chapter in *Concerning the Spiritual in Art* to "The Language of Form and Color." He probably first encountered the concept through the early abstract painter and teacher Adolf Hölzel in Munich. Kandinsky himself formulated different associations to Hölzel between specific colors and shapes, and later developed this part of his color theory in surveys he conducted at the Bauhaus art school where he taught between 1922–1933: "A triangle filled in with yellow, a circle painted blue, a green square, another triangle in green, a yellow circle, a square in blue, these are different forms that have separate distinctive effects," he wrote.

KANDINSKY

ÜBER
DAS GEISTIGE
IN DER KUNST

ZWEITE AUFLAGE

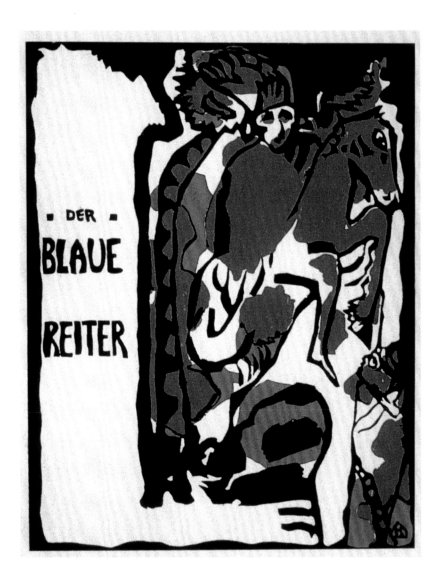

Right: Kandinsky's design for the cover of *The Blue Rider* almanac from 1912.

Opposite: Kandinsky's *Einige Kreise* (*Several Circles*, 1926), which places overlapping circular shapes against a black background, allude to the relationship between light, darkness and color. The effect is that of pulsating color forms interacting. Here, Kandinsky is clearly playing with ideas of the multidimensionality of color.

Kandinsky had allegedly worked on the book for roughly a decade, which ties in with the course of his path from representational art to near complete abstraction. The year it was finally published was also the year he co-founded the artists' group Der Blaue Reiter (the Blue Rider) in Munich, together with Franz Marc, Gabriele Münter, Alexej von Jawlensky, Marianne von Werefkin, August Macke and other associated artists, such as Lyonel Feininger and Albert Bloch. Inspired by Post-Impressionists, Vincent van Gogh in particular, medieval as well as folk art, and primitivism, they shared an interest in abstraction, new forms of expression and unconventional ways of using color.

The name chosen for the group, the title of a painting by Kandinsky from 1903 showing a horseman in a blue coat on a white horse in a landscape, reflects the significant role that color played in their art and philosophy. Blue was both Kandinsky's and Marc's favorite color and became a key motif in their work. Kandinsky especially considered blue to be the color of spirituality, masculinity, purity and infinity: "The deeper the blue the more it beckons man into the infinite, arousing a longing for purity and the supersensuous. It is the color of the heavens just as we imagine it, when we hear the word heaven." Yellows, by comparison, were considered feminine, while reds and blacks were used to depict passion, violence and conflict. More radically than anyone before them, Blue Rider artists used color as an expressive tool and a compositional element in both representational and abstract pictures.

Science and Math in a Complex Color System

Friedrich Wilhelm Ostwald was a Baltic-German scientist who turned his interest to the fine arts, and in particular to color theory, after receiving the Nobel Prize for Chemistry in 1909. As an amateur painter he made his own pigments and paints, and he published a small practical guidebook entitled *Malerbriefe* in 1904. An English translation, *Letters to a Painter*, appeared in 1907. The *Letters* combined his artistic aspirations with his interest as a chemist in pigment quality and stability. While lecturing chemistry at Harvard University in the United States in 1905/6, he met and was greatly inspired by Albert Henry Munsell (see pages 140–145), whom he followed in his systematic approach.

Ostwald published his first book on color theory, *Die Farbenfibel* (*The Color-Primer*) in 1916, followed in 1918 by an extended treatise on the same subject *Die Harmonie der Farben* (*The Harmony of Colors*). Both were small-format and slim volumes that appear simple in design, deceptively like school exercise books, but Ostwald's system is complex, combining geometry and math, and has been known to baffle even experts in the field. Although manufacturing industries were keen on a standardized color system, there was some resistance to the idea from traditionalist and craft circles. At one point Ostwald's system was even banned in Prussia.

Nevertheless, the *Farbenfibel*, was a successful publication and went into sixteen editions until 1944, found a readership outside the German speaking world, and was mentioned in *Wilson's Colour Chart* from 1938, despite having by then been superseded by other systems, including Munsell's. Among artists it was particularly popular with the Dutch De Stijl movement, who saw the aesthetic appeal of the strict geometry of the illustrations and the idea of black and white as distinct elements of color harmony.

Ostwald argued for dividing colors into three basic groups, a concept similar to Munsell's hue, value and chroma. He noted neutral colors, which denote the grayscale between black and white; full colors (or hues), without any black or white; and mixed colors of hues with gray or black content. Informed by Leonardo da Vinci and Karl Ewald Konstantin Hering, Ostwald proposed not three but four "basic colors:" yellow, red, ultramarine and sea green. From these four colors he developed a 24-grade circle of "standard of hues" (right). He determined a total number of 100 hues on his color wheel, as indicated by numbers on the inside of the ring, but only the 24 "standard" ones are shown, in the form of pasted-in color chips.

His system orders color by the amount of white or black added to the pure colors represented on the wheel, allowing precise mixtures to be recorded in a numeric formula recording color content, whiteness and blackness. Ostwald represented this in a triangular shape (see overleaf), while a rhomboid device allowed him to depict complementary colors; that is, those appearing opposite on the wheel.

Color harmony and contrast are other main themes of the book. Ostwald included several pages of examples of color pairs and trios, represented (respectively) as square or cubic diagrams, the latter used to illustrate the cover of *Farbenfibel*. The illustrations are consistently simple in design but

Opposite: Ostwald's color wheel demonstrates his tetrachromatic color order, based around the hues yellow, red, ultramarine and sea green.

ganze Zahl abzurunden. Für 31¼ schreiben wir also 31 und 63 für 62½. Die Farben des achtteiligen Kreises von S. 14 erhalten

77 bis 100. (Die Zählung beginnt bei dem Farbton 00 und läuft im Sinne des Uhrzeigers.)

derart statt der Zahlen 00, 12½, 25, 37½, 50, 62½, 75, 87½ die Zahlen 00, 13, 25, 38, 50, 63, 75, 88 zugeordnet.

2*

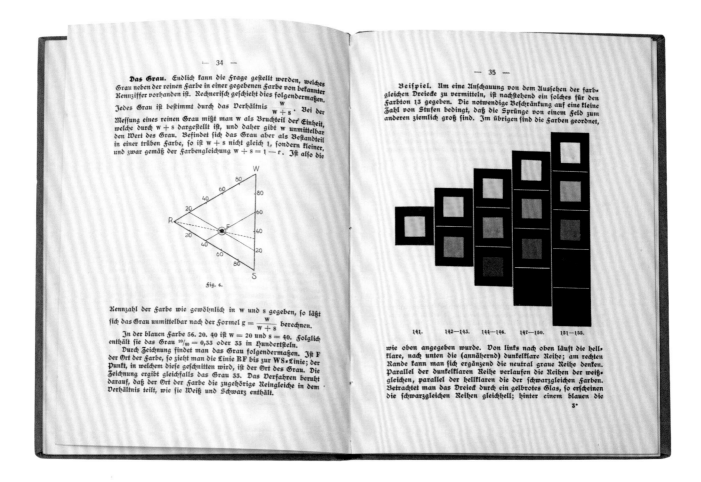

Above: One of Ostwald's hues, broken down on a pyramid structure, into intermediates based around a tonal scale.

high in quality: each hue is represented as a small square and either set in a black outline or against a completely black square. The color squares are not painted or printed but cut out from colored paper or card produced by Ostwald himself (as he proudly notes in the foreword) or under his supervision, ensuring the most accurate color depiction. To allow his readers to isolate certain color squares or to see them against a different colored background, the book has a small square template cut out of green cardboard, attached to a silk string and incorporated into the binding. It is not known why Ostwald chose this particular color for the template, but we might assume it was because he considered it neutral, or sufficiently different to black or white.

Although criticized for his complex system, Ostwald proved hugely influential in color education and spent the rest of his life developing his theories. He continued to publish illustrated books on color, including several color atlases. In the 1930s Winsor & Newton published a simplified version of Ostwald's system in English,

written by J. Scott Taylor—*The Simple Explanation of the Ostwald Colour System*. This short treatise (51 pages) is described as a handbook that "has been written to supply the demand which has arisen, both in Great Britain and America, for a small explanatory work on the Ostwald Colour System." It contains six lithographed illustrations. Ostwald's 24-hue color wheel and his bar of eight shades of "achromatic" grays form the frontispiece and are the only colored plates. As in the original work, the hues are pasted-in squares of colored card, here "executed with Winsor & Newton's Ostwald's Standard Showcard Colours." In 1969 Faber Birren rekindled an interest in Ostwald when he republished an edited English-language version of the *Farbenfibel* in America as *The Color Primer: A Basic Treatise on the Color System of Wilhelm Ostwald*, along with *A Grammar of Color: A Basic Treatise on the Color System of Albert H. Munsell* and a treatise written by Birren himself, *Principles of Color: A Review of Past Traditions and Modern Theories of Color Harmony*.

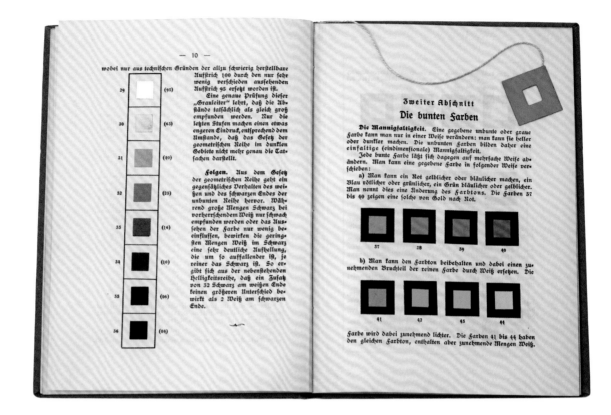

Above: On the left, Ostwald's "achromatic scale" (unbunt) of eight shades from white to black, and on the right a range of his "chromatic" (bunt) colors, with the square template on a silk string.

Right: On the left, simple examples of color contrast and interaction, and on the right Ostwald gives examples of "three-tone" (Dreiklang) color combinations, where each hue is at a 33.3-degree distance to the others on the color wheel.

Paul Klee and the "Chromatic Keyboard"

> *"Color and I are one.*
> *I am a painter."*

The Swiss-German painter Paul Klee was born into a musical family and was an accomplished violinist even as a young boy, but despite his musical leanings he chose to study art. In 1898 he traveled to Germany to study at the Academy of Fine Arts in Munich. Munich was then an important center of the arts, rivalling Paris as a place where avant-garde groups congregated and exhibited. Impressionism, Symbolism and At Nouveau/Jugendstil were the prominent styles and movements of the period, but by 1911 other styles such as Post-Impressionism and Expressionism had developed from these, moving toward abstraction and using color as an expressive tool and for its own sake.

In Munich, Klee saw exhibitions showing work by Paul Cézanne and Vincent van Gogh and was greatly impressed. There was also the powerful presence of Wassily Kandinsky, who founded Der Blaue Reiter group in Munich in 1911 (see pages 162–165), with which Klee was loosely associated. On visits to Paris around the same time he met Robert Delaunay (see page 156), whose compositions of abstract geometric color forms had the most direct influence on him. Klee's early work was representational, though with strong abstract tendencies, but after these encounters he began thinking and painting in concepts of color order and harmony and composed pictures of completely abstract color planes and shapes. In 1910 he remarked that the layout of colors in a paintbox was of greater importance to him than creating realistic images, referring to the paintbox as a "chromatic keyboard."

Over the next decades Klee produced many paintings that depicted color in formations of carefully placed squares and rectangles, reminiscent of pressed watercolor blocks, color charts in artists' guidebooks, or toy building blocks. His geometric compositions often appear like overlapping shapes and depict color shading and gradation, or chromatic impressions such as evening light or sunsets. Further inspired by travels to North Africa, Klee became obsessed with color, considering it the essence of painting: "Color and I are one. I am a painter," he exclaimed in 1914, after having seen the light and colors of Tunisia. In the same year the First World War broke out, breaking up many recently founded artist movements and groups, including Der Blaue Reiter.

Opposite: Paul Klee's painting *Alter Klang* (*Ancient Harmony*, 1926) is an example of Klee associating color arrangements with musical arrangements, and of his preferred visual composition of colors like geometric building blocks.

BAUHAUSBÜCHER

2

PAUL KLEE
PÄDAGOGISCHES
SKIZZENBUCH

The Notebooks

In 1925 Paul Klee published a 50-page volume of condensed versions of his lectures delivered during his early years at Bauhaus. This *Pädagogisches Skizzenbuch* (literally: *Pedagogical Sketchbook*, see above) was part of the small-format series Bauhausbücher, which ran between 1925–1930 and was edited and designed by Walter Gropius and László Moholy-Nagy. Apart from this and a couple of other modest volumes, Klee did not publish any of his writings or research on color during his lifetime, but he left nearly 4000 pages of notes, sketches and diaries relating to Bauhaus principles (see overleaf) and his teaching between 1923 and 1931. These manuscripts were sent from Germany to Switzerland in a large trunk after Klee emigrated in December 1933, fleeing the Nazi regime. They are known as Klee's *Bildnerische Form- und Gestaltungslehre* (literally: *Pictorial doctrine on form and creation*) but more commonly referred to as *Paul Klee's Notebooks*, and survive in the archives of the Zentrum Paul Klee in Bern, Switzerland. Between the 1950s and 1970s parts of these notebooks were published by Jürg Spiller, but he received considerable criticism for taking much of

Klee's work out of context. In 1970 a first facsimile and transcription of Klee's earliest lectures at Weimar were published by the Paul Klee Foundation, edited by Jürgen Glaesener.

Klee's contributions to art and color theory were considered so important that in 2012 the Paul Klee Zentrum in Bern digitised all the pages of his notebooks and made them available online, with transcriptions and annotations. These are highly personal sketches and notes, not edited or necessarily meant for immediate publication, but they give an unparalleled insight into Klee's thinking and particularly how closely he associated color order with musical compositions. While some colored sketches are relatively familiar geometric representations of color order—overlapping squares, circles or triangles of colors representing color mixtures—others convey more movement and rhythm. A number of them reveal how carefully the artist arranged color squares in his most abstract compositions, assigning each hue a musical note, creating visual color harmonies.

These facsimile manuscripts are an invaluable historical source and a prime example of knowledge and image capture in the digital age.

Above: Klee's *Pedagogical Sketchbook*, a coursebook produced for Bauhaus.

Right: One of several colored pages of Klee's notebooks. Here he visualises the relationship between primary, secondary and tertiary color mixtures in a diagram of overlapping triangles. On the right edge of the pages he added in pencil the hierarchical structure of these colors.

gleichen Teilen, und analog. verhalten sich orange und violett ihre Wirkungen: zu ihren Ursachen Gelb Rot bezw. Rot Blau. Wir sind also wohl berechtigt, den rechts erscheinenden Farben _verschiedenen Rang_ beizumessen.

Darstellung
Die Geometrische ~~Anschauung~~ des ganzen Geschehens wird uns dies mit noch knapperer Deutlichkeit zeigen.

Blau	Blau	4 Blau + 0 Gelb = Blau
		3 " + 1 " = Blaugrün
		2 " + 2 " = grün
		1 " + 3 " = grüngelb
Gelb	Gelb	0 " + 4 " = Gelb
		1 Rot + 3 " = gelborange
		2 " + 2 " = Orange
		3 " + 1 " = orangerot
Rot	Rot	4 " + 0 " = Rot
		3 " + 1 Blau = rotviolett
		2 " + 2 " = violett
		1 " + 3 " = violettblau
Blau	Blau.	0 " + 4 " = Blau

fig.11

Jetzt springt der secundäre Charakter der drei Mischungen direct ins Auge. Ihre Einordnung in die primäre Blau= Gelb= und Rot bewegung kann klarer nicht zum Ausdruck kommen. Die Ursächlichkeit der drei Primäre...

Bauhaus: Minimalist Color in Art and Design

In 1921 Klee was invited to join the German art school Staatliches Bauhaus in Weimar, Germany, formed in 1919 by the modernist architect Walter Gropius and in the early years strongly informed by the Swiss painter and color theorist Johannes Itten (see overleaf). Other significant members and teachers at the Bauhaus were Kandinsky, who joined in 1922, the sculptor Oskar Schlemmer, Oskar Kokoschka, Lyonel Feininger, László Moholy-Nagy, Theo van Doesburg and, later, Mies van der Rohe. Although the influence of Expressionism and even Art Nouveau was strong, Bauhaus style was radically minimalist, promoting clean lines, clarity, pure colors and strong materials. The overriding aim was to bring together the fine and applied arts, expressed in beautiful, simple and functional designs for all aspects of life, including kitchenware, furniture, toys and architecture. Like no other art and design movement, the Bauhaus school incorporated color theory in teaching and practice, and Paul Klee was at the heart of this for ten years. He resigned from the Bauhaus, which had moved to Dessau and eventually Berlin, in 1931, to take up a position at the Düsseldorf Academy of Fine Art. In 1933 the Bauhaus was labelled "un-German" by the Nazi party and the then Director Mies van der Rohe was forced to close it down. In the same year the Gestapo also removed Klee from his post in Düsseldorf, referring to his association with Bauhaus and labelling his art "degenerate."

Kandinsky, Itten and Klee all taught color courses, giving it a prime role as a powerful tool in art and design, often alluding to its synaesthetic qualities. Kandinsky, who attempted to find a universal correspondence of primary colors and geometric shapes (see pages 158–161), asked his students to color in shapes as part of a questionnaire. Although the results weren't uniform, the test highlights the correlation between form and color as a key principle of Bauhaus design and art. The Bauhaus Cradle (opposite, bottom), originally designed in 1922 by Peter Keler, is a striking example of the use of geometry and color in the design of everyday objects. It is constructed from red squares that form the sides, yellow triangles as head and foot of the cradle, held together by tubular, blue perfect circles that allow for a rocking motion. It comes as no surprise to learn that Keler was a student of Kandinsky.

In 1923 one of Itten's students, Alma Siedhoff-Buscher, designed a set of toy building blocks for a children's room of a model Bauhaus building in Weimar. *Bauspiel: Ein Schiff* (right, top) is just one of many examples of the clean lines, geometric shapes, robust materials and the use of strong primary and secondary colors in Bauhaus designs. These and other colorful building blocks were marketed for both children and adults, encouraging them to order color into either abstract three-dimensional compositions or recognizable structures, such as ships or bridges. Like the trichromatic cradle and many other functional objects, Siedhoff-Buscher's set of building blocks remains in production today.

Above: *Bauspiel: Ein Schiff* is a set of toy blocks designed in classic Bauhaus color and shape.

Right: The Bauhaus Cradle from 1922 introduces the clean lines and pure colors to a baby's cot.

The Art of Color:
Theory and Phenomenon

Opposite: Itten proposed a color globe as the ideal form for visualising color. Elevations of the globe can be seen at the bottom of the page, while its opened-out form presents as a 12-pointed star.

Overleaf: In this spread from the chapter on the "Theory of Color Expression" in *The Art of Color* Itten uses examples inspired by the four seasons to demonstrate complex harmonies in color palettes exemplifying different qualities; for example the "luminous colors" of spring (fig. 146); yellow and yellow-green with contrasting pinks and blues to "amplify and enrich the chord." Winter (fig. 149), by contrast, typifies "passivity in nature" and "require[s] colors connoting withdrawal."

Like Paul Klee, Johannes Itten was a Swiss-German painter who taught at the Bauhaus school—only relatively briefly, but during the experimental first years from 1919 to 1923. Invited by the school's founder Walter Gropius, who initially gave him a completely free hand, Itten developed and delivered the "Basic Course," in which students were given a chance to work in a number of different materials and attend short lectures on art theory, including color, as well as on general subjects from everyday life.

Itten famously started his lessons with relaxation and breathing exercises, replacing the traditional morning prayer, with the aim of concentrating the students' thoughts on the day's subject. Ideas of rhythm, contrast and composition were compared and applied to breathing patterns and physical movement, a method that caused initial bafflement among some students, but helped many to relax and focus. Despite introducing radical and experimental teaching methods, Itten was most strongly inspired by the seemingly more traditional and analytical approach of one of his own teachers, Adolf Hölzel, who in turn had been influenced by Goethe's writings on color. According to Itten, Hölzel had put much emphasis in his lectures on meticulously analyzing the line and color composition of Old Master paintings.

Itten's color theory was based on a twelve-part color wheel developed from three primaries (yellow, red and blue) and three secondaries (green, orange and violet). He further formulated seven contrast effects of colors: (1) pure color (hue), (2) light-dark, (3) cold-warm, (4) complementary, (5) simultaneous, (6) quality (saturation) and (7) quantity. Itten wished to "liberate the study of color harmonies from associations with form" and—perhaps inspired by Klee—considered the chess board the most suitable pattern for color studies (overleaf). In an attempt to provide "a clear and complete map of the world in color" he developed his color wheel into a color sphere, if only in two-dimensional form (opposite, bottom). His twelve-pointed color star (opposite,

top; Itten himself referred to it as both a star and a sphere) is a color diagram that can be projected on to a three-dimensional globe, with a graded tonality of the twelve colors—arranged in pure form around the equator—from light (white) to dark (black), as proposed by other color theorists such as Runge and Munsell before him (see page 144).

Itten wished to "liberate the study of color harmonies from associations with form"

Itten left the Bauhaus after an argument with Gropius about his teaching methodology in 1923 and opened his own art school in Berlin in 1926. Like the Bauhaus school Itten's art college came under pressure from the Nazis and he felt forced to dissolve it in 1934. In 1938, refusing to adopt German nationality, he emigrated to Switzerland.

The Second World War and its immediate aftermath caused a long gap in the publication of significant writings on color by the wider Bauhaus circle, but in 1961 Itten triumphed with an ambitious and state-of-the-art book on color that became an immediate classic. *Kunst der Farbe* (*The Art of Color*) was published simultaneously in German and in an English translation by Ernst van Haagen. It was immediately made available in America where it was influential in the field of abstract color and other art movements. Within ten years it was translated into French, Serbo-Croatian, Italian and Japanese. The book's subtitle *Subjektives Erleben und objektives Erkennen als Wege zur Kunst* (*The subjective experience and objective rationale of color*) reflects both Itten's interest in psychoanalysis and his desire to provide a reliable instructive color system for general use in art and design.

146

147

130

The optical, electromagnetic and chemical processes initiated in the eye and brain are frequently paralleled by processes in the psychological realm. Such reverberations of the experience of color may be propagated to the inmost centers, thereby affecting principal areas of mental and emotional experience. Goethe spoke of the ethico-aesthetic activity of colors. By careful analysis, I shall try to elucidate this topic, so important to the color artist.

I recall the following anecdote:

A businessman was entertaining a party of ladies and gentlemen at dinner. The arriving guests were greeted by delicious smells issuing from the kitchen, and all were eagerly anticipating the meal. As the happy company assembled about the table, laden with good things, the host flooded the apartment with red light. The meat looked rare and appetizing enough, but the spinach turned black and the potatoes were bright red. Before the guests had recovered from their astonishment, the red light changed to blue, the roast assumed an aspect of putrefaction and the potatoes looked moldy. All the diners lost their appetite at once; but when the yellow light was turned on, transforming the claret into castor oil and the company into living cadavers, some of the more delicate ladies hastily rose and left the room. No one could think of eating, though all present knew it was only a change in the color of the lighting. The host laughingly turned the white lights on again, and soon the good spirits of the gathering were restored. Who can doubt that colors exert profound influences upon us, whether we are aware of them or not?

The deep blue of the sea and distant mountains enchants us; the same blue as an interior seems uncanny, lifeless, and terrifying. Blue reflections on the skin render it pale, as if moribund. In the dark of night, a blue neon light is attractive, like blue on black, and in conjunction with red and yellow lights it lends a cheerful, lively tone. A blue sun-filled sky has an active and enlivening effect, whereas the mood of the blue moonlit sky is passive and evokes subtle nostalgias.

Redness in the face denotes wrath or fever; a blue, green or yellow complexion, sickness, though there is nothing sickly about the pure colors. A red sky threatens bad weather; a blue, green or yellow sky promises fair weather.

On the basis of these experiences of nature, it would seem all but impossible to formulate simple and true propositions about the expressive content of colors.

Yellow shadows, violet light, blue-green fire, red-orange ice, are effects in apparent contradiction with experience, and give an other-worldly expression. Only those deeply responsive can experience the tonal values of single or simultaneous colors without reference to objects. Musical experience is denied to those with no ear for music.

The example of the four seasons, Figs. 146 to 149, shows that color sensation and experience have objective correlatives, even though each individual sees, feels and evaluates color in a very personal way. I have often maintained that the judgment "pleasing-displeasing" can be no valid criterion of true and correct coloration. A serviceable yardstick is obtained only if we base each judgment on the relation and relative position of each color with respect to the adjacent color and the totality of colors. Stated in terms of the four seasons, this means that for each season we are to find those colors, those points on and in the color sphere, that distinctly belong to the expression of that season in their relation to the whole universe of colors.

The youthful, light, radiant generation of nature in Spring is expressed by luminous colors; Fig. 146. Yellow is the color nearest to white light, and yellow-green is its intensification. Light pink and light blue tones amplify and enrich the chord. Yellow, pink and lilac are often seen in the buds of plants.

The colors for Autumn contrast most sharply with those of Spring. In Autumn, the green of vegetation dies out, to be broken down and decomposed into dull brown and violet; Fig. 148.

The promise of Spring is fulfilled in the maturity of Summer.

Nature in Summer, thrust materially outward into a maximum luxuriance of form and color, attains extreme density and a vividly plastic fullness of powers. Warm, saturated, active colors, to be found at their peak in only one particular region of the color sphere, offer themselves for the expression of Summer; Fig. 147. For contrast with and amplification of these principal colors, their complements will of course also be required.

To represent Winter, typifying passivity in nature by a contracting, inward movement of the forces of earth, we require colors connoting withdrawal, cold and centripetal radiance, transparency, rarefaction; Fig. 149.

148

149

131

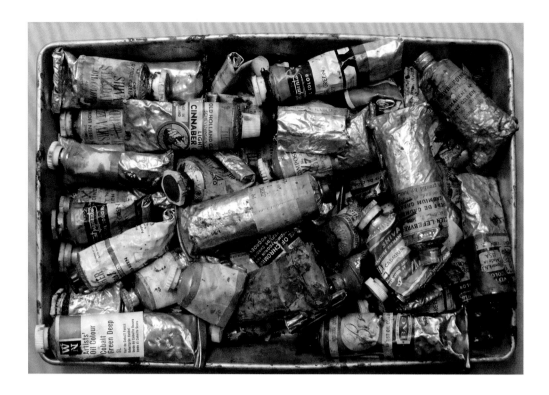

Above & opposite: In about 1949, after Albers had settled in Newhaven, Connecticut, he began exploring the relationship between colors and color and space in a series of almost 2,000 paintings referred to as "Homage to the Square." This is an example of Albers experimenting with shades of green. A tin box of green paints used by him survives in the archives of the Josef and Anni Albers Foundation.

Kunst der Farbe was an impressive vehicle for Itten's modern color theory and its application in art. Produced in a large square format (29 x 31 cm), the 155-page volume is elegantly bound in pale gray cloth, using Bauhaus-informed minimalist typography. Most importantly, it contains no fewer than 174 photographic tipped-in plates with color diagrams and related images, and an additional 28 color plates of Old Master paintings (here his teacher Hölzel's influence is obvious) and works by modern artists, such as Piet Mondrian, Henri Matisse and, of course, Klee. Among the images are Itten's well-known twelve-part color circle, the color sphere (star), plates illustrating simultaneous contrast, color composition, mixing and the use of color as an expressive tool (see pages 176–177). The greatest of care was clearly taken in the reproduction and printing of the plates and the book must have been an ambitious publishing project in its time. In his acknowledgments Itten mentions the "painstaking attention to color fidelity" that was paid by the design company Graphische Anstalt E. Wartelsteiner, who produced most of the illustrations. In 1973 an improved edition was printed, utilizing further advances in color printing.

Itten's *Art of Color* had a strong impact on the art world and modern color theory, and his lavish volume was soon after followed by smaller publications documenting his Bauhaus teaching and methodology. Other important publications on color appeared in the wake of Itten's

book and heralded a new era of ambitious book design. Among them was one by Itten's former student, the German artist, color researcher and teacher Josef Albers who, after the closure of Bauhaus, had emigrated to America, where he taught art, design and color at various institutions, including Yale University.

Albers was less interested in scientific color theory than the practical and phenomenal aspects of the use and combination of color, especially in "hard-edge" abstract art. For nearly 30 years he experimented both as an artist and a teacher with the ways colors appear, how they influence each other, and how the human eye and brain perceive them. It is not surprising that the publication that made him famous, *Interaction of Color*, was essentially a beautifully executed, didactic and inspiring book of optical exercises.

It was Yale University Press that in 1963 first published Albers's hugely popular book in a limited edition with 150 silkscreen-printed plates, showing predominantly Albers's distinctive overlapping color squares and rectangles. This elegant and highly instructive book, in which the author decrees that color is a more important pictorial element than form, was eventually published in a pocket-format paperback in 1971 and has never been out of print since. In 2009 Yale reproduced the original silk-screen edition in a lavish new edition and in 2013 made it available in digital interactive form as a mobile app.

COLOR FOR COLOR'S SAKE: THE RADICAL EARLY TWENTIETH CENTURY · 181

Psychological Color for the Modern Home

Just after the First World War, the aesthetic ideals of clarity, functionality, good design and sparing use of ornament as advocated by the Bauhaus Group and other Modernist movements and styles gave rise to the use of primary colors and bolder schemes in interior decoration, furniture and household objects. Illustrated books on how to use color in your home followed a book that was less concerned with avant-garde style and architecture and treated all colors and style of buildings and interiors equally. It is illustrated with black-and-white photographs and a number of colored plates with images after photographs where considerable retouching is noticeable. The interiors shown are not radical modern schemes but a range of rooms from buildings of all ages. The chapters deal with eleven colors and their uses individually, followed by additional chapters on color contrast, practical issues, as well as an unusual one that deals with the dislike of colors, in which Ionides discusses why and how certain colors go temporarily out of fashion ("Disrepute of colours").

> The author weaves in psychological notions, for example how we respond emotionally to color and express ourselves through color

Above & opposite: The frontispiece to Basil Ionides' *Colour and Interior Decoration* (above) features a traditional wood-panelled bedroom, marking its disregard for trends and applying its theories to rooms and buildings of any description. Here, "a bedroom with brown walls enlivened by bright colour." The room featured on the frontispiece to John Gloag's *Colour & Comfort* (opposite), on the other hand, is the height of interior fashion.

quickly and became hugely popular, and photography was now being used widely to illustrate print media, although color reproduction of photographs was still in its infancy and considerably more expensive than older methods such as lithography. In 1924 John Gloag wrote about the "power of colour" and suggested economical and effective ways of making the most of this power in twentieth-century houses. Finding a balance between color and form, with the aim of creating comfortable interiors, is the main theme in his book *Colour & Comfort* (opposite). It is illustrated with line drawings throughout, but the frontispiece shows an open plan sitting and dining room in which blues, greens and yellows dominate. The floor is shiny and the lines are clean—a truly modern interior.

Just two years later, the architect Basil Ionides published *Colour and Interior Decoration* (left),

In addition to his focus on practical advice and design guidelines, the author weaves in psychological notions, for example how we respond emotionally to color and express ourselves through color choices in interiors:

The psychology of colour effect is held to influence many people and to show character greatly. Most people wish to express their personality in their rooms, and most people do this with colour. Blues in deeper tones are said to be restful and to tend to contemplation and philosophy. It is a peaceful colour. Green having blue in it and also yellow, which is a cheerful colour, is happy and is affected by those whose life is contented. Mauve belongs to the weak, morbid, and discontented. Pink is apt to be cruel as it has red rays in it, and red is essentially a cruel colour.

The book became a best-seller and was followed in 1934 by the also successful *Colour in Everyday Rooms.*

PALMER-JONES.

A Sitting Room and Dining Room

In 1933, the young and aspiring British writer Derek Coventry Patmore published a stylish book on contemporary interior design entitled *Colour Schemes for the Modern Home*. Patmore came from an intellectual family that moved in artistic circles, but his father had to file for bankruptcy in the 1920s and his parents split up soon after. Patmore spent some of the 1920s in New York, immersing himself in the design scene and writing for *Vogue* and *House and Garden*. Patmore's book is unusual for a 1930s publication on interior design because he discusses not just color as used in interiors but also color theory and psychology. In the 30 pages of text preceding the 24 photographic tipped-in color plates showing actual contemporary interiors, Patmore writes at considerable length about the effects of color on mood. He begins by explaining that the scientific examination of color is a relatively recent subject and places Isaac Newton at the beginning of color studies, going on to mention several other theorists including Johann Heinrich Lambert, Goethe and Ostwald. Subscribing to the material view of color, he even includes a plate with a color chart of nine varieties of colors derived from the primaries red, yellow and blue, demonstrating how the colors mix (above).

However, Patmore's intention was not to add another textbook on color or color theory. His aim was to provide suggestions as to how color can be usefully applied in interiors. "How many of us stop to analyse our feelings and reactions to colours?" he asks. "Yet modern science tells us that the colours we live with can make us either depressed or happy. A room may be cheerful, restful, or thoroughly depressing by reason of the shades of colour used for its decoration."

Patmore continued with a list of the possible psychological associations (both positive and negative) of the main colors yellow, red, blue, dark blue, green and black, connected with their applications. Blue, for example, he explains, "is associated in our minds with peace but it can also suggest coldness. Dark blue, however, used sparingly, such as on a ceiling in a bedroom, will be found very soothing."

The rooms shown in Patmore's photographic illustrations are joyfully modern, and the plates are all in color. Many of the rooms have one dominant color or combine a few strong, complementary colors. There is, for example, an all-white living room (opposite, top left), designed by Syrie Maugham, and an apple-green dining room (opposite, bottom right) accented with silver and chrome. A room designed by the Bloomsbury Group artists Duncan Grant and Vanessa Bell combines yellows and whites with brown and blues (opposite, top right). Most of the furnishings are contemporary but occasionally antique furniture is contrasted with brightly colored walls and twentieth-century artwork, as for example in a room by John Armstrong, where "a colour scheme of sky blue, burnt sienna and golden yellow" (opposite, bottom left) forms the background for dark wood Chippendale chairs.

Above right: A color chart from Patmore's 1933 *Colour Schemes for the Modern Home* resembles a gas flame, burning from deep red through orange, yellow and green, to a deep blue.

Opposite: Patmore's book is an early example of photographic illustrations of interiors printed in full color. The plates show a variety of rooms, both modern and traditional, both multicolored and monochromatic.

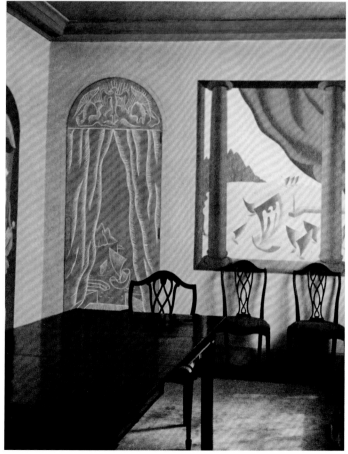

Practical and Beautiful:
The Art of Color Printing

Thomas E. Griffits was a much-respected printer and writer who worked for many years for the color printing companies Vincent Brooks Day & Son and the Baynard Press, both operating in London. He specialized in lithographic reproduction of early twentieth-century works of art and wrote a number of popular handbooks on the art and technique of lithographic printing, inspiring many contemporary artists and designers.

Lithography had been invented in 1796 by the German Alois Senefelder. It involved drawing on a close grain and absorbent stone with a greasy paint or ink before etching its surface slightly with a weak acid solution, dampening the stone and then applying ink to it with a roller. Unlike other printing methods it was "planographic," meaning the print surface is flat, and relied on the base of water and grease not mixing. The resulting images were softer and grainier than those from etchings or engravings, giving the appearance of a color wash or a chalk drawing. Lithographic printing was championed in Britain by the publisher Rudolph Ackermann in the early nineteenth century. He not only published a translation of Senefelder's treatise on this new and exciting printing method (*A Complete Course of Lithography*, from 1819), but also set up a lithography press in London and began incorporating lithographic illustrations into several of his popular magazines and other publications. By the late nineteenth century, lithography had developed from pure line drawing to a three- or four-color printing process, creating colored images by overlaying transparent printing ink in cyan, magenta, yellow and black. Both early drawn lithography and the later technique of overlay printing would prove highly useful for color illustration and the reproduction of artwork.

With *The Technique of Colour Printing by Lithography: A Concise Manual of Drawn Lithography* Griffits's intention was to provide a practical and easy-to-use reference book for artists using or intending to use the lithographic method. First published by Faber and Faber in 1940 and reissued in 1944, it is an impressive example of how a beautiful and relatively

Opposite: Griffits's beautiful and inventive *The Technique of Colour Printing*, first published in 1940.

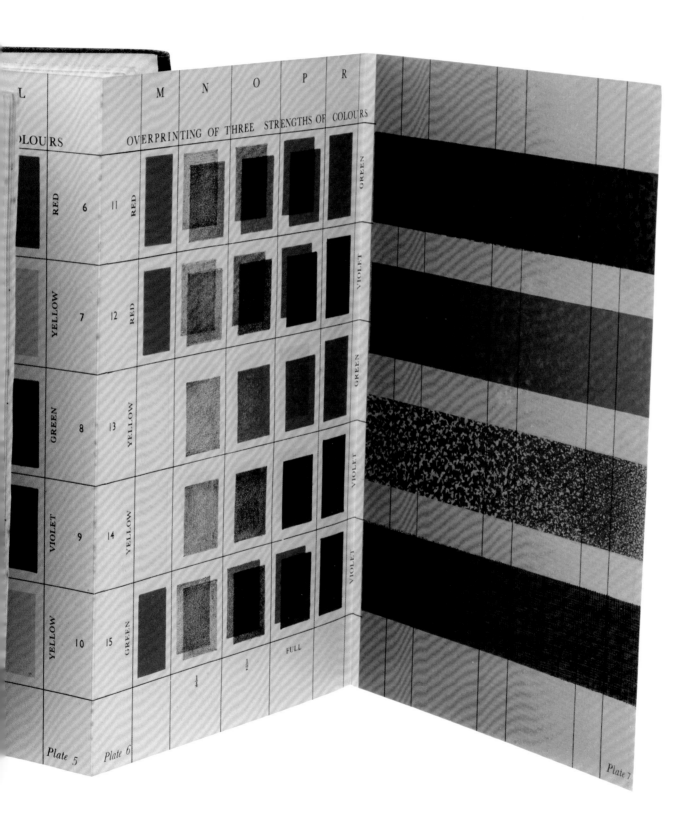

complex book on color could be produced during the war years. The format of the book is small (21 x 14 cm) and the paper—typical for many books published during or just after the Second World War—is grayish and thin. Despite these restrictions the book is highly appealing. The simple green-and-black cloth boards are subtly decorated in imitation of the variety of textures and looks achieved through lithographic printing.

Cut-outs and Fold-outs

Above & opposite: Griffits's book is replete with fold-out plates, and cut-out bookmarks and "colour stops." Readers could place the color stops over various parts of the diagrams to isolate colors, the better to analyze their effects and interactions.

Griffits's book contains many drawings of printing tools and techniques, and a number of colored plates illustrating the various stages of the printing process. A fold-out chart on stiffer paper shows a range of strengths of colors produced in overprinting (see previous page and above), as well as a plate that illustrates the effect of colored or textured paper. Most interesting though, are the "colour stops" included

in the form of loose bookmarks and templates with cut-out windows that can be laid over plates of color charts (above). They allow the reader to isolate certain colors and experiment with color combinations. One can imagine how these bookmarks would be useful for comparing the appearance of a color both in combination with others and on its own. Griffits was not the first to use overlay templates with cut-out areas that help isolate colors: a similar technique was used by Moses Harris and his color charts in *Natural System of Colours* in the 1770s (see pages 26–29), and in the early twentieth century Wilhelm Ostwald had included a small color stop in the form of a bookmark on a ribbon in his color manuals (see pages 166–169). Griffits's color stops are thin and fragile but, with relatively simple means, he and his publisher managed to produce a highly useful manual on color printing in the 1940s. In the introduction Frank Pick noted that this book was "a piece of impersonal biography, for it summarises and explains the practice of lithography as Mr. Griffits has known and elaborated it over nearly forty years, and stands as a record of his business life."

Plate 2

A Color Dictionary:
The Villalobos *Colour Atlas*

One of the most extensive twentieth-century color identification systems in print culture was produced in 1947 by the Argentinian artist Cándido Villalobos-Domínguez and his architect son Julio Villalobos. Their *Atlas de los Colores/Colour Atlas* was published in a bilingual Spanish/English edition in Buenos Aires, Argentina. It aimed to help printers, artists, scientists and designers identify colors in an era when mechanical tools for measuring color and light intensity (spectrophotometers) were still considered an unrealistic option for many designers. The large

(22 x 32 cm), sturdy and attractively designed book was going to be the affordable alternative, and it is clear that the authors and publishers were targeting a wide international audience.

A "Chromatic Hexagon," similar to many other twelve-part color wheels, based on six spectral colors (here named Yellow, Green, Turquoise, Ultramarine, Magenta and Scarlet) forms a reference image for the Villalobos system and is followed by a brief introductory text section. The other 38 pages contain 7279 glossy printed color chips, each measuring 1 x 1 cm, arranged

Above left & above right:

Two plates of color chips from the 1947 *Colour Atlas*, showing shades of green (opposite) and ruby (above).

in color groups and pasted on to the plates. Each of the color chips has a tiny off-center hole, which allows users to see through to other pages and compare the tints with others. The plates are arranged in the style of a dictionary, with a thumbnail color index along the bottom edge of the print block. They can also be removed, as they are not glue-bound but held together in ring-binder style.

The organization of the *Colour Atlas* follows the CIELAB system—a color space measuring system of all colors visible to the human eye that was developed by the Commission internationale de l'éclairage (International Commission on Illumination), founded in 1913—but it also shows similarities to Munsell's system (see pages 140–145). The *Atlas* was an ambitious attempt to produce in print a comprehensive system of color mixtures. Intended as a tool, it was soon superseded by new technology, but it is an aesthetically pleasing and highly tactile book on color that was designed for practical use and extensive physical handling.

Color into the Future: The Wheels Keep On Spinning

After a dark and difficult period in print culture during and immediately after the Second World War, popular magazines and paint manuals from the late 1940s onwards encouraged readers to opt for a daring use of color in order to mark a new beginning and to boost morale. In the 1950s and '60s consumers once again began to fully embrace color in fashion, art and architecture. Books, magazines, advertising material and ephemera promoting color, paints and design schemes were produced in large quantities.

Many publications on color in the immediate post-war years were printed on relatively low-quality paper, but despite these material restrictions the passion for color and the desire to push book design and color illustration forward is evident. Indeed, many of the most stunning books on color by teachers and artists from the Bauhaus circle, as seen in the previous chapter, were actually published in the 1960s and '70s, when photographic color printing had developed much further and had almost entirely replaced hand-coloring and metal-plate or woodblock printing. However, as we see in examples such as the contemporary paint sample cards of Patrick Baty's Papers and Paints company, in certain areas the meticulous and reliable technique of representing colors and paints as real paint samples prevails. The later twentieth century saw the advent of digital printing in color, which is now the standard form of book illustration.

From the beginning of the twentieth century, CMYK (a subtractive color model in which all colors can be made out of four pigments: cyan, magenta, yellow and black) was understood as the basis of color printing. By the middle of the century this was standardized, when the printing company M & J Levine Advertising hired a chemist, Lawrence Herbert, in 1956, to systematise their color production. In 1962, Herbert bought the company and renamed it Pantone. The result of his efforts was a color matching system, intended to make it possible for designers to identify and discuss colors accurately and for manufacturers to reproduce a color exactly, no matter what equipment they used. Similar attempts at color standardization had been made before, but this was the most successful. Today Pantone and its proprietary Pantone Matching System (PMS) is an industry standard across the globe.

> *In the 1950s and '60s, consumers once again began to embrace color in fashion, art and architecture*

At the same time as companies like Pantone were applying standards, other industries were employing a more experimental use of color, for example in the Brutalist architecture of the 1950s and '60s. One of the areas this is most interesting to observe is newly built and restored religious buildings as in Sir Basil Spence's designs. Here, the symbolic use of colored glass was both tapping into ancient traditions and reflecting new ideas such as deliberately juxtaposing contrasting building materials or reinterpreting color order in a religious context.

The renowned Centre Georges Pompidou in Paris, built in the 1970s, meanwhile, combines utility with decoration in its application of color. The building's unique design places all functional structures outside, maximising the space inside. Adopting a tetrachromatic system, the architects made color a key part of their design, assigning each function a color; for example, pipes for circulating air are colored blue, electrical cables are encased in yellow pipes, water pipes are green and lifts and escalators are colored red.

Left: Basil Spence's design for the Meeting House Chapel, completed in 1966, references traditional stained glass windows, a feature of church architecture since the seventh century, while also embracing new ideas about color by using it in an abstract way.

While there is a long tradition of painters depicting themselves with their palettes and other painters' tools, in the twentieth and twenty-first centuries many artists made color order and color theory in particular a theme in their art, with varying degrees of overt references to specific writings on color. We saw how in the early twentieth century many artists embraced color as a powerful expressive tool. They explored the symbolic and spiritual connotations of color, giving it more compositional importance than it had ever before enjoyed. Color retained this importance into the twenty-first century, but here, in contrast with the meaning-laden function of color of previous decades, Modernist movements in America and Europe utilized color as an abstract absolute, often devoid of any representative quality. By the mid-twentieth century, artists such as Barnett Newman, Mark Rothko, Bridget Riley, Gerhard Richter and countless others were making artworks that seemed to celebrate color, just for color's sake. They often worked (and some still do) on a monumental scale, making full use of the visual power of pure color without figurative representation, but their work is grounded in theories of color harmony developed decades or even centuries earlier. Rothko, for example, is famous for his highly abstract works that place two or three colors, or shades of a color, over each other in simple rectangular forms. The viewer is invited to consider the qualities of the colors in themselves and in combination with each other; the longer one stares, the more expansive the color seems to become, offering more of itself up to be noticed.

One artist for whom color was a main concern was Yves Klein, whose particular obsession was with the color blue. Until the invention of Prussian blue in the eighteenth century, the best blue pigment (ultramarine) was prohibitively expensive, and its use was almost entirely limited to the depiction of holy, religious subjects, such as the Virgin Mary. As we saw with the example of Kandinsky (see page 162–165), blue retained its associations with spirituality into the twentieth cenutury. Until his death in 1962, Klein, too, was interested in precisely this aspect of his chosen color, which expressed it through monochrome paintings made with "IKB" or International Klein Blue a pigment based on ultramarine that he himself had invented, with the help of a modern-day "colorman," the Parisian paint supplier Edouard Adam. The key to this bluest of blues was the binder that allowed the ultramarine to retain more of its intensity than traditional binders.

The pursuit of the purest and most stable of colors has remained a theme for artists since humans began painting, but it certainly seems to have become a theme in the later twentieth and twenty-first centuries. British sculptor and painter Anish Kapoor, for example, frequently worked with bright, primary colors, but in 2014 he made himself somewhat unpopular in the artworld by obtaining an exclusive license to work with Vantablack—the "blackest black." In response, Kapoor's fellow artist Stuart Semple created "the world's pinkest pink," a pigment he made available to all artists except Kapoor, whom he banned from using it.

Modernist movements in America and Europe utilized color as an abstract absolute

The examples of Klein, Kapoor and Semple show how important material color remains for artists; however, new technologies have always played a part in determining the kinds of works that will be made in a particular time. In the latter twentieth century through to the present day, this has often meant incorporating electronics and digital technologies into artworks, allowing artists to explore immaterial color as never before. David Batchelor is just one example of an artist using technological developments to represent immaterial through video installations and colored lights.

In recent years, many graphic designers and conceptual artists have been responding to traditional and new ideas and concepts of color, with some of them literally putting a new spin on color wheels. The continued fascination with color and its abstract nature and beauty remains a popular and dominant theme in many domains of our culture. This book can provide only a very small and subjective selection of recent artistic interpretations of color order and color systems, but it will hopefully give a taste of the role concepts of color still play in the creative process.

Left: Mark Rothko's *Light Red Over Black* (1957) invites the viewer to meditate on the colors seen on the canvas.

Simple and Pictorial: A Children's Guide to Printing

This booklet, straightforwardly titled *Printing* (1948), was the 70th title in Penguin's Puffin Picture Book series. This series was aimed at young readers between the ages of seven and fourteen and covered a wide range of topics, with a strong focus on natural history and technology. Produced at the beginning of the Second World War, the first three volumes were highly topical: *War on Land*, *War at Sea* and *War in the Air* (all published in 1940). The series was marked by the clarity, figurative detail and strong colors we often associate with children's books of the mid-twentieth century. It ran to a total of 120 volumes until 1965, with the post-war volumes being noticeably more colorful. The series' aim was to be both educational and entertaining.

This particular volume was written by none other than Harold Curwen, who was running the famous Curwen Press, founded by his father, John Curwen, in 1863. Under Harold, the press became especially known for high-quality and stylish typography, book designs and lithographic printing. Fittingly, this Puffin volume was itself lithographed by the Curwen Press. The booklet is illustrated in detailed and colorful style by Jack Brough. His cover design shows various tools of the printing trade, and includes an image of the three primary, overlapping print colors on the cover, which form secondaries and combine into a black center, much like the earliest published color wheels for artists. This color diagram is a simple, abstract and bold feature placed like a final seal on a cover design that is wonderfully literal and direct.

Left: The cover of Harold Curwen's *Printing*, an introductory title aimed at children. The cover manages to fit many elements of the print trade into its design, including a letterpress of the title, backwards, of course.

POPPY RED

Poppy B.C.C. 97
Scarlet 5
Rouge Grenadier 82/1
XIV 6 pa

EQUIVALENT TO
BRITISH COLOUR COUNCIL
RIDGWAY
REPERTOIRE
OSTWALD

16/₃

16/₂

16/₁

16

History :

General representation of the wild
corn Poppy, as used by the textile
and paint trades for over 200
years.

Foreign Synonyms :

Dutch : *Papaverrood*
French : *Rouge Coquelicot*
German : *Mohnrot*
Italian : *Rosso di Papavero*
Latin : *Papaverinus*
Spanish : *Punzón*

Horticultural Examples :

16/₃

16/₂

16/₁ *Fuchsia serratifolia (petals)*
 Macleania insignis

16 *Papaver orientale*
 Streptosolen Jamesonii
 Solanum Capsicastrum (fruit)

Robert Francis Wilson and the Post-War Workspace

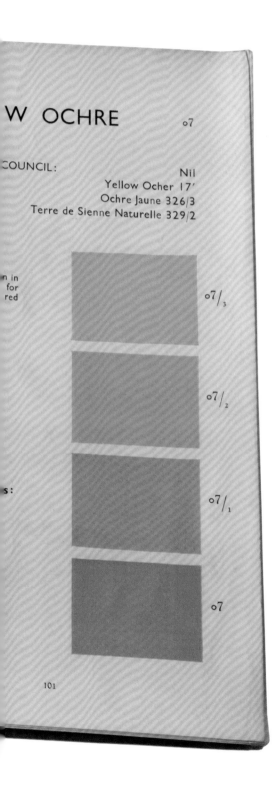

W OCHRE o7

COUNCIL: Nil
 Yellow Ocher 17'
 Ochre Jaune 326/3
 Terre de Sienne Naturelle 329/2

 o7/₃

 o7/₂

 o7/₁

 o7

101

Left: Wilson's color chart
from 1938 aimed to provide a
useful standard and reference
chart, comprising 100
plates in the first volume and
translating each color given
into its equivalent in different
languages and color systems.

In 1931 Robert Francis Wilson, a British designer
and dedicated researcher, founded the British Color
Council. Over the course of the next twenty years,
this organization would produce color charts and
reference codes for various industries. Wilson himself
produced several color charts and wheels in this
period, perhaps most importantly, the first volume
of a horticultural color chart in 1938, in collaboration
with the Royal Horticultural Society. The eponymous
Wilson Colour Chart (left) was a collection of 100
individual plates with printed color samples, hole-
punched to allow users to remove plates as they
needed. Each color was reproduced in four degrees
of saturation and the accompanying text was factual,
precise and highly informative, including the
equivalent of the color in other color systems, the
color name in six foreign languages and a very brief
history of each color. Three years later, Volume Two,
comprising a further 100 plates, was published. A
later reissue contained the plates loose in a folder.

The aim of the *Wilson Colour Chart* was to produce
a reliable and international standard of colors; a
standard to be measured in flowers, so to speak, but
for use far beyond the realm of horticulture:

There will thus be but one colour name
recognised for each hue in the textile and
all colour-using industries as well as by
artists' colourmen. While therefore, the
colours chosen and names used have been
selected primarily for the purposes of
horticulture, the Royal Horticultural Society
Colour Chart will also have a use and value
far outside its horticultural scope.

But Wilson also had a great interest in the psychological
impact of color. His 1953 publication *Colour and Light
at Work* focuses on how we respond to color in our
immediate environment and offers a fascinating insight
into concerns about working conditions in the post-war
years. Wilson comments in his preface that he is grateful
"to live at a time when colour and light are recognised
as partners in helping to combat sickness, improving
working conditions for millions of people, and making

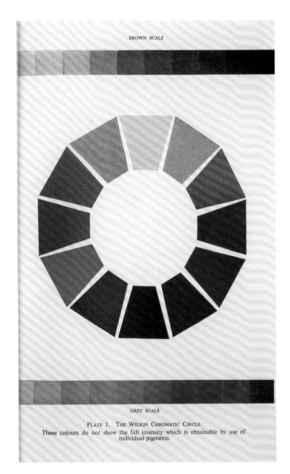

BROWN SCALE

GREY SCALE

PLATE 1. THE WILSON CHROMATIC CIRCLE.
These colours do not show the full intensity which is obtainable by use of individual pigments.

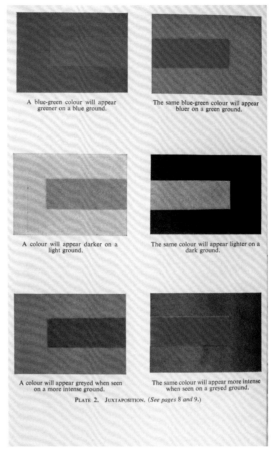

A blue-green colour will appear greener on a blue ground.

The same blue-green colour will appear bluer on a green ground.

A colour will appear darker on a light ground.

The same colour will appear lighter on a dark ground.

A colour will appear greyed when seen on a more intense ground.

The same colour will appear more intense when seen on a greyed ground.

PLATE 2. JUXTAPOSITION. (See pages 8 and 9.)

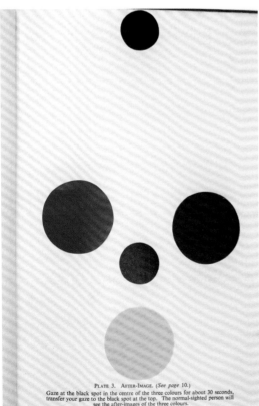

PLATE 3. AFTER-IMAGE. (See page 10.)
Gaze at the black spot in the centre of the three colours for about 30 seconds, transfer your gaze to the black spot at the top. The normal-sighted person will see the after-images of the three colours.

their work safer and more enjoyable." The small-format book was illustrated with charts and diagrams supporting Wilson's arguments for the careful and deliberate coloring and lighting of both workspaces and the machines themselves.

In the book's twelve colored plates, Wilson included illustrations of abstract color theory, such as "juxtaposition," which deals with the effects that colors have on each other, in various combinations.

Six of the plates, however, show industrial working spaces and machinery, visually making a case for using color as both a psychological and a safety tool. Plate 12, for example (opposite), addresses depression caused by working conditions, drawing comparisons with a lack of sunlight: "Successive days of dull grey skies promote a feeling of depression; drab, untidy, dreary workrooms have the same effect. What a difference in mental outlook when the sky is bright with sunshine, what a change of heart to work in rooms made cheerful with colour."

This lesser-known book of Wilson's is a mid-twentieth-century expression of thoughts on the psychological and emotional aspect of color first voiced by Johann Wolfgang von Goethe, Thomas Hope, Humphry Repton and others 150 years earlier.

This page: Three of Wilson's diagrams illustrating his color theory, including his chromatic circle showing "the full intensity" of different pigments (top left), one of his Juxtaposition plates (top right), and the "after-image" effect (left).

Right: A more figurative plate explains "The Value of Colour in Industry" comparing a drab workroom to overcast skies.

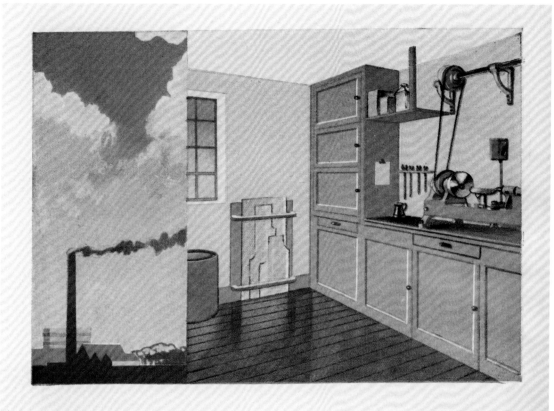

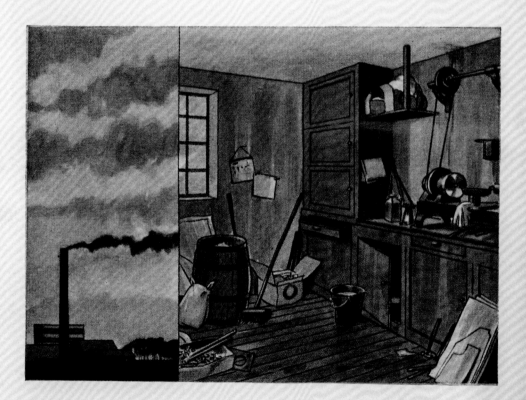

PLATE 12. THE VALUE OF COLOUR IN INDUSTRY.

Successive days of dull grey skies promote a feeling of depression; drab, untidy, dreary workrooms have the same effect. What a difference in mental outlook when the sky is bright with sunshine, what a change of heart to work in rooms made cheerful with colour.

Accent on Color:
A Bold New Palette

The desire and, indeed, the need in the post-war years to create interiors with brighter and stronger colors reached its climax in the 1960s. A distinct sense of wanting to make a fresh start and to leave the dark, difficult and lean period of the war behind is apparent in many areas of culture and industry. It was an age of joyful and experimental consumerism, manufacturing and advertising, and color played a major role in expressing this newfound zest for life. Ephemera such as the *Homes and Gardens* gift booklet titled *Accent on Colour* (above), produced in association with, and essentially an advert for, the paint manufacturer Walter Carson & Sons Ltd. in 1960, were mass-produced

and became common. Here, modern bungalows are pictured alongside Georgian terraces, and suggested color schemes are vibrant and shimmery. The booklet suggests, for example, "an orange-painted ceiling to add invigorating warmth to pale silvery walls. Lay deep blue linoleum on the floor and paint a matching blue door—both practical and smart." Machines, so Walter Carson & Sons Ltd. informs us, will help you mix the shade you desire and match it with others: Carson's "Spectro-Matic Colour Dispenser" gives you the option to choose from a range of displayed colors and produce them immediately. The "hazards of home decorating" have been abolished.

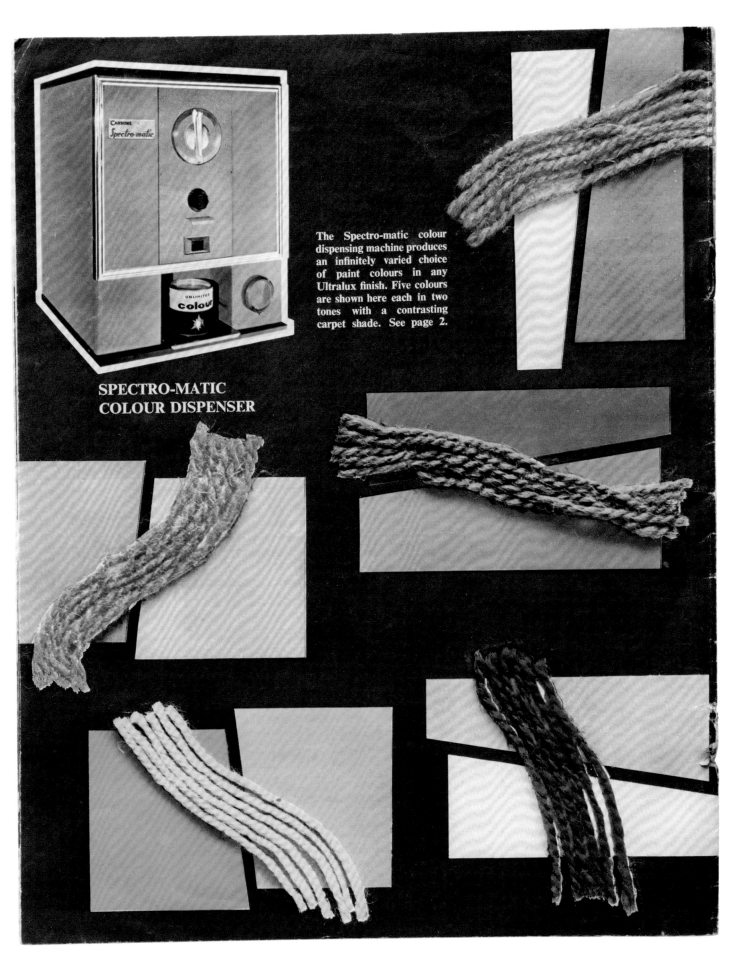

**SPECTRO-MATIC
COLOUR DISPENSER**

The Spectro-matic colour dispensing machine produces an infinitely varied choice of paint colours in any Ultralux finish. Five colours are shown here each in two tones with a contrasting carpet shade. See page 2.

"This Is Color Surprise": Popular Art Manuals in 1950s and '60s America

In the second half of the twentieth century, newspapers, magazines and periodicals became larger in format and more lavishly illustrated, with most publications moving toward color illustration. Amateur painting manuals published in the 1950s and 1960s reflected new trends in fashion and popular culture and many, especially American examples, are particularly vibrant, bold and experimental in their use of color and design.

In the 1950s the American amateur artist and businessman Walter T. Foster began self-publishing oversized (35 x 26 cm) art manuals in a magazine style with little text but many large and colorful images. Foster had founded Walter Foster Publishing in 1922 and was working from his home in California, with complete control over his publications. At first he authored, illustrated, printed and packaged every manual himself, aiming to create affordable, exciting and modern-looking art manuals. The manuals were displayed in specially designed metal racks, allowing

the customer to see the striking covers. Foster's manuals were hugely successful and over time he started employing other artists and authors to work on specific subjects, publishing hundreds of issues. The number of colored illustrations increased over the years and lists of available titles at the back of each issue gave specific information on how many pages were printed in color.

Predictably, color and pigment use featured in many issues. Although not considered to be of academic value, these teach-yourself guides to color are interesting, since Foster created a number of color charts, wheels and palettes based on the same principles that we have seen in earlier, more serious publications on color. Foster largely depicted his color orders by photographing blots of oil or acrylic paints arranged on paper or canvas. Sometimes he illustrated color mixing by depicting the act of painting in photographs or in watercolor, with hands, paintbrushes and palettes visible.

THIS IS COLOR SURPRISE
GOING AROUND THE WHEEL

① IF YOU WERE TO SQUEEZE SOME COLOR FROM A TUBE AND DIVIDE IT INTO TWO PARTS, ADDING WHITE TO ONE PART AND BLACK TO THE OTHER: AND IF THE LIGHTER ONE WAS LAID AGAINST THE DARKER ONE, IT WOULD CREATE THE ILLUSION OF LIGHT AND SHADOW OF A COLOR. THIS IS THE ESSENCE OF COLOR SURPRISE.

② IF YOU WERE TO REPEAT THIS PROCESS, BUT AS YOU ADD WHITE ADD A BIT OF COLOR ABOVE ON THE COLOR WHEEL, YOU WOULD HAVE A RELATED SEQUENCE OF COLOR COMING TO LIGHT.

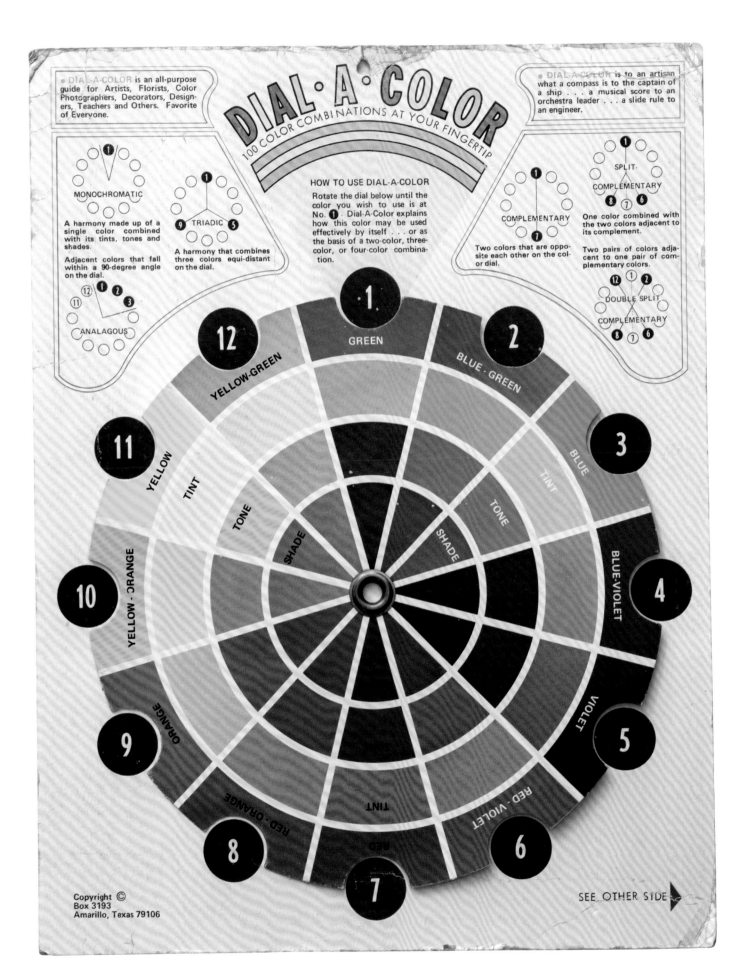

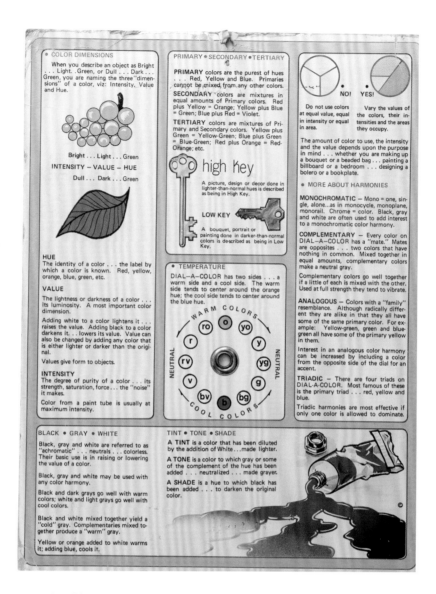

Foster's publications undoubtedly inspired and instructed many thousands of readers. His color wheels, charts and pigment lists are of no less historical value than those seen in more "serious" publications, and reflect the print culture and taste of his time. The combination of minimal text and actual paints and materials captured photographically allowed Foster to explain complex concepts in a highly accessible way. On the plate "This Is Color Surprise/Going around the Wheel," for example (see page 207), he explained the dimension of color value in a few sentences:

If you were to squeeze some color from a tube and divide it into two parts, adding white to one part and black to the other: and if the lighter one was laid against the darker one, it would create the illusion of light and shadow of a color. This is the essence of color surprise.

After Foster's death at the age of 90, his children took over his company and continued publishing.

The company is now owned by Quarto Publishing, but Walter Foster's name is still used as a trademark for accessible instructive art manuals.

Foster's work is a prominent example of color theory being popularized through new means of publishing, and there are many examples of color guides and printed ephemera being produced in the later twentieth century, as color printing became easier and cheaper. This American cardboard "Dial-A-Color" sheet (opposite and above) from the 1960s was intended to be "an all-purpose guide for artists, florists, color photographers, decorators, designers, teachers and others. Favorite of everyone." On its two sides, the guide manages both to provide a spinning color wheel and introduce several fundamental principles of color theory, such as the trichromatic system, color harmony, value, color temperature, and so on. This chart is color theory made easy, and was designed to be put up on the wall as a tool and constant source of reference.

Left & above: The idea is, you turn the color dial until your chosen color is at the "1" position, and the information at the top of the sheet shows you various combinations, such as "analagous" (1, 2 and 3) and "split complementary" (1, 6 and 8). The back of the sheet offers more information about different qualities of color.

Parsons' *Tint Book* Revisited

In 1802 Thomas Parsons founded a firm of paint and varnish makers, with premises in Long Acre in central London. The House of Parsons soon gained a reputation for supplying high-quality paint and other decorating materials. In the early twentieth century they produced small fold-out cards with samples of their ranges, including enamel paint, stressing the already long history of the firm.

In 1934 the firm, by now called Thomas Parsons & Sons Ltd and located in London's Oxford Street, published *A Tint Book of Historical Colours Suitable for Decorative Work*, containing 136 pasted-in color samples. The firm was regularly receiving requests for reproductions of colors of the past, and the *Tint Book* was intended to address that need. Parsons pointed out the great care that had gone into producing the book, which he hoped would be "of service to the architect, the decorative artist and the student of colour." The book was elegantly bound with shimmering green and gold water-patterned covers and endpapers. It was essentially a very elaborate piece of advertising for the firm, since all of the paints featured in the book could be purchased from them.

The colors were grouped into "families" of historical periods, pigment types, styles or themes, such as Colors of Egypt, Oriental Colors, Tyrian Purple, Etruscan Red and Porphyry, Pompeian

Colors, Medici Blue, Moorish Colors, William & Mary, Georgian Greens, Delft Ware Colors, and so on. A color index preceded these groups of swatches and the final chapters provided information about the firm's "colour scheme service" and listed types of paints and enamels they could supply. Each chapter contained a short text with information about the color group.

Parsons had to move premises during the Second World War, but continued to publish their popular *Tint Book* during the war and post-war years. It was reprinted at least six times until 1961 and is a wonderful document of a desire for rich and quality colors in interior decoration at a time when paints were often in short supply. The firm folded in the 1960s, but their book remains influential. Shortly before she died, the last director of Parsons handed the range over to the London-based paint makers Papers and Paints, founded by Robert Baty in 1960. In the 1980s his son Patrick Baty, an architectural paint historian, joined the firm and since then the Parsons colors have been reproduced as their "Historical Colours" collection. Papers and Paints produce painted color cards of 112 of the colors based on Parsons' tints as seen in the fourth edition from 1950. The copy shown here (above) is that fourth edition.

Above: Parsons' *Tint Book* was a clever and beautifully produced reference work, offering the reader a wealth of color schemes grouped by theme or historical period.

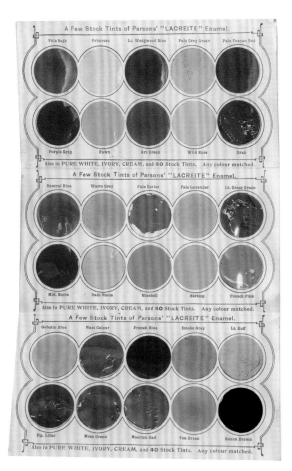

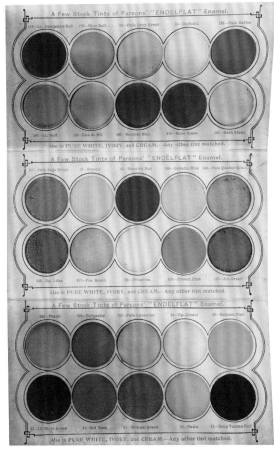

Above right: Two small sample "tint cards" by Thomas Parsons from the early twentieth century, when the company was still in its original premises at 8 Endell Street, Long Acre, London.

Right: Two contemporary hand-painted color cards from Papers and Paints, London, based on Parsons' *Tint Books.*

Stained Glass:
New Church Architecture

Above: Sam Allen's color key for all 460 panes of colored glass in Basil Spence's Meeting House chapel.

Opposite: In his notes on Spence's fenestration, Sam Allen interprets the color layout in relation to the circular ground plan of the building, the movement of natural light during the day, and other ornamental and structural features.

Overleaf: The sun shines through the colored windows of the Meeting House.

The chapel of the circular Meeting House on the Sussex University campus in the UK, built in 1966, is a striking example of how color patterns have been used by a number of artists and architects in twentieth-century ecclesiastical architecture. Referencing the tradition of the use of stained glass in churches, the architect Sir Basil Spence employed here a language of color, clarity and contrast, combining the shape of the circle with the color spectrum. It owes much to the high-profile project he had finished just a few years earlier, the rebuilding of Coventry Cathedral. At Coventry Cathedral he commissioned glass features from other artists, most importantly John Hutton and John Piper, who designed the clear, engraved west window and the large, colorful Baptistry window, respectively. In keeping with the scale of the cathedral, Piper's window design was monumental and abstract, featuring a circular spectral order with a yellow center.

In the much smaller Meeting House chapel, Spence set 460 panes of colored glass into a honeycomb pattern of fourteen tiers of reinforced concrete blocks, illuminating the space with light that would be changing constantly according to the time of day and the seasons. When it is lit at night, the drum-shaped building resembles a lantern of colored light from the outside.

Spence deliberately paired different materials, most prominently a surprisingly thin and therefore fragile colored glass, which is set directly into the recesses of the roughly textured concrete blocks. He had envisaged "a full spectrum of coloured glass panes, each in a single colour" for the chapel fenestration. However, not all windows are of a single color. The layout roughly follows a chromatic scheme with green shades in the east, through yellow and white in the north above the altar and in alignment with the Meridian, to

deep reds and blues in the west. The symbolic use of the circle is evident here, with allusions to the circle of life, the Christian year, or the unbroken circle as a manifestation of safety and security, expressed in architectural language.

The symbolism of the fenestration is subtle and open to interpretation: no area of colored glass is separate, all shades merge into each other, and each area contains elements of the others. Crucially, no one pane is identical to another, each one a new aperture through which some of Spence's other buildings can be glimpsed. A Christian interpretation of the color scheme is, of course, possible. For example, the yellow and white above the altar may represent divine light, while the deep red tones in the west could symbolize sacrifice and the blood of Christ. Spence did not make specific comments on color symbolism, but he alluded to the design expressing the "variety of the human race

Opposite, top: Egon Eiermann's Kaiser Wilhelm Memorial Church in Berlin references long-held spiritual associations of the color blue.

Opposite, bottom: Gerhard Richter is known for his computer-generated works of art. Here, he uses the technology to put a modern spin on traditional stained glass windows.

banded together in a circle of unity." A couple of drawings indicate that he thought carefully about the location of each pane, laying out a key for the fenestration and even providing notes on some of the pigments used: French selenium red, orange and yellow. Spence's original chart drawings are not colored, but in 2014 Sussex student Sam Allen made a complete color chart of the chapel (see page 213) adding to the understanding of the deliberate color arrangement in the space.

There are many more examples of the use of color symbolism and color order in the fenestration of recent church architecture, for example the hexagonal main church building and belfry of the Kaiser Wilhelm Memorial Church in Berlin (opposite, top), built between 1959 and 1963 to designs by Egon Eiermann. Like at Coventry Cathedral, the architect was briefed to create something new out of and within the ruins of the original church, which was bombed in the Second World War. Like Spence, Eiermann opted for a simple and clear combination of geometry and color, following a specific pattern. In his design, blue as a spiritual color dominates, enhanced by subtle inclusions of other primary colors in the individual blue squares.

An often-noted example of the use of recent colored glass design in churches is Gerhard Richter's window for the south transept of the gothic Cologne Cathedral (opposite, bottom). The original 20-meter-tall medieval window was destroyed by bombs in the Second World War and replaced with clear glass, until Richter was commissioned to fill in the frame. In 2007 his design was revealed: a grid comprising 11,263 squares of different colored glass, each measuring 9.6 x 9.6 cm, created from a range of 72 colors. The resulting pattern is entirely abstract and reminiscent of computer pixels. Quite deliberately so: Richter had long had an interest in color order and specifically computer-generated color charts, and with the Cologne Cathedral window he expressed the beauty of randomly created color combinations. In great contrast to Spence, Piper or Eiermann—or indeed most medieval designers of church windows—his color pattern was created randomly. Richter used a computer program to generate the colors; and the only deliberate aspect was his initial choice of colors. The visual effect of colored light illuminating the interior remains impressive, but there is no color symbolism to be found in Richter's window.

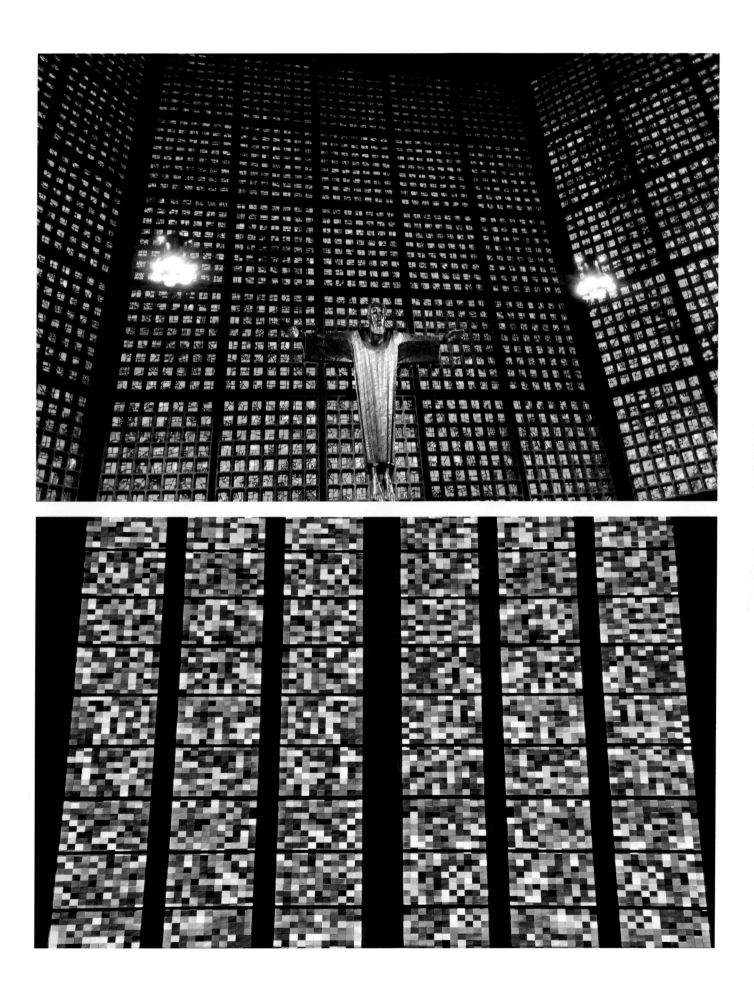

Sky and Sea: Color Wheels for the Natural World

In the eighteenth century, naturalists and explorers used a tool called a cyanometer to measure and record the color of the sky. This simple handheld device, invented by Swiss physicist Horace-Bénédict de Saussure in 1789, included a numbered sequence of 53 shades of blue ranging from white to almost-black (below). The blue pigment used in the cyanometer was Prussian blue, which was invented around the turn of the eighteenth century and is considered to be the first "modern," chemically produced and manufactured pigment.

De Saussure used the cyanometer to measure the exact blueness of the sky on hiking trips in the Alps, and the German naturalist Alexander von Humboldt, a friend of de Saussure's, took one on his voyages to

South America between 1799–1804. As whimsical as the tool appears, the results of the measurements taken with it led to the scientific discovery that the color of the sky was influenced by suspended particles in the atmosphere.

In recent times, natural color wheels have made a comeback, this time in the art world. Spencer Finch is an American artist whose work focuses on observations of natural phenomena. Much like an early nineteenth-century landscape artist or an Impressionist painter, he meticulously records the appearance of places in changing atmospheric condition, or charts the colors

he dreams of, before he transforms these observations and memories into a new medium, for example photography, drawings and moving images. Often the results are abstract paintings in oil or watercolor, and sometimes more complex installations incorporating lightboxes and filters. In one work he recorded colors he had perceived in his dreams and then produced blot paintings in matching colors, thereby creating a link between an entirely subjective perception and a material expression of it.

In 2010 Finch observed the color of the sea on the south coast of England for several weeks and assigned a Pantone® color to each hue he noted. When he had observed 100 different shades he dyed 100 flags in these monochrome colors. He also created a spinning color wheel with these 100 Pantone swatches along its edge and a static aperture (opposite). The installation, titled *The Color of Water*, was erected at Folkestone, Kent, looking out over the English Channel, on the occasion of the town's second art Triennial, in 2011. Each morning of the Triennial, an observer identified the color of the sea and the flag of the corresponding color was flown in the town. The flags are no longer there, but the color wheel remains, inviting passers-by to observe and record the color of the sea at the time of their visit.

This pair of wheels is a good example of the subtle overlap between art and science across several centuries. Both are relatively simple, man-made tools that help capture and chart observations of natural phenomena. Both are at once exciting in the range of tints displayed on them, but at the same time a glance at them also induces a sense of the impossibility of capturing all the nuances of the natural world. The sea clearly appears in more colors than the 100 contained in the wheel, and there are certainly more than 53 shades of sky blue. The wheels are also beautiful objects in their own right, an expression of humankind's desire to understand, find patterns and see order, but both are ultimately crude and conceptual rather than exact. Romantic artists were known to observe atmospheric conditions meticulously and accurately, often consulting scientific tools and academic literature—but expressed in painting. Finch has created a measuring tool that can be used according to this function, but it was always intended to be a work of art and ultimately refers back to the subjectivity of color perception.

Right: The cyanometer, first used in the eighteenth century, was invented as a tool for recording the precise shade of blue seen in the sky.

Opposite: Spencer Finch's *The Color of Water* installation featured a kind of modern-day cyanometer. This one is not systematically ordered, and it was designed for noting the color of the sea rather than the sky.

The Rainbow Lives On: Newton's Legacy in Contemporary Art and Culture

Nowadays many people probably associate the image of a prism refracting light into rainbow colors with Pink Floyd rather than Isaac Newton

Isaac Newton has inspired art and artists ever since he unraveled the rainbow in the late seventeenth century. The spectral range of colors, created from light but often experienced and explained in the context of darkness, has become one of the most recognizable concepts and images of the modern world. It is a pure, simple and universal order that can be expressed in many ways but is most commonly visualised as a scale, a ring, a wheel, or as light entering and exiting a prism. As a diagram, it has strong visual and conceptual qualities that make it a popular motif in many forms, genres and subjects of art and culture, particularly in graphic design.

A literal take on Newton's experiment of splitting white light with the help of a prism was the inspiration for the now iconic vinyl record sleeve of British band Pink Floyd's 1973 album *The Dark Side of the Moon* (opposite). It was designed at the Hipgnosis studio in London by Storm Thorgerson, using commissioned artwork by illustrator George Hardie. Against a background of deep unstructured black we see the outlines of a prism, represented as an equilateral triangle, suggestive of the darkness of Newton's studio and possibly also in reference to the theme of the album title. A thin white line of light enters the triangle from the left and emerges on the other side as six spectral colors (in a deviation from Newton's proposed seven colors, omitting indigo, as do many painters' color wheels). This band of colors bleeds onto the inside of the double sleeve, where it morphs into an image of acoustic wavelengths, thus continuing the tradition of drawing analogies between color, music and rhythm, as Newton himself had done. In this context the imagery referred specifically to the audio, visual and sensual experience of Pink Floyd's live performances, which included elaborate light shows. The sleeve art of *The Dark Side of the Moon* became so popular that Thorgerson quipped shortly before his death in 2013 that nowadays many people probably associate the image of a prism refracting light into rainbow colors with Pink Floyd rather than Isaac Newton.

Opposite: Pink Floyd's iconic The Dark Side of the Moon packaging references Newton's groundbreaking experiment, including the prism and white light but, like so many others, omitting indigo and depicting only six spectral colors.

Many contemporary artists directly or indirectly refer to Newton's spectrum, using the universal beauty of pure color order and symbolic associations with rainbows. American artist Tyree Callahan has superimposed the colors of the visible spectrum onto a 1930s manual typewriter (above), thus creating the concept of an alphabet of color and a mechanical system of producing paintings. One could criticize the very idea of mechanical production of daubs of paint, but there is a nice coincidence here in Newton having been criticized in the early nineteenth century for de-romanticising the rainbow by applying hard science to it. Callahan's *Chromatic Typewriter* is just another way of ordering color, and is not dissimilar to the arrangement of color in paint boxes, on palettes, or in diagrams, but here it is embedded in conceptual art.

Mexican-born artist Gabriel Dawe "weaves" rainbows into architectural spaces, using only colored thread, narrow panels of wood and small hooks, creating sculptural pieces that give the impression of beams of colored light and challenge notions of materiality and immateriality (opposite). The materiality is definite and double in meaning: each piece is made from dyed thread, and each piece is contructed specially for the place it will be shown. From a distance, however, it appears as colored light, and the colors mix in the eye, distinct only when viewed up close. This series of woven rainbows is titled *Plexus*, a medical term for the complex interlacing network of nerves or blood vessels. Although not intentionally referencing Newton or color order, Dawe notes that "*Plexus* evokes the intrinsic order within the apparent chaos that exists in nature."

The ephemeral and immaterial nature of colored light, and rainbows in particular, adds another symbolic dimension to the color spectrum. Many conceptual and installation artists have tried to create ways of making the intangible tangible. Colored light plays a key role in the art of the Icelandic-Danish artist Olafur Eliasson, who has often experimented with

Above: Gabriel Dawe's
Plexus at the Renwick Gallery
of the Smithsonian American
Art Museum in 2015. Though
comprising only fifteen colors
of thread, it represents the full
spectrum of visible light,

chromatic order in various formations; for example in
the *Color Spectrum Series* in 2005, where he placed
neat rectangles of framed colors in a linear rainbow
pattern on the walls of the exhibition space, or the later
glassy color circle *Polychromatic Attention* (overleaf,
page 225) in 2015. Eliasson's color wheels in the
Turner Colour Experiments series, painted in 2014
for Tate Britain in response to J. M. W. Turner's use
of light and color across seven paintings, bear an
uncanny resemblance to Chevreul's lithographs in
Cercles Chromatiques (see pages 98–101). In a direct
nod to Newton, Eliasson has also created circular
rainbows in darkened rooms using lenses and projectors.

In larger-scale installation projects Eliasson has
succeeded in creating spaces in which visitors can
physically immerse themselves in the color spectrum.
The most ambitious of these is *Your Rainbow Panorama*
(overleaf, page 224) a rainbow walkway 150 meters in
length, constructed from timber, steel and colored
glass, installed on the top of the ARoS Aarhus

Kunstmuseum in Denmark between 2006 and 2011.
Here, museum visitors can walk in a perfect circle
through the entire visible spectrum of colors, the city
around them changing color as they move. From the
street below and other vantage points in the city the
transparent perfect color circle is visible, seemingly
suspended, as if it is just about to land on the building,
with silhouetted human figures walking through it, its
colors constantly changing according to the intensity
and angle of the sunlight.

Left, top & bottom:
Your Rainbow Panorama is a walkway of colored glass on the roof of the ARoS Aarhus Kunstmuseum in Denmark, a large-scale and immersive interpretation of the visible spectrum, which can be experienced from the inside as well as viewed from a distance.

Above: Eliasson's *Polychromatic Attention*, an installation from 2015, is a color circle of 24 crystal-glass spheres, forming a complete ring of the visible spectrum in graded hues. The hues are created by concave sheets of colored chrome, inserted into the spheres. The highly reflective surfaces of this work visually blur the boundaries of light, water and solid materials.

Falling Back in Love with Color

David Batchelor is a British artist who focuses on ideas about color in both his art and his writing. But it wasn't always the case; in fact the absence of color has inspired him as much as color itself. In a recent publication, *The Luminous and the Grey* (2014), he explained that for about twenty years he didn't consider color worth thinking about, quietly accepting the preference for black and white in late twentieth-century conceptual art. His early work included, perhaps predictably, monochromatic canvases and timber-and-glass constructions in either black or white. He "discovered" color quite by chance, by impulsively adding a vibrant magenta color to one side of a small piece of a sculpture in 1993, which then stood out sharply against the otherwise black-and-white interiors of his studio, making him question the absence of color in contemporary art and design. He then began embracing color artistically, conceptually and intellectually, but at the heart of his work as a writer and artist, is the exploration of our ambivalent relationship with color.

In 2000 Batchelor published the extended essay *Chromophobia*, in which he discussed the current obsession with white spaces in the West—and the long-standing aversion to color. Reading and rereading historic color literature, such as Charles Blanc's *Grammaire des arts du dessin architecture, sculpture, peinture* from 1867, he found a long tradition of color avoidance and fear of color. *Chromophobia* is a quietly shocking and beautifully composed argument against the marginalization of color as feminine, dangerous, secondary, primitive or a mere ornamental addition. Batchelor has also edited an anthology of excerpts from color literature since 1846, which gave him a particularly strong understanding of our complex relationship with color and how ideas about color are expressed in writing. *The Luminous and the Grey* also deals with those liminal spaces where color begins or ceases to exist; the non-color gray, associated with death, decay and absence.

In Batchelor's art, both two- and three-dimensional, intense pure color, including black and white, illumination and color order are recurring and dominant features. The influence of color theory is particularly prominent in a 2015 installation titled *Chromocochere* (opposite), a large LED-lit color ring of changing hues that was mounted on the entrance to the MK Gallery in Milton Keynes in the UK. The color ring was illuminated in single intense colors, going through the complete spectrum within each full hour. Earlier work such as *Magic Hour* (above), from 2004–2007, also shows spectral colors in a fluorescent starburst pattern, emanating from found lightboxes that were stacked up, facing a white wall in a darkened room. It is tempting, and perhaps intended, to associate this installation with Newton's experiments with prisms and light in a darkened room, or to think of his rival Goethe's argument that color is created in the space where light and darkness meet.

Pantone® Sets
a Color Standard

Today there are many systems in place that help us choose and combine colors in art, design, printing, interior decoration and branding. Many companies that deal in colors and paints produce charts, sheets or catalogs with color samples, from simple ranges that reflect the choice of ready-made housepaints available, to more elaborate ones that can be made to order. A few companies, such as Pantone, aim to provide comprehensive standardized color systems that can be used internationally in design, branding, printing, industrial production and the arts. In 1963, Pantone revolutionised the printing industry with the colorful Pantone Matching System®, an innovative tool allowing for the faithful selection, articulation and reproduction of consistent, accurate color anywhere in the world. The tool organizes color standards through a proprietary numbering system and chip format, which have since become iconic to the Pantone brand.

Since the company introduced its first color guides, it has become an established industry authority on color, widely used by the print industry, but it has also become a tastemaker. Conducting consumer color preference research since 1986, the Pantone Color Institute studies the role of color in psychology and design, making the world of color charts, guides and lists relevant in new ways. Calling out the top ten colors at NY Fashion Week since 1993, many now use the Pantone Color Institute for their seasonal color direction. Since 2000 the Pantone Color Insitute has been selecting a "color of the year," reflecting what is taking place in our global culture at a particular moment in time, bringing color and the color industry into the realms of the press and social media. Understanding that color is lifestyle, Pantone also offers consumer products including a range of stationery, mugs and other products that showcase the colors contained in the different Pantone Color Systems.

Right: Pantone's Formula Series fan deck, including 1,867 Pantone spot colors and providing the ink formulation for each.

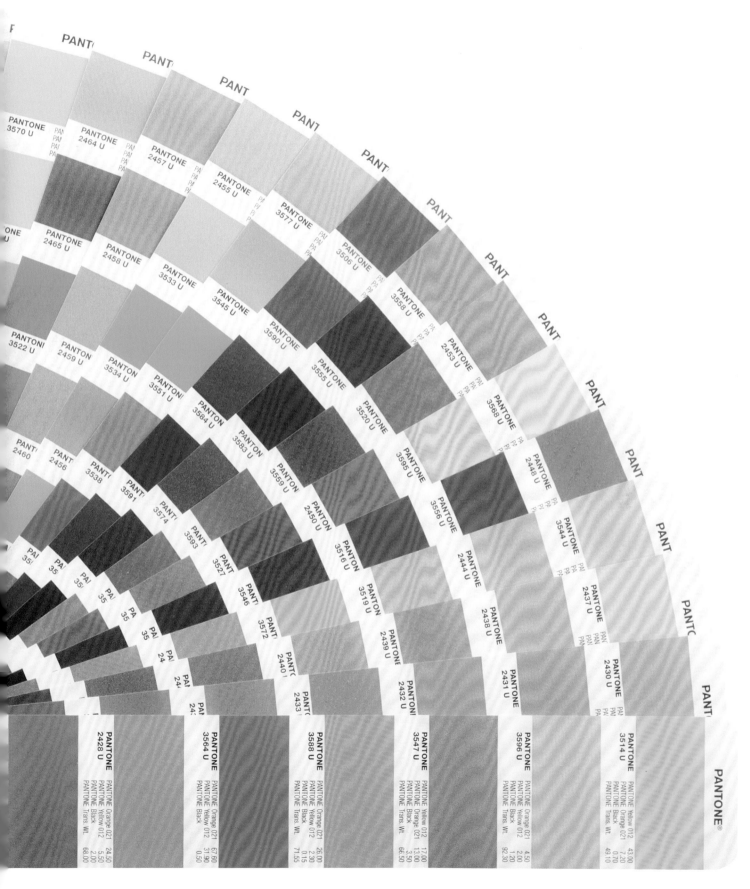

Glossary

Additive Color See *Immaterial Color*
See also *Material Color*.

Analogous Color
Analogous colors are groups of three colors that lie next to each other on the *Color Wheel*. One is *Primary*, one is *Secondary* and one is *Tertiary*.

Aquatint
A printmaking technique where tonal effects are produced by using acid to "eat into" the printing plate, creating sunken areas which hold the ink.

Bauhaus
Bauhaus was a revolutionary school of art, architecture and design established in Germany in 1919. Its aim was to bring together the fine and applied arts and its style was radically minimalist, promoting clean lines, pure colors and strong materials. Bauhaus incorporated color theory in its teaching and practice.

CIELAB
This is a system for numerically defining and communicating all the colors visible to the human eye, published in 1976 by the International Commission on Illumination.

Chroma See also *HVC, Saturation*.
Chroma, a term first used by Munsell, denotes the *Saturation* or brilliance of a color. Highly chromatic colors contain maximum *Hue* with few impurities or additives such as white, gray or black. A color without hue is called "achromatic" or "monochromatic" and appears gray.

CMYK See also *RGB*.
A color system that is used mostly in printed design. Modern color theory determined that the three colors that combine most effectively are cyan, magenta and yellow (CMY). With the advent of photomechanical printing, black ink was added and the system was named CMYK (cyan, magenta, yellow and black).

Color Wheel
A circular diagram that is used to show the relationships between Primary, Secondary, Tertiary and Complementary colors. Since Isaac Newton first popularized this visual aid to explain color, many different versions, not all of them round, have been proposed.

Complementary Color
Complementary colors appear opposite each other on the Color Wheel. The color complement of each Primary Color can be obtained by mixing the two other primary colors together.

Enlightenment
An intellectual and philosophical movement originating in Europe in the seventeenth century and spanning the eighteenth century. Freedom, democracy, and reason were advocated as the primary values of society.

Engraving
A printmaking technique that involves making incisions into a metal plate, traditionally copper, with a sharp tool. Ink is rolled onto the plate and the incisions retain the ink and form the printed image when transfered to paper.

Etching
Etching is a printmaking technique where a plate, traditionally copper, is covered with varnish, then a design is scratched through it. Acid is applied to the plate and affects only the exposed metal, etching the design onto the plate. The varnish is removed and the plate inked for transfer to paper.

Fauvism
A movement by artists including Henri Matisse and André Derain from around 1905 to 1910, characterized by strong colors and loose brushwork.

Hue
The attribute commonly described as color; that which makes it discernible as red or green, and so on. Hues are dependent on the dominant wavelength of light that is emitted or reflected from an object and are independent of *Saturation* or *Tone*. Pure white, black and grays have no hue.

HVC (Hue, Value, Chroma)
A numerical color system expressed using a flexible three-dimensional model that was devised by Munsell and based on three identifiable and measurable qualities of color: *Hue, Chroma* and Value (*Tone*).

Immaterial Color Also known as *Additive Color*. See also *Material Color*. Immaterial, or Additive, color is created by mixing different colors of light. Red, green and blue are the most commonly used immaterial primary colors, and if the same intensity of all these are overlapped, white light results. Immaterial colors are the basis of all colors used on screen.

Impressionism
Impressionism is an art movement developed in France in the nineteenth century and is based on the practice of painting rapidly outside (*en plein air*) rather than in a studio from sketches. This spontaneous method resulted in a greater awareness of light and color.

Industrial Revolution
The Industrial Revolution was the transition to new manufacturing processes. In this time, from about 1760 to sometime between 1820 and 1840, rural societies in Europe and America became industrial and urban.

Intensity See *Saturation*

Lithography
Lithography is printing process based on the antipathy of grease and water. A flat stone or metal plate is treated with a greasy medium so as to repel ink except where it is required for printing.

Material Color Also known as *Subtractive Color*. See also *Immaterial Color*. Material or Subtractive colors are used in painting and are associated with the reflection and absorption of light. The material *Primary Colors* are red,

blue and yellow and different colors result when these colors are combined, each due to some wavelengths of light being partially or completely subtracted (that is, absorbed). Exactly equal amounts of red, blue and yellow produce black.

Monochromatic
The term "monochromatic" means containing or using only one color with varying *Tones* or shades of it, although it is often used loosely to describe works in which a single color predominates. It is also used to mean a color without *Hue*, which appears gray.

Optical Mixing
Optical mixing is when two different colors placed side by side appear to create a different color. The Impressionists (and other groups) used this technique rather than pre-mixing paint colors on a palette.

Orphism
Orphism was an abstract offshoot of Cubism developed by Robert and Sonia Delaunay around 1912, which gave priority to light and color.

Picturesque See also *Romantic* and *Sublime.*
The term "picturesque," often applied to landscapes in the eighteenth century, referred to an ideal that is beautiful but has some elements of wildness. Earlier in the eighteenth century, aesthetic ideas favored either the *Sublime* at one extreme (awesome sights such as great mountains) or, at the other extreme, beautiful, peaceful, even pretty sights. Picturesque came in between.

Pigment
The pigment is the element in paint that provides its color. Pigments can be made from a wide range of materials including minerals, natural and synthetic dyes, and other man-made compounds.

Primary Colors Also known as *Primitive Colors, Pure Colors*
The primary colors vary depending on the type of color system. The painting color system which is Material or subtractive includes red, yellow and blue (RYB), the three pigment colors that cannot be formed by any combination of other colors. Red, green and blue (RGB) colors are the primaries of the Immaterial or additive system.

Primitive Colors See *Primary Colors.*

Pure Colors See *Primary Colors.*

RGB See also *CMYK*
This is an Immaterial or additive color system in which red, green and blue light is added together to produce a full range of colors. This system is the basis of all colors used on screen.

Romantic See also *Picturesque* and *Sublime.*
The term "Romantic" when used to describe a period or style applies to art, literature and music chiefly of the late eighteenth early nineteenth century, exhibiting certain characteristics such as individuality, emotion, drama and an interest in the natural world. Romanticism represented a shift away from the restraint of Classicism.

Saturation Also known as *Intensity.*
Also known as intensity, saturation describes the strength of a color with respect to its Tone or lightness and describes how bold or pale a color looks under different light conditions. Commonly used as a synonym for *Chroma* especially in graphic arts.

Secondary Colors Also known as *Compound Colors.*
The colors produced by combining or mixing two *Primary Colors.* Since the *Immaterial* and *Material Color* systems have different primary colors, their secondary colors vary too.

Spectral Colors
These are the colors visible to the human eye when white light is split, as in Newton's experiments splitting white light using a prism. Individual colors are evoked by a single wavelength of light in the Visible Spectrum. Spectral colors, as in a rainbow, are most commonly arranged from violet with the shortest wavelength to red with the longest. Related to *Immaterial Color.*

Sublime See also *Picturesque* and *Romantic*
The sublime is an impression of grandeur, awe and fear, and theories about conveying it were developed by Edmund Burke and other thinkers in the mid-eighteenth century. Burke defined the sublime as an artistic effect that produces the strongest emotion the mind is capable of feeling. To evoke the sublime, he advocated darkness and gloom in painting and architecture and advised against gaudiness induced by the use of color.

Subtractive Color See *Material Color*
See also *Immaterial Color.*

Tertiary Colors
The colors produced by combining or mixing a *Primary* and a *Secondary Color* such as red and green or two secondary colors such as green and orange. Combining two secondaries results in muddy colors: browns, grays and blacks. On the *Color Wheel* it may also refer to a subtler gradation between primaries and secondaries such as olive green.

Tone Also known as *Value.*
Tone refers to the relative lightness or darkness of a color, its brightness, rather than the color or *Hue* itself.

Value See *Tone*

Visible Spectrum
The visible spectrum is the portion of the electromagnetic spectrum that is visible to the human eye. See also *Spectral Color.*

Bibliography

Ackermann, Rudolph, *The Repository of Arts, Literature, Commerce, Manufactures, Fashions and Politics* (Published monthly, London: 1809–1828).

Albers, Josef, *Interaction of Color* (New Haven: Yale University Press, 1963; paperback edition, 1971).
——*Interaction of Color: New Complete Edition* (New Haven: Yale University Press, 2009).

Arrowsmith, Henry William and A., *The House Decorator and Painter's Guide; Containing a Series of Designs for Decorating Apartments, Suited to the Various Styles of Architecture* (London: Thomas Kelly, 1850).

Baretti, Joseph, *A Guide Through the Royal Academy, By Joseph Baretti Secretary For Foreign Correspondence To The Royal Academy* (London: printed by T. Cadwell c. 1781).

Barnard, George, *The Theory and Practice of Landscape Painting in Water-Colours* (London: Hamilton, Adams & Co., 1855; 2nd edition, 1858).

Batchelor, David, *Chromophobia* (London: Reaktion Books Ltd, 2000).
——(ed.) *Colour: Documents of Contemporary Art* (London: Whitechapel Gallery and Cambridge, Mass: The MIT Press, 2018).
—— *The Luminous and the Grey* (London: Reaktion Books Ltd, 2014).

Benson, William, *Principles of the Science of Colour, Concisely Stated to Aid and Promote their Useful Application in the Decorative Arts* (London: Chapman and Hall, 1868).

Birren, Faber, *The Color Primer: A Basic Treatise on the Color System of Wilhelm Ostwald/A Grammar of Color: A Basic Treatise on the Color System of Albert H. Munsell/Principles of Color: A Review of Past Traditions and Modern Theories of*

Color Harmony (New York: Van Nostrand Reinhold, 1969).

Blanc, Charles, *Grammaire des arts du dessin architecture, sculpture, peinture* (Paris: Jules Renouard, 1867).

Boutet, Claude (attr.), *Traité de la peinture en mignature pour apprendre aisément à peindre sans maître* (The Hague: van Dole, 1708).

British Colour Council, *The British Colour Council Dictionary of Colour Standards: A List of Colour Names Referring to the Colours Shown in the Companion Volume* (London: British Colour Council, 1934).

Burke, Edmund, *A Philosophical Enquiry into the Origin of Our Ideas of the Sublime and Beautiful* (London: printed for R. and J. Dodsley, in Pall-Mall, 1757).

Burnet, John, *Practical Hints on Colour in Painting* (London: J. Carpenter & Son, 1827).

Campbell, Richard, *The London Tradesman* (London: printed by T. Gardner, 1747).

Carpenter, Henry Barrett, *Suggestions for the Study of Colour* (Rochdale: H. B. Carpenter, 1923).

Cawse, John, *The Art of Painting Portraits, Landscapes, Animals, Draperies, Satins, &c. in Oil Colours: Practically Explained by Coloured Palettes* (London: Rudolph Ackermann, 1840).
——*Introduction to the Art of Painting in Oil Colours* (London: printed for R. Ackermann, 1822).

Cennini, Cennino (author), Mary Philadelphia Merrifield (translator), Signor Tambroni (introduction and notes), *A Treatise on Painting, Written by Cennino Cennini in the Year 1437* (London: E. Lumley, 1844; first published in Italian in 1821).

Chevreul, Michel Eugène, *Atlas. Expose d'un moyen de definir et de nommer les couleurs*

d'après une méthode précise et expérimentale: avec l'application de ce moyen a la définition et a la dénomination des couleurs d'un grand nombre de corps naturels et de produits artificiels (Paris: Didot, 1861).
——*Des couleurs et de leurs applications aux arts industriels à l'aide des cercles chromatiques* (Paris: J. B. Baillière & fils, 1864)
—— *De la loi du contraste simultané des couleurs et de l'assortiment des objets colorés: considéré d'après cette loi dans ses rapports avec la peinture, les tapisseries des gobelins, les tapisseries de Beauvais pour meubles, les tapis, la mosaique, les vitraux colorés, l'impression des étoffes, l'imprimerie, l'enluminure, la décoration des édifices, l'habillement et l'horticulture* (Paris: Pitois-Levrault et cie, 1839).
——*The Principles of Harmony and Contrast of Colours, and Their Applications to the Arts: Including Painting, Interior Decoration, Tapestries, Carpets, Mosaics, Coloured Glazing, Paper-staining, Calico-printing, Letterpress Printing, Map-colouring, Dress, Landscape and Flower Gardening, Etc. Tr. from the French by Charles Martel* (London: Longman, Brown, Green and Longmans, 1854).

Chevreul, Michel Eugène and René Henri Digeon, *Cercles chromatiques de M. E. Chevreul* (Paris: E. Thunot, 1855).

Cox, David, *A Series of Progressive Lessons, Intended to Elucidate the Art of Landscape Painting in Water Colours* (London: T. Clay, No. 18, Ludgate Hill, London, printed by J. Hayes, 1811).
——*The Young Artist's Companion or, Drawing-book of Studies and Landscape Embellishments: Comprising a Great Variety of the Most Picturesque Objects Required in Various Compositions of Landscape Scenery Arranged as Progressive Lessons* (London: S. & J. Fuller, 1825).

Curwen, Harold, *Printing* [Puffin Picture Book series] (London: Penguin, 1948).

de Lemos, Pedro Joseph, *Applied Art: Drawing, Painting, Design and Handicraft* (California: Pacific Press Publishing Association, 1920; reissued 1933).

Doerner, Max, *The Materials of the Artist and their Use in Painting, with Notes on the Techniques of the Old Masters* (New York: Harcourt Brace and Company, 1934).
—— *Malmaterial und seine Verwendung in Bilde: nach den Vorträgen an der Akademie der bildenden Künste in München* (München: Verlag für praktische Kunstwissenschaft, 1921).

Field, George, *Chromatics, or, An Essay on the Analogy and Harmony of Colours* (London: printed for the author by A. J. Valpy, Tooke's Court, Chancery Lane; and sold by Mr. Newman, Soho Square, 1817).
—— *Chromatographie. Eine Abhandlung über Farben und Pigmente, so wie deren Anwendung in der Malerkunst etc.* (Weimar: Verlage des Landes-Industrie-Comptoirs, 1836).
—— *Chromatography, or, A Treatise on Colours and Pigments, and of their Powers in Painting, &c.* (London: Tilt and Bogue, Fleet Street, 1835).
—— *Rudiments of the Painters' Art: or A Grammar of Colouring, Applicable to Operative Painting, Decorative Architecture, and the Arts*, 2nd edition (London: John Weale, 1858).

Fielding, Theodore Henry, *Index of Colours and Mixed Tints for the use of Beginners in Landscape and Figure Painting* (London: printed for the author, 1830).
—— *On Painting in Oil and Water Colours for Landscape and Portraits* (London: Ackermann and Co., 1839).

Fischer, Martin, *The Permanent Palette* (Maryland and New York: National Publishing Society, 1930).

Gartside, Mary, *An Essay on a New Theory of Colours, and on Composition in General, Illustrated by Coloured Blots Shewing the Application of the Theory to Composition of Flowers, Landscapes, Figures, &c.* (London: T. Gardiner, W. Miller and I. and A. Arch, 1808).
—— *An Essay on Light and Shade, on Colours, and on Composition in General* (London, printed for the author, by T. Davison, and sold by T. Gardiner, 1805).

Gilpin, William, *Hints to Form the Taste & Regulate ye Judgment in Sketching Landscape, ca. 1790.* Manuscript, Yale Center for British Art, Paul Mellon Collection, ND1340 G5, 1790.
—— *Three Essays: On Picturesque Beauty, on Picturesque Travel and on Sketching Landscape. To Which is Added a Poem, on Landscape Painting* (London: Printed for R. Blamire, in the Strand, 1792).

Goethe, Johann Wolfgang von, *Beyträge zur Optik* (Weimar: Im Verlage des Industrie Comptoirs, 1791/1972).
—— *Theory of Colours*; translated with notes by Charles Lock Eastlake (London: J. Murray, 1840).
—— *Zur Farbenlehre* [3 vols] (Tübingen: J. G. Cotta'sche Buchhandlung, 1810–1812).

Griffits, Thomas E., *The Technique of Colour Printing by Lithography: A Concise Manual of Drawn Lithography* (London: Faber & Faber Ltd, 1948).

Harris, Moses, *An Exposition of English Insects: Including the Several Classes of Neuroptera, & Hymenoptera, & Diptera, or Bees, Flies, & Libellula* (London: printed for the author, sold by Mr. White, bookseller, in Fleet-Street, and Mr. Robson, in New Bond Street, 1776 [1782]).
—— *The Natural System of Colours, Wherein is Displayed the Regular and Beautiful Order and Arrangement, Arising from the Three Premitives [sic], Red, Blue, and Yellow* (London: Laidler, c. 1769–1776).
—— *The Natural System of Colours, Wherein is Displayed the Regular and Beautiful Order and Arrangement, Arising from the Three Primitives, Red, Blue, and Yellow.* New edition with additions by Thomas Martyn (London: Harrison and Leigh, 1811).

Hay, David Ramsay, *The Laws of Harmonious Colouring, Adapted to Interior Decorations, Manufactures, and Other Useful Purposes*, 5th edition (London; W. S. Orr and Co, 1844).
—— *A Nomenclature of Colours, Hues, Tints, and Shades, Applicable to the Arts and Natural Sciences; to Manufactures, and other Purposes of General Utility* (William Blackwood and Sons, 1845).

Hayter, Charles, *A New Practical Treatise on the Three Primitive Colours* (London: J. Innes, 1826).

Hogarth, William, *The Analysis of Beauty, Written with a View of Fixing the Fluctuating Ideas of Taste* (London: printed by J. Reeves for the Author, 1753).

Hope, Thomas, *Household Furniture and Interior Decoration, Executed from Designs* (London: Longman, Hurst, Rees, & Orme, 1807).

Howard, Frank, *Colour as a Means of Art: Being an Adaptation of the Experience of Professors to the Practice of Amateurs* (London: Joseph Thomas, 1838).
—— *The Sketcher's Manual; or, The Whole Art of Picture Making Reduced to the Simplest Pinciples* (London: Darton and Clark, 1837).

Ibbetson, Julius, *An Accidence, or Gamut, of Painting in Oil and Water Colours* (London: for the author by Darton and Harvey, 1803).

Itten, Johannes, *The Art of Color: The Subjective Experience and Objective Rationale of Color*; translated by Ernst van Haagen, 2nd edition (New York: Van Nostrand Reinhold, 1962).
—— *Kunst der Farbe: Subjektives Erleben und objektives Erkennen als Wege zur Kunst* (Ravensburg: Otto Maier, 1961).

Jacobs, Michel, *The Art of Colour* (London: William Heinemann, 1925; first published in 1923, New York: Garden City).

[continued overleaf]

Jones, Owen, *The Grammar of Ornament* (London: Day & Son, 1856).

Kandinsky, Wassily, *Über das Geistige in der Kunst, insbesondere in der Malerei*, 2nd edition (München: R. Piper, 1912).

Klee, Paul, *Pädagogisches Skizzenbuch* (München: Albert Langen, 1925).
——*Beiträge zur bildnerischen Formlehre*, edited by Jürgen Glaesemer (Basel/Stuttgart: Paul Klee-Stiftung, 1979).

Lacouture, Charles, *Répertoire chromatique: solution raisonnée et pratique des problèmes les plus usuels dans l'étude et l'emploi des couleurs* (Paris: Gauthier-Villars, 1890).

Lambert, Johann Heinrich, *Beschreibung einer mit dem Calauschen Wachse ausgemalten Farbenpyramide, wo die Mischung jeder Farben aus Weiß und drei Grundfarben angeordnet* (Berlin: Haude und Spener, 1772).

Le Blon, Jacob Christoph, *Coloritto, or, The Harmony of Colouring in Painting / L'Harmonie du coloris dans la peinture* [...] (London: [publisher not identified], 1725).

[Le Blon, Jacob Christoph] Gautier de Montdorge, Antoine, *L'art d'imprimer les tableaux : traité d'après les écrits, les opérations & les instructions verbales de J. C. Le Blon.* (Paris: Ches P.G. Le Mercier [etc.], 1756).

Leonardo da Vinci, *A Treatise on Painting* (London: Senex and Taylor, 1721).

Mérimée, Jean-François-Léonor, *The Art of Painting in Oil and in Fresco: Being a History of the Various Processes and Materials Employed from its Discovery, by Hubert and John Van Eyck, to the Present Time/Translated from the Original French Treatise of J.F.L. Mérimée, with original observations on the rise and progress of British art, the French and English chromatic scales, and theories of colouring, by W.B. Sarsfield Taylor* (London: Whittaker, 1839).

——*De la peinture à l'huile, ou Des procédés matériels employés dans ce genre de peinture, depuis Hubert et Jean Van-Eyck jusqu'à nos jours* (Paris: Mme Huzard, 1830).

Merrifield, Mary Philadelphia, 'The Harmony of Colors as Exemplified in the Exhibition', in: *The Art Journal Illustrated Catalogue: The Industry of All Nations* (London: published for the proprietors by George Virtue, 1851).

Munsell, A. H., *Atlas of the Munsell Color System* (Malden, MA: printed by Wadsworth, Howland & Co., c. 1915).
——*A Color Notation. A measured color system, based on the three qualities Hue, Value and Chroma* (Boston: Geo. H. Ellis Co., 1905; 5th edition, New York: Munsell Color Company, 1919).
——*A Grammar of Color: Arrangements of Strathmore Papers in a Variety of Printed Color Combinations According to the Munsell Color System* (Mittineague, Mass.: The Strathmore Paper Company, 1921).

Newton, Sir Isaac, *Opticks: or, A Treatise of the Reflexions, Refractions, Inflexions and Colours of Light* (London: Sam. Smith & Benj. Walford, 1704).

Oram, William, *Precepts and Observations on the Art of Colouring in Landscape Painting* (London: printed for White and Cochranne by Richard Taylor, 1810).

Ostwald, Wilhelm, *Die Farbenfibel* (Leipzig: Unesma, 1917).
——*Die Harmonie der Farben* (Leipzig: Verlag Unesma, 1918).
——*Letters to a Painter on the Theory and Practice of Painting*; translated by H. W. Morse. (Boston/New York/Chicago/London: Ginn & Company. 1907).
——*Malerbriefe. Beiträge zur Theorie und Praxis der Malerei* (Leipzig: Verlag von S. Hirzel, 1904).

Parsons, Thomas, *A Tint Book of Historical Colours*, 4th edition (London: Thomas Parsons & Sons, 1934; 1950).

Piot, René, *Les palettes de Delacroix* (Paris: 1930).

Repton, Humphry, *Fragments on the Theory and Practice of Landscape Gardening* (London: printed by T. Bensley and Son, Bolt Court, Fleet Street; for J. Taylor, at the Architectural Library, High Holborn, 1816).
——*Observations on the Theory and Practice of Landscape Gardening* (London: printed by T. Bensley and Son, Bolt Court, Fleet Street; for J. Taylor, at the Architectural Library, High Holborn, 1803).

Rood, Ogden Nicholas, *Colour: A Text-Book of Modern Chromatics with Applications to Art and Industry*, 3rd edition (London: Kegan Paul, Trench, Trubner, [1st ed. as below]; 1890).
——*Modern Chromatics, with Applications to Art and Industry* (New York: D. Appleton and Company, 1879).

Runge, Philipp Otto, *Die Farben-Kugel, oder Konstruktion des Verhältnisses aller Mischungen der Farben zu einander, und ihrer vollständigen Affinität, mit angehängtem Versuch einer Ableitung der Harmonie in den Zusammenstellungen der Farben* (Hamburg: Friedrich Perthes, 1810).

Schiffermüller, Ignaz, *Versuch eines Farbensystems* (Vienna: Agustin Bernardi, 1772).

Schopenhauer, Arthur, *Über das Sehn und die Farbe* (Leipzig: Johann Friedrich Hartnoch, 1816).
——*Über das Sehn und die Farbe*, revised and extended edition (Leipzig: Johann Friedrich Hartnoch, 1854).

Scott Taylor, J., *The Simple Explanation of the Ostwald Colour System* (London: Winsor & Newton, 1935).

Senefelder, Alois, *A Complete Course of Lithography* (London: Ackermann, 1819).

Sol, J. C. M., *La palette theorique: ou, Classification des couleurs* (Vannes: N. de Lamarzelle, 1849).

Sowerby, James, *A New Elucidation of Colours, Original, Prismatic and Material; Showing their Concordance in Three Primitives, Yellow, Red, and Blue; and the Means of Producing Measuring and Mixing Them: with Some Observations on the Accuracy of Sir Isaac Newton* (London: Richard Taylor & Co. 1809).

Syme, Patrick (editor), *Werner's Nomenclature of Colours, With Additions, Arranged so as to Render it Highly Useful to the Arts and Sciences, Particularly Zoology, Botany, Chemistry, Mineralogy, and Morbid Anatomy. Annexed to Which Are Examples Selected From Well-known Objects in the Animal, Vegetable, and Mineral Kingdoms* (Edinburgh: William Blackwood, and London: John Murray and Robert Baldwin, 1814; London: T. Cadell, 1821).

Turner, Joseph Mallord William, "Colour," from *Royal Academy Lectures by Joseph Mallord William Turner, R.A., as Professor of Perspective and Geometry, a Post to Which he Was Elected 10 Dec. 1807 and Which He Resigned 10 Feb. 1838.* Manuscript, British Library Add MS 46151 A-BB: 1806–1902; transcribed and printed in J. Gage, *Colour in Turner: Poetry and Truth* (London: Studio Vista, 1969), pp. 196–197.

Wittgenstein, Ludwig, *Bemerkungen über die Farben / Remarks on Colour*; edited by G. E. M. Anscombe, translated by Linda L. McAlister and Margaret Schattle (Oxford: Basic Blackwell, 1977).

Vanderpoel, Emily Noyes, *Color Problems: A Practical Manual for the Lay Student of Color* (New York, London, Bombay: Longmans, Green & Co., 1902).

Vanherman, T. H., *Every Man his Own House-painter and Colourman, the Whole Forming a Complete System for the Amelioration of the Noxious Quality of Common Paint; a Number of Invaluable Inventions, Discoveries and Improvements, and a Variety of Other Particulars that Relate to the House-painting in General* (London: I. F. Setchel; Simpkin and Marshall; and J. Booth, 1829).

Varley, John, *J. Varley's List of Colours* (London: J. Varley, 1818).
——*Varley's Specimens of Permanent Colours* (London: J. Varley, 1850).

Villalobos-Domínguez, Cándido and Julio Villalobos, *Atlas de los Colores/Colour Atlas*; translated by Aubrey Malyn Homer (Buenos Aires: El Ateneo Editorial, 1947).

Voltaire, *Eléments de la philosophie de Newton/mis à la portée de tout le monde, par Mr. de Voltaire* (Amsterdam: Chez Jacques Desbordes, 1738).

Waller, Richard, "A Catalogue of Simple and Mixt Colours, with a Specimen of each Colour prefixt to its proper Name," in *Philosophical Transactions of the Royal Society of London* Vol. 16, 1686.

Warren, Henry, *Hints Upon Tints, with Strokes Upon Copper and Canvass* (London: printed for J.F. Setchel, 1833).

Werner, Abraham Gottlob, *Von den äusserlichen Kennzeichen der Fossilien* (Leipzig: Crusius, 1774).

Wilkinson, Sir John Gardner, *On Colour and the necessity for a General Diffusion of Taste among all Classes* (London: John Murray, 1858).

Wilson, Robert Arthur, *The Colour Circle, Based Upon Nature (The Rainbow) and Hand-Coloured* (UK, privately published, no date, *c.* 1920s).

Wilson, Robert Francis, *Colour and Light at Work* (London: Seven Oaks Press, 1953).
——*The Wilson Colour Chart*, (London: British Colour Council, *c.* 1938).

Index

Picture Credits

Photography by Clive Boursnell.

Additional picture credits:

Alamy Stock Photo *Classic Image 30; Granger Historical Picture Archive 129; Heritage Image Partnership Ltd. 165; Ivy Close Images 128; Peter Horree 156.* **akg-images** *44; Bildarchiv Steffens 217 below.* **Alexandra Loske** *142, 204, 205, 217 above.* **Bibliothèque de Genève** *218.* **Bridgeman Images** © *British Library Board. All Rights Reserved 18, 19; Courtesy of the Warden and Scholars of New College, Oxford 15; Haags Gemeentemuseum, The Hague, Netherlands 158; Hamburger Kunsthalle, Hamburg, Germany 144; Jeu de Paume, Paris, France 122; Kunstmuseum, Basel, Switzerland/Gift of Richard Doetsch-Benziger, 1960 171; Louvre, Paris, France/De Agostini Picture Library/G. Dagli Orti 126; National Portrait Gallery, London, UK/Photo © Stefano Baldini 31; Philadelphia Museum of Art, Pennsylvania, PA, USA/The Louise and Walter Arensberg Collection, 1950.* © *ADAGP, Paris and DACS, London 2017 157; Private Collection 164; Private Collection.* © *The Joseph and Anni Albers Foundation/VG Bild-Kunst, Bonn and DACS, London 2017 181; Sterling and Francine Clark Art Institute, Williamstown, Massachusetts, USA 127.* **Courtesy of the Josef and Anni Albers Foundation** *180.* **Courtesy Sam Allen**, *photo by Clive Boursnell 212.* © **David Batchelor** *227, photo by Marcus Leith 226.* © **Gabriel Dawe**, *Plexus A1, 2015, Renwick Gallery of the Smithsonian American Art Museum, Courtesy Conduit Gallery. Photo by Ron Blunt 223.* **Getty Images** *Hulton Archive 35; Science & Society Picture Library 23 right.* **Getty Research Institute** *16.* **Jim Pike** *47, 74, 75.* **National Gallery of Art Washington**, *Collection of Mr. and Mrs. Paul Mellon 100.* © **Olafur Eliasson**, *Photo by Jens Ziehe, Berlin; Courtesy the artist; Tanya Bonakdar Gallery, New York 225, Photo by Ole Hein Pedersen; Courtesy the artist; ARoS Aarhus Kunstmuseum 224 above, Photo by Thilo Frank, Studio Olafur Eliasson; Courtesy the artist; ARoS Aarhus Kunstmuseum 224 below.* **Penguin Random House UK**, *cover design* © *Penguin Books Ltd., 1948, reproduced by permission of Penguin Random House UK 198.* **Photo by Clive Boursnell**, *used with permission of David Gilmour, Nick Mason, Roger Waters and the Richard Wright Estate 221.* **REX Shutterstock** *British Library/Robana 7 below.* © **RMN**-*Grand Palais (musée du Louvre) / Hervé Lewandowski 125.* **Royal Academy of Arts, London**; *Photographer: John Hammond 22.* © **Spencer Finch** *219.* **Strat Mastoris** *34, 175 above.* **SuperStock** *3LH 123.* **Tate Images** *Digital Image* © *Tate, London 2014 89; Digital Image* © *Tate, London 2014,* © *1998 Kate Rothko Prizel & Christopher Rothko ARS, NY and DACS, London 196; Digital Image* © *Tate, London 2014,* © *Succession Henri Matisse / DACS 2018 134; Digital Image* © *Tate, London 2017 82, 83.* **Tecta** *175 below.* © **The Trustees of the British Museum** *37.* **Tyree Callahan** *222.* **Universitätsbibliothek Heidelberg** *via CC licence 54. Wikimedia Commons public domain 17, 21.* **www.kettererkunst.com** © *DACS 2017 6.* **Yale Center for British Art**, *Paul Mellon Collection 33.* **Zentrum Paul Klee** *173.*

Right: Artist Eva Bodinet's color globe, made from a traditional cardboard globe overlaid with strips of paper painted with acrylic paint.

Acknowledgments

For their support, both personal and professional, and inspiration through the
years I would like to thank:

All my friends and colleagues at the University of Sussex, the Royal Pavilion and Brighton Museums, the Arts and Humanities Research Council, the Attingham Trust, the Yale Center for British Art, the Colour Reference Library at the Royal College of Art, the National Art Library at the V&A, the British Library, The Keep Archives in East Sussex, and, especially, Tracy Anderson, Mark Aronson, Kevin Bacon, David Batchelor, Patrick Baty, David Beevers, Andrew Bennett, Meskerem Berhane, Clare Best, Carole Biggam, Eva Bodinet, David Bomford, Clarisse Bourgeois, Clive Boursnell, Janet Brough, Franky Bulmer, Meaghan Clarke, Nicola Coleby, Patrick Conner, Fiona Courage, Steve Creffield, Neil Cunningham, Jessica David, Stuart Durant, Olafur Eliasson, Kate Elms, Jenny Gaschke, Sarah Gibbings, Gordon Grant, Fergus Hare, Maurice Howard, Carl Jennings, Colin and Rose Jones, Renate Klauck-Neils, Simon Lane, Zara Larcombe, Ric Latham, Robin Lee, Carol Lewis, Flora Loske-Page, Jenny Lund, Chris McDermott, Erwin Paul Mark, David J Markham, Robert Massey, Tamsin and Strat Mastoris, Jonathan Menezes, Jochen Menge, Peter Messer, Shona Milton, Klaus Neils, Michelle O'Malley, Patrick Marrin, Roy Osborne, Jeremy Page, Neil Parkinson, Steve Pavey, Jim Pike, Matthew Platts, Sarah Posey, Geoff Quilley, Rupert Radcliffe-Genge, Hazel Rayner, Jacqueline Rietz, Linda Rossbach, Jae Jennifer Rossman, Rachel Silverlight, Abraham Thomas, Lindy Usher, Jennifer Veall, Ian Warrell, Marianne Wiehn, and Chandra Wohleber.